Environmental Sustainability at Historic Sites and Museums

ABOUT THE SERIES
The American Association for State and Local History Book Series publishes technical and professional information for those who practice and support history, and addresses issues critical to the field of state and local history. To submit a proposal or manuscript to the series, please request proposal guidelines from AASLH headquarters: AASLH Editorial Board, 1717 Church St., Nashville, Tennessee 37203. Telephone: (615) 320-3203. Website: www.aaslh.org.

ABOUT THE ORGANIZATION
The American Association for State and Local History (AASLH) is a national history organization headquartered in Nashville, Tennessee. AASLH provides leadership and support for its members who preserve and interpret state and local history in order to make the past more meaningful to all Americans. AASLH is a membership association representing history organizations and the professionals who work in them. AASLH members are leaders in preserving, researching, and interpreting traces of the American past to connect the people, thoughts, and events of yesterday with the creative memories and abiding concerns of people, communities, and our nation today. In addition to sponsorship of this book series, AASLH publishes *History News* magazine, a newsletter, technical leaflets and reports, and other materials; confers prizes and awards in recognition of outstanding achievement in the field; and supports a broad education program and other activities designed to help members work more effectively. To join AASLH, go to www.aaslh.org or contact Membership Services, AASLH, 1717 Church St., Nashville, TN 37203.

Environmental Sustainability at Historic Sites and Museums

Sarah Sutton

ROWMAN & LITTLEFIELD
Lanham • Boulder • New York • London

Published by Rowman & Littlefield
A wholly owned subsidiary of The Rowman & Littlefield Publishing Group, Inc.
4501 Forbes Boulevard, Suite 200, Lanham, Maryland 20706
www.rowman.com

Unit A, Whitacre Mews, 26-34 Stannary Street, London SE11 4AB

British Library Cataloguing in Publication Information Available

Library of Congress Cataloging-in-Publication Data
Sutton, Sarah, 1961 August 16–
 Environmental sustainability at historic sites and museums / Sarah Sutton.
 pages cm. — (American Association for State and Local History book series)
 Includes index.
 ISBN 978-0-7591-2415-8 (cloth : alk. paper) — ISBN 978-0-7591-2443-1
(pbk. : alk. paper) — ISBN 978-0-7591-2416-5 (electronic) 1. Historic sites—
Environmental aspects. 2. Historic sites—Management. 3. Museums—
Environmental aspects. 4. Museums—Management. 5. Sustainability. I. Title.
 CC135.S88 2015
 363.6'9—dc23 2015000454

♾ ™ The paper used in this publication meets the minimum requirements of
American National Standard for Information Sciences—Permanence of Paper
for Printed Library Materials, ANSI/NISO Z39.48-1992.

Printed in the United States of America

Dedication

To Bob Beatty for his leadership at the American Association for State and Local History, his generous support of history professionals, and his impeccable timing with encouragement. I am very, very grateful.

And to Elizabeth Wylie for introducing me to my future. I am very, very grateful indeed.

CONTENTS

FIGURES
AND PHOTOS

ACKNOWLEDGMENTS

MUSEUM PEOPLE are incredibly generous. Everyone I came across during this writing project was generous with their personal experience and institutional story. If at any moment I wondered if enough of us were doing this good green work, it was short-lived. Always I would soon hear from someone, or come across someone, who was leading the charge at their institution. They all had great ideas to share. Each time I was reassured that more of us, every day, are working to promote environmental sustainability in the field. I am grateful to all those who spoke with me and shared their stories and information and images. And I am sorry I could not speak with more of you, or fit you all into these pages.

Thank you, in particular, to these folks who provided encouragement and inspiration, and who shared material included in this book: Claudia Berg, Matthew Hill, Mary Alexander, Bob Beatty, Amy Killpatrick Fox, Barry A. Loveland, Elizabeth Merritt, Karen Wade, Robert Barron, Paul Spitzzeri, Mike Leister, Elizabeth Wylie, Shengyin Xu, Carol Haines, David Wood, Margaret Burke, Carl R. Nold, Michael C. Henry, Cinnamon Catlin-Legutko, Julia Clark, Liz Callahan, Reed Cherington, Susan Funk, Robert Hanna, Kim VanWormer, Danielle Henrici, Gwendolyn Miner, Sheryl Hack, John Forti, Bridgitte Rodguez, John Mayer, Jeremy Linden, David Rhees, Dan Snydacker, Kari Jensen, Andrea Jones, Leighton Deer, Adam Luckhardt, Rebecca Celis, and Amy Bradford Whittey.

And thank you to Denise Mix, who helped me with the final manuscript and materials when the hour was getting late.

The personal and professional stories I continue to hear during my research and my work demonstrate creativity, commitment, professionalism, and hope. You folks are marvelous resources for the field and are critical for moving us forward. Thank you, all, for the work you are doing, and will do, for the field, your communities, and the planet.

INTRODUCTION

A DISCUSSION overheard at the 1700s Log Farm at Landis Valley Village & Farm Museum, Lancaster, Pennsylvania:

Visitor #1: I wouldn't want to have lived back then: no air-conditioning.

Visitor #2: They didn't need it: there wasn't all this asphalt to heat things up.[1]

That's a pretty stunning conversation, isn't it? The discussion bridges nearly four centuries, compares and contrasts preindustrial and postindustrial cultures, and creates a personal connection for both visitors. It's an interpretive trifecta! It's too bad there isn't an environmentally literate interpreter nearby to help refine their assumptions.

Visitor #1 is remarking on the difference in living conditions from colonial times to the twenty-first century, ones she sees as uncomfortable or unacceptable. She hasn't allowed for different tolerance levels for heat across those centuries, and she's assumed that no cooling measures, such as hand fans and open windows and doors, would have provided welcome relief and pleasure. A well-placed interpreter could invite her to sit in the shade, rock in a chair, and fan herself as she enjoys a break.

Visitor #2 clearly recognizes that the green grass, bushes, and trees keep the area cooler. And he acknowledges a warming planet associated with human changes, but he gives urban heat island effect too much

responsibility for global climate change, leaving out fossil fuels from heating and air-conditioning, and driving cars—and air pollution.[2]

Unfortunately, just as there is never time during a single visit to tell our guests all we have to share about our sites, there isn't time for a full climate change lesson either. Still, the environment, and human effects on it, is a hot topic right now, and an excellent opportunity for any historic site to engage guests by connecting history to today, illustrating change over time, and linking visitors' daily experiences to the variety of fascinating decisions humans have made over the last four hundred years. The concepts embedded in environmental sustainability, and the discussions about how we can change our behaviors to help the environment and ourselves, are excellent opportunities to demonstrate the responsiveness of history museums and historic sites to present-day interests and expectations.

If you're muttering to yourself that "historic sites and history museums have always been green because we have no money for buying anything," then you are right. Using less, whether by choice or necessity, *is* often a more sustainable way, but it isn't the full measure of environmental sustainability at our sites. Here's a dramatic example, for illustration purposes only, of how using less might not be more green. It may seem environmentally sustainable to use less energy and, therefore, limit how much you dehumidify some spaces. Taking this too far leads to creating an environment for mold: mold that damages the collection and mold that spreads. The process to eradicate that mold is very likely more damaging to the environment (not to mention your structure or collection) than using more energy to run the dehumidifier more frequently and then splashing the resulting water over the kitchen garden, or using it for washing-up in the 1840 farmer's kitchen, or watering the chickens. No one is saying—yet—that sustainability trumps preservation and collections care. Learning to make the most appropriate, most sustainable choices, however, is very, very important.

The mantra *reduce, reuse, repurpose, recycle* is a simple guide for environmental choices, but history management is a profession and we must be careful to marry our professional needs and environmental opportunities thoughtfully. Saving energy can be good for the environment, but indiscriminate energy savings can be bad for our work and for other aspects of the environment. Green choices are usually complex choices. That is one reason why the concepts have been slow to permeate our lives in general and museum work specifically. That is also why the literature on environmental practice is expanding so rapidly. Making good green choices requires practice. Making good choices also means recognizing professional

standards. That is what this book is about: how to go green for history museum and historic sites *professionally.*

How This Book Works

The first two editions of the book *The Green Museum: A Primer on Environmental Practice* (Brophy and Wylie, 2008 and 2013), and written under the name Sarah S. Brophy, showcased a variety of institutions, including some great history museums and historic sites. In this more focused book, I would hate to leave them out, but there should be space for new sites and organizations. So most of the cases and people you will encounter in this book are new examples; wherever possible, I have highlighted different aspects or provided new and updated details for any repeat appearance by an institution.

Since I began writing on this topic in 2005, environmental sustainability has gained significant momentum, and opportunities and knowledge have expanded exponentially; it would be such a disadvantage if just a few voices represented the field. In this book, you will find case stories where I have asked the professionals to speak for themselves and their institutions on specific aspects of their work. This is a chance to make sure we all hear more of these voices and recognize that environmental sustainability at historic properties and history museums is expanding.

Please do not panic if you are surprised at the amount of green work going on around you; many of us are surprised, too, and may have that unwelcome feeling that we've been left behind. You are not "behind" if you just get going, but you *are* behind if you observe this transformation of our field and do not begin changing your institution immediately. In these pages are the stories and ideas to get you started or to move you up a level. What matters most is that you move your institution forward, and you help move the public forward as well. If you don't, you will be left behind mainstream America. If you do, you will begin to develop the literacy and skills you need to keep up with a changing climate, economy, and public attitude.

One last note: "green" is a shorthand term for environmentally friendly choices and materials. Many people like the term; just as many do not. Environmental sustainability is such a complex topic that a single-syllable word cannot do justice to it; still the word is useful for comfortable reading.

What to Expect

Each chapter begins with a vision statement for history organizations. Then each chapter provides information and recommendation, stories from the

field—cases in some chapters—and the most prominent resources in that topic area. Here's what you will find in each section.

Chapter 1: Value: How Environmental Sustainability Strengthens History Sites and Museums

This is a discussion of how thoughtful application of sustainability ideas can complement your mission and improve your quadruple bottom line with benefits to people, planet, profit, and program.[3]

Chapter 2: Starting to Go Green: Making Choices and Facilitating Change

This chapter reviews how to make choices, prioritize opportunities, and how to encourage change among staff. The Workman and Temple Family Homestead story in this chapter is a marvelous example of how green change begins. This chapter also has a case from Dumbarton House, museum and headquarters for the National Society for the Colonial Dames of America, Washington, District of Columbia.

Chapter 3: Energy Choices

When you change energy use by changing your lighting, this affects objects and visitors in your buildings. Here is where the case stories really make a difference. This chapter explains energy efficiency and alternative energy options, and provides examples illustrating how each decision really is based on your personal situation (geography, financing, neighbors, etc.) and on your professional choices (preservation, interpretation, institutional planning, and opportunity). Examples include the Newport (Rhode Island) Historical Society's geothermal installation over a decade ago, inspiration from the Bakken Museum in Minneapolis, Minnesota, and an evolutionary tale from Hanford Mills Museum in New York.

Chapter 4: The Idea: Environmental Sustainability in Collections Care

This chapter provides a brief introduction to resources available as guidance for reviewing environmental conditions, working with a consulting professional, and then planning and implementing changes to strategies for collections care. Many sites and museums are testing relaxed guidelines for temperature and relative humidity levels to reflect new understandings

of collections needs and the realities of system performance, and to help with energy and cost savings. This chapter reviews that change, provides resources, and offers a case story from the Minnesota Historical Society.

Chapter 5: Rediscovering Connections: Buildings, Land and Water, Plants and Agriculture, and Animals

For many of us, the landscapes tell more than half our story and take up more than half our attention. How can sustainable practices enhance your story while remaining in alignment with professional responsibilities? This may mean changing your plantings or restoring connections to the landscape. The cases for this chapter come from Andalusia, the Home of Flannery O'Connor, in Athens, Georgia, and Strawbery Banke Museum in Portsmouth, New Hampshire.

Chapter 6: Sharing These Connections: Historic Interpretation and Community Engagement

This is where we can shine. Whether you're instructing on canning and drying foods, demonstrating the use of bushes or a laundry line for drying clothes, or you're focusing on bigger topics such as political or geographical changes associated with the environment and the history of your site, this is where we can tell sustainability stories in ways that can really engage the public and may inspire them to action. This is all about contemporizing our relevance. We can host farmers' markets and community-supported agriculture programs, or go further by offering present-day discussions of land use and other environmental issues, and fostering public participation in community gardens and habitat restoration work, to show how our sites connect to contemporary issues. That kind of community impact is an opportunity not to be missed. Stories in this chapter come from the Concord Museum in Concord, Massachusetts, and Wyck Historic House, Garden, and Farm in Germantown, Pennsylvania.

Chapter 7: Materials: What Comes, What Goes, What Gets Recovered, and What Gets Transformed

It isn't just about recycling anymore. It's about sourcing sustainable materials and products closer to home and choosing items only when you can't repurpose others. Limiting our use of new materials is critical, especially in exhibits. Any new items or materials should come with less packaging and should be durable and energy efficient. And what you want to get rid

of should first be repurposed and then recycled. Recycling is an art and a science, so give it the attention it requires to make it work well for you and your visitors. Turn what waste you can into nutrients or energy. What is left will have to be thrown away, but someday we will get to where the waste stream is the least of what leaves our sites. The goal is zero waste.

Chapter 8: Sustainability Policies and Planning

Sustainability plans aren't yet settling onto bookshelves alongside disaster plans, ethics policies, and investment manuals. This chapter discusses options for creating your own plan or building it into all the others you already have or are working to finish. There are examples from Connecticut Landmarks, and Accokeek Foundation, in Accokeek, Maryland.

Chapter 9: Creating Our Future

Our future includes rising sea levels, the Internet of Things, managing PILOT fees, preparing for climate change and climate events, responding to greener building codes and mandates for managing waste and stormwater onsite, allying ourselves with other agencies tasked with teaching about sustainability, and finding new ways to capture funding. How are we going to be ready if we don't think about these challenges now by noticing early opportunities to become even better stewards of our properties and collections?

By the end of this book, you will be able to assess a situation and identify probable effect chains, and recognize the options for degrees of green change. If they are not obvious now, don't worry; let the examples and stories in these pages build both your recognition of the language and your skills at identifying smart, creative solutions to help you green your institution.

While you read, I suspect you will keep wondering "how do I pay for this?" The answer is "the same way you pay for anything else at your institution." Going green is neither a luxury nor an add-on, and it is not triggered solely through new funding sources. This is *the* new way of doing business. It's a cost of business. As you and those around you are able to recognize and internalize this, the rate of change in your institution will escalate exponentially.

It will take more than this book to create this change in you and your organization, but here is where you start, and you must start by believing that embracing these principles and practices creates an energy loop of its

own that will build you up, and build up your institutional capacity for this work simultaneously. As you build your knowledge, experience, and networks, sustainable results will become a constantly recharging progress loop. Green breeds green on many levels, but only after you *choose* to encourage this sustainability work. I encourage you to reread, or skim, this book again three to six months from now. You'll discover two things: (1) you'll understand more of it and know just what to do with the information, and (2) you'll realize just how much you've started to do. It will feel great.

Of these nine chapters, many address practices and management; a few address historic interpretation. Don't let that imbalance fool you. Telling the stories of historic practices that were more sustainable than today's practices (and the ones that were much less so) is an exciting area of interpretation for museums and sites. It is such a terrific opportunity for public engagement, as is the history of the environmental movement. Yet both topics have been overlooked, or underplayed, too often in our work. Let's change that. By the time there is a second edition of this book, let's make sure that imbalance between operational practice and historic interpretation has been repaired.

Now surely many readers are muttering "Why didn't she ask us? We have a great example!" Gosh, I wish I had, and I hope you will still tell me about what you're doing. I especially hope you will tell others what you're doing so they will feel encouraged to join us in our efforts.

Notes

1. Discussion overheard by the author while visiting Landis Valley Village & Farm Museum, Pennsylvania, August 11, 2013.

2. Louis Bergeron, "Urban 'heat island' effect is only a small contributor to global warming, and white roofs don't help to solve the problem, say Stanford researchers," *Stanford Report*, October 19, 2011, accessed August 27, 2014, http://news.stanford.edu/news/2011/october/urban-heat-islands-101911.html. Only about 2 percent to 4 percent of the total historical global temperature change is currently attributed to the higher temperature levels found in cities and resulting from displacement of hard, heat-absorbing surfaces versus vegetated landscape and healthy soil, which allow water to evaporate and cool the air nearby.

3. Brophy blog post citation. Sarah Brophy, "Quadruple Bottom Line: People, Planet, Profit AND Program," *Sustainable Museums* (blog), May 18, 2010, http://sustainablemuseums.blogspot.com/2010/05/quadruple-bottom-line-people-planet.html.

୭⃝୭

VALUE: HOW ENVIRONMENTAL SUSTAINABILITY STRENGTHENS HISTORY SITES AND MUSEUMS

Vision

History museums and historic sites recognize that environmental sustainability adds cultural and economic value to their organizations and their local and national communities. They recognize that it does so in a manner that protects the past and the future.

> "There is so much noise and chatter about sustainability. It's so important to be very thoughtful about choices, especially when dealing with an historic site and other people's money."
>
> —Liz Callahan, executive director,
> The Hanford Mills Museum, New York[1]

Connecticut Landmarks uses the tagline "History Moving Forward." Sheryl Hack, its executive director, says, as an organization "we have to figure out how to be a community player and educator. . . .

1

Our buildings, land, sites, and collections are collective resources. I believe strongly in the notion of public good. It's a huge privilege to have these resources. We must treat it like a privilege." The growth of public interest in environmental sustainability is a gift to historical organizations. It is an invitation to connect with the public using our knowledge, collections, and sites to discuss how human practices and interactions with the environment in the past were—and were not—environmentally sustainable.

At the Abbe Museum in Bar Harbor, Maine, environmental sustainability practices align with the museum's decolonization initiative. Executive Director Cinnamon Catlin-Legutko says that decolonization can be broadly defined as the process of reversing colonialism, both politically and culturally. "It involves not only recognizing indigenous perspectives and the ongoing colonization of indigenous nations, but the devastating effects that colonialism has on indigenous cultures." This recognition permeates decision-making at the museum. "As we think about sustainability issues, using a decolonized view, our greening practices would be consistent with the cultural values of the people we work with and represent. For example, in our exhibits and educational programs, if we are going to talk about Wabanaki concerns for the environmental damage that has taken place and continues to impact their homeland, our daily operations should strive to be consistent with our interpretive messages."[2]

This mission alignment is incredibly valuable, but too few sites capitalize on environmental sustainability opportunities, large or small. To most history organizations, being green is limited to using less energy, buying less stuff, and recycling more; these organizations don't apply environmental sustainability institution-wide or include it in interpretation much beyond agriculture. Others take the default position that environmental sustainability is about science so the science centers and museums should be the ones discussing the environment. Let's take a step back from these approaches and recognize that if we interpret any aspect of social or political history, we interpret the human experience, and so much of the human experience is associated with environmental issues; we are irresponsible if we overlook that aspect. For each of our sites, there is an angle on the environment. Going green should change the way you operate, engage the community, *and* fulfill your mission.

Take the three-day Fourth Annual Honey Fest in 2013 hosted by the Philadelphia Beekeepers Guild and three local historical organizations. The Wagner Free Institute—a natural history museum—had a science program on "Pollinator Power!," two screenings of a documentary on bees, and a Honey Happy Hour featuring local, honey-themed drinks and food. The Wyck Historic House, Garden, and Farm's activities included talks on

beekeeping, planting a bee-friendly garden, and making mead—a traditional drink of fermented honey—followed by a mead- and beer-tasting event, and with a farmer's market onsite. Bartram's Garden, a National Historic Landmark house and garden, offered open hive and honey extraction demonstrations, a lecture on "Beekeeping Through the Year," a bee costume pageant for kids, house tours, a guided tour of the Urban Nutrition Initiative garden at the site, and sales of vegetables, fruit, and plants.[3]

Just think how this collaborative program enhanced the exposure for all four organizations! It was an excellent alignment of programming for public engagement, environmental literacy, and income, plus alignment for mission. That's called the quadruple bottom line. It's a valuable mantra for guiding environmentally sustainable thinking that benefits people, planet, profit, and programs. Here's what I mean: *people*, meaning the learners, benefitted by active engagement in learning new skills, or the opportunity to observe others practicing aspects of sustainable living. The *planet* benefited because guests learned about the critical role of bees as pollinators, the risks to bee populations today, and everyone's ability to support bee populations either as beekeepers but especially as providers of bee habitat through selection of trees, flowers, and bushes specifically to support bees. The institutions made a *profit* through significantly wider outreach to promote event admissions, local happy hour income, and traffic to support sales of fruits, vegetables, plants, honey, and gardening materials. And clearly the *program* supported institutional missions to share local history and historic practices, and to teach about natural history, in relevant ways, and to contribute to the quality of life in the community. It was good all around. Now let's examine those four categories more generally and as they may apply to your site.

People

Green practices are beneficial for people when they foster conditions that are physically more comfortable, active and healthy, visually appealing, and build spirit. General recognition of the value of nature for well-being has broadened the definition of quality spaces for work and learning. The definition now includes natural environments that improve people's engagement and effectiveness. For example, we know daylight improves attitude, productivity, and health in workers and learners. And an office space with daylight and air that is fresh and at a comfortable temperature makes most workers happier and healthier. The expanding market for green products and finishes has supported a range of great options for designing and fitting out work and visitor spaces that mean cleaner air from reduced chemical emissions in finishes and furnishings, and also attractive and comfortable

spaces using natural woods and textiles. The same applies to our visitors. "Museum fatigue" is not just a function of standing on a hard marble floor, cognitive and sensory overload, or a diminishing interest. Well-managed daylight into or visible from gathering spaces and exhibit spaces can alleviate museum fatigue significantly. If your visitors are more energetic, they may choose to stay longer. That is good for us all.

The Pennsylvania Historical and Museum Commission's Railroad Museum of Pennsylvania in Strasberg houses rolling stock in a cavernous space. Until a few years ago, the space remained unconditioned because of the costs of heating and cooling such a large area. The closed-loop, ground-source geothermal system installed in 2011 has proven very successful at creating temperatures that are consistent and comfortable. This has been a tremendous boon to visitation and volunteering. The space no longer discourages volunteers from signing up to work, and visitors from coming or staying longer, or during Pennsylvania's freezing winters and hot, humid summers. Without the efficiency of geothermal to control costs, this project would not have been feasible, yet look what human benefits came with a more sustainable solution.[4]

Planet

Sustainable choices benefit the planet. At a minimum, they reduce negative environmental impacts such as resource depletion, pollution, greenhouse gas production, and loss of biodiversity. At their best, they restore the planet. In between, there is lots of room for innovation, creativity, and improvement. For example, washing your farm or other vehicles on the tarmac depletes resources because the wash water, and all the dirt and soap in it, and the dirt and chemicals it picks up from the tarmac, runs off into a sewer that takes it directly to a natural water source or to the municipality's energy- and chemical-intensive wastewater treatment program. A more green approach would be to wash your vehicles on the grass or gravel instead of the tarmac. This is because the ground is a natural filter and will clean the water as it slowly migrates to the water table. Now, if you washed the vehicle in a place where the water ran into a rain garden or retention pond adjacent to a re-created wetland, then you'd be keeping the water out of the municipal system, cleaning it, and supporting a natural setting that *also* provided habitat for birds and bugs, and a few critters on the way through. Now *that's* restorative. It's what we are able to do when we are at our best in green practice.

Profit

Green can be good for your bottom line if you spend less; if visitors increase their participation, buying goods or renting your event spaces; and if donors are more motivated to support your project or organization. Usually using less of something saves money right away and often reduces related costs or future costs. For example, when you spend less money on energy because you have more moderate office temperatures, you're helping your immediate bottom line. When you invest in the right energy efficiency or alternative energy sources, you can calculate a reasonably predictable return on investment, or payback period, through reduced long-term expenses. That's good for your bottom line in the long term.

Green also motivates a certain segment of the population to buy products and services based on their personal environmental values instead of price points or convenience. Your institution's association with those values through noticeable green practices will motivate a segment of the economy willing to buy more frequently, or spend as much or more money, for local and organic products, and for services designed to reduce impact or capitalize on environmental qualities. Plimoth Plantation's Plymouth Grist Mill sells its milled corn products at two local stores, a few health food stores, and at museums such as Old Sturbridge Village in Massachusetts, Henry Ford Museum and Greenfield Village in Michigan, Gettysburg in Pennsylvania, and Mystic Seaport in Connecticut. They would like to produce enough for wholesale markets as soon as they can grow enough grain to support demand. Some museums have been selling heirloom seeds they've saved, meat and egg products, and fiber such as wool or linen lengths. The retail cache of a product from, or relationship with, a museum is valuable, and the sustainability characteristics such as local and organic simply add value.

There is a growing market for green events and rentals. Green weddings, in particular, appeal to the age demographic supporting environmental sustainability. In other ten or so years, that attitude may have rubbed off on others, and perhaps green retirements and funerals will be happening too. If you are a site for corporate events or educational retreats, a growing portion of that audience is interested in truly reducing their environmental impact, or branding themselves as doing so. Yes, it is important to be wary about helping others with green branding. They may just learn something from your assistance, so it may be an opportunity to teach and, therefore, may be an important communication opportunity.

The public responds well to this work if they know about it. Barry Loveland, Chief of Architecture and Preservation, Pennsylvania Historical and

Museum Commission, says, "Our experience has been that adding this component of sustainability, whether it is geothermal systems, energy efficient lighting or some other sustainable design feature, is a win-win . . . saving money but also gaining a lot of good publicity. The newspapers focus on how [a project] is a good thing for the environment and is of public interest. . . . Once a project is complete, the response from visitors has been very positive."

Sheryl Hack, executive director at Connecticut Landmarks, says that environmental sustainability is "a critical part of my personal value system. I see it as part of our stewardship role as a museum organization." She explains: "I believe there is a social contract, that tax-exempt organizations are given federal and state tax exemptions because we operate on behalf of the public. We need to know and be able to articulate what we are doing to contribute to the public good. Being a leader in environmental stewardship and green preservation is a critical part of the public benefit we can deliver."

Environmentally motivated donors are another audience attracted to sustainable building, practice, and programming both as a demonstration of appropriate mission alignment and as funding opportunities. Often the donor identifies his or her interests, indicating a willingness to support a specific project such as solar panel installation, additions to your heritage breed herd, rain barrel purchases, or an energy audit. And sometimes a donor contributes to a green needs list in your newsletter for an infusion of reusable mugs or for a dishwasher so that you can stop using disposable items for workshops and programs. On a larger scale, capital campaigns can include more activities or components that highlight environmental sustainability to reduce the institution's long-term operating expenses and support financial *and* environmental sustainability. We know that raising money for endowments has traditionally been difficult; investing in energy efficiency is a way to raise money today for long-term financial health without calling it endowment. Green donors get that message anyway, that's for sure: they are already looking at the long-term.

Program

The opportunity to teach is how green can be good for our mission: community, education, and preservation. It's an incredibly valuable way to connect with today's audiences and to have an effect on your visitors, and it's necessary for long-term survival of our sites and collections. As we exercise our charitable nature by improving the planet, we are modeling community-minded behavior; as we use green themes to connect with visitors, we can develop a whole interpretive area as standalone programs or to weave into our regular interpretation, and as we adapt to climate we improve our ability to protect collections.

Think about a weather event that either was a recent occurrence or is common to your area: the history of floods or blizzards or hurricanes or droughts in your area. You can identify frequency, public response, civil engineering solutions, and changes in community design (or failure to change). And you can use that as a springboard for discussions about today's experiences and modern versions of public response, civil engineering solutions, and changes in community design (or failure to change). Or maybe your community is adopting alternative energy guidelines and you have a chance to highlight your historic windmill, historic architectural designs for daylighting, or the history of paperweights (open windows as alternatives for air-conditioning necessitate paperweights, in case you've forgotten). This process of comparing current topics to historical themes is in our DNA; now we can use environmental themes as a hook for popular programming.

But it isn't just about our educational mission; it's also our preservation mission. Why is this so important? Because it is no longer a choice; environmental awareness as an amenity has become climate awareness as a necessity. Evidence in your building and landscapes may be something

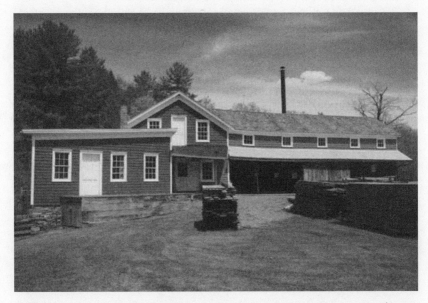

PHOTO 1.1. Hanford Mills Museum, located in East Meredith in New York's Delaware County, features a water- and steam-powered sawmill, gristmill, and woodworking shop. The Museum works to inspire audiences of all ages to explore connections among energy, technology, natural resources, and entrepreneurship in rural communities, with a focus on sustainable choices. www.hanfordmills.org.
Courtesy Hanford Mills Museum

that focuses your awareness. Karen Wade from the Workman and Temple Family Homestead Museum in the City of Industry, California, reports increased effects of rain events, tree damage as a result of rain-softened soil no longer holding roots, and the first incidence of mold on the property. Seas and storms threaten historic coastal communities. Flooding increasingly threatens sites near rivers. What structural precautions, collections care changes, and insurance approaches do you need to take for the new way of life?[5] What self-sufficiencies must you develop: backup or locally generated power, power triage plans, new supplies, changes to storage, provisions for sheltering in place? Do you have a role in a community disaster response as shelter, for services, for technical information, for access, or as a haven for others' objects? Can you dry, store, and care for your objects if you are affected by the disaster, or for others' if you aren't? Your mission will help you determine your role in this new climate. The next chapters will help you develop the skills, and identify the priorities, to support that mission.

Notes

1. Liz Callahan in interview with the author, July 10, 2014.

2. Cinnamon Catlin-Legutko, email correspondence with the author, September 25, 2014.

3. "4th Annual Honey Fest," Philadelphia Beekeepers Guild press release, August 20, 2013.

4. Barry A. Loveland (chief of architecture and preservation, Pennsylvania Historical and Museum Commission) in interview with the author, September 15, 2014.

5. Elizabeth Merritt, "A Rising Tide: The Changing Landscape of Risk Assessment," *Center for the Future of Museums* (blog), May 31, 2012, accessed April 10, 2014, http://futureofmuseums.blogspot.com/2012/05/rising-tide-changing-landscape-of-risk.html.

Resources

Brophy, Sarah S., and Elizabeth Wylie. "It's Easy Being Green; Museums and the Green Movement." *Museum News* (September-October 2006): 38–45.

Brophy, Sarah S., and Elizabeth Wylie. *The Green Museum: A Primer on Environmental Practice*, 2nd ed. Lanham: AltaMira Press, 2013.

"Green Is a Team Sport." In *Greener Museums: Sustainability, Society, and Public Engagement*, ed. Gregory Chamberlain. United Kingdom: Museum Identity, 2011. pp. 224–227.

STARTING TO GO GREEN
Making Choices and Facilitating Change

Vision

Historic sites and museums recognize that there are choices in operating sustainably, and that operating sustainably is no longer a choice.

How you start is up to you. Most organizations begin in a piecemeal fashion as one staff member sets the tone for turning out lights, or helps others learn to print double-sided. Then someone realizes a colleague has been taking home the recycling for a few years and will offer to share the responsibility until they can establish a pickup. And then someone asks at a staff meeting if everyone could help out by lowering the indoor temperature in winter, or suggests the organization use potted flowers as centerpieces and guest favors at the next event to limit the amount of decoration waste.[1] Then it just keeps on going. Barry Loveland at Pennsylvania Historical and Museum Commission commented on how one green act led to another: "As we got into [sustainability work] we thought 'we can do this [a green project], and let's also add this [another green project].'" Sustainability experiences have this effect; they create an interest and excitement in developing creative and helpful solutions for doing our work better. Over

the years the Pennsylvania Historical and Museum Commission has "built up a lot of experience; it is becoming easier to understand how systems perform, and we learn how to tweak them to work better for the next time. Longer-term experience has made [this work] a lot easier."

For more inspiration, let's look at the evolution of sustainable practices at the Workman and Temple Family Homestead Museum. It is a six-acre site with an 1870s country home that incorporates an 1840s adobe structure, a 1920s Spanish Colonial Revival mansion, and a private family cemetery. The museum strives to "create advocates for history through the stories of greater Los Angeles." Focusing on a century of change, 1830 to 1930, the museum encourages visitors "to think about how their own lives are part of 'history'. Everyone has a story to tell, and everyone has the ability to shape history."[2] That leaves them marvelous opportunities for talking about environmental sustainability and practicing it.

Executive Director Karen Wade says adopting sustainable practices has been a "gradual process. Years ago we began sensitizing staff" to sustainable choices. They chose the projects where they would find the most cost savings and those that were most helpful. That meant, in operations, trying to become a paperless office, choosing green supplies, and making changes to office lighting. Robert Barron, facilities coordinator, remembers the staff meeting where they discussed green initiatives and chose to start with finding more sustainable resources such as paper towels, soap, ink, and recycled-content items. That was 2007. First it was 100 percent recycled paper towels in the bathrooms and then they moved to reduce paper by using a Dyson hand dryer. Today they've chosen Sustainable Earth products, cut back on copy paper use, and use soy-based ink for their printers.[3]

Their first move into energy efficiency was partly because the State of California is phasing out the use and production of the candle flame–shaped light bulb the Homestead had used in La Casa Nueva, the 1920s historic house. They were able to switch to a warm CFL and then converted to LED. What started inside the building soon moved outside. The Homestead is owned by the City of Industry. When the city was interested in reducing energy costs, Barron was part of a conversation with city personnel and contractors about energy-efficiency opportunities. He was personally interested in hosting the pilot project for changing exterior lighting along a nonhistoric walkway, one lit with expensive metal halide lights. He invited Consolidated Electrical Design in the City of Industry representatives to visit and provide test lights.

He piloted, and has kept, an induction lighting system with great results. The gas bulbs remain cool and use only 20 percent of the energy consumed by the previous metal halide system while producing twice the light.

Induction lighting is a version of fluorescent lighting, with some adaptations. Fluorescents work with electrodes, which can become thin and then fail, contributing to the incidence of those long-lived curlicue types inexplicably dying too soon after you buy one. (Induction lighting is an ultraviolet-producing light, so it's an outdoor solution unless you filter it.[4]) With this change, Barron could abandon eight of sixteen poles along the walkway, replace the fixtures on half with more period-appropriate acorn-shaped light housings, and repurpose the other half of the poles for displaying banners. The new lighting dramatically cut maintenance demands because the old housing units would eventually melt with the hot metal halide lamps and the lamp and housing needed to be replaced more often. The new fixtures have an option for antilight-pollution covers that prevent light from escaping upward (and being wasted), distracting birds and bats, and diffusing the view of the night sky. That synergy is an example of how the obvious but overlooked situations became an opportunity to improve sustainability on many levels: energy efficiency, utilities costs, site appearance, promotion, and materials reuse. Really, it doesn't get much better than that!

The next step was to move inside to the museum's gallery where they tackled the project of relighting the central dome. Thirty-eight individual lights were swapped for LEDs. Energy consumption is now down to 20 percent of previous levels in that gallery, and the museum has the ability to change the color of lighting in the dome to match special programs and events. Those old U-shaped fluorescent fixtures in the ceiling are now all LEDs using 30 percent of previous levels. "This is much easier to do on a small scale," he says, because the old fluorescent lamps cost six dollars each, but the LEDs are, on average, twenty years, but they last at least ten years. In addition, Barron notes, "the labor savings for *not* replacing bulbs so frequently is terrific."

The City of Industry is using the Homestead as a proving ground. A small-scale test at the museum is great for both partners. El Campo Santo Cemetery is a half-acre historic property once owned, lost, and regained by the Temple and Workman families, and one of the oldest private cemeteries in Southern California. It is now a California State Historic Landmark.[5] They're saving half in operating costs by changing the metal halide flood lights to LEDs. Step by step, they're making smart decisions. By 2018, the museum will have completed changes to all the exterior lights, using induction and LEDs, and cutting energy use by over 50 percent. Within three to four years, they will recoup their initial investment.

Yes, the Homestead has an advantage because Barron has such a good technical grasp, but even he depends on contractors and suppliers for advice. They're the ones who develop and test new materials and products,

and who have more experience installing and maintaining them, so any lack of technical abilities shouldn't be allowed to be a barrier for the rest of us. The staff at the Homestead is learning as they go and developing interests in new areas of sustainability. You can, too. We'll come back to them in other chapters for more examples.

As we move through topics, you will notice that in other cases and stories there is a refrain of "when I began as director," "when the city came to us," or "when the rules changed." These stories are origin stories. There was an empty space to fill, a new path to follow, or a problem to solve, and the institution gave responsibility and authority to someone new. I am not sure anyone can say that the newcomer approach is either easier or harder than change without such an obvious catalyst. Change in smaller steps, but in various places around the institution, can be more diffused and organic, and is more difficult to recognize than a change led by a new point person. Either can be the right approach.

Your goal is fully integrated green thinking at all levels. How you get there is a mix of internal leadership decisions, institutional maturity, and external conditions. An important study of corporations known for leadership in sustainable operations found that there were many approaches to implementing green practices, but that there were four characteristics of sustainability work frequently found in these organizations: leader-supported, execution-focused, externally oriented, and deeply integrated. The report explained them this way:

> The first approach is characterized by actively engaged leaders across the company, employee encouragement, and clear strategy; the second by clear structure, accountability, and middle-manager engagement; the third by the use of external ideas, networks, and relationships, as well as top-leader and middle-manager engagement; and the fourth by employee incentives for sustainability work, a focus on talent, and even engagement on sustainability at all levels of tenure.[6]

I recognize these characteristics in the museums, zoos, gardens, and sites I've encountered that were most successful in greening their work.

But that is your future; what about right now? Where should you start? That question throws everyone. It shouldn't because it has a simple answer: start where you can, and start now, today, before you finish this chapter. Right now! Just do something green—unplug an unused cell phone charger or electric pencil sharpener, move the paper recycling bin to the most convenient spot you can, learn how to tell your system to print double-sided at

least in draft mode, set up a bulletin board for green practices, schedule an energy audit or find out how to schedule one and set an appointment to meet your boss to schedule it. Just get started. Your green efforts will encourage others, and that is the critical part of the work. If you get hung up on the "right" answer and the "best" way, you'll be stuck in research forever (analysis paralysis) when you could be making an impact. For the planners in the audience, this more random approach of start-where-you-are is a necessary precursor to planning green change on a larger scale. Be patient. Sustainability planning will be far more effective if staff are comfortable with green practices and understand sustainability enough to develop perspective. The early steps are the training and the exposure needed to become proficient at sustainability decision-making. One of the cases for this chapter, Dumbarton House, headquarters for the National Society of the Colonial Dames of America, demonstrates just that approach, and with good result: in 2013, the organization was recognized with a Mayor's Sustainability Award from the Washington, District of Columbia, Department of the Environment, and was the first museum in the District of Columbia to receive the award.

So let's have the discussion about the value of small actions versus major change. Why am I not telling you, right away, to take on sprawl in your area, or to ban chemical use immediately in landscape management, or to give up your staff flights to conferences? Because chances are excellent that you will not be able to sustain those particular efforts yet. If you have lots of experience in sustainability, and you work in an organization that already embraces sustainability, then those big changes may well be appropriate choices for you, but most of us are not there yet. We're not ready for that scale of change because environmental sustainability is quite complex because it's about systems. The planet is a system; it's a system of systems. As you disturb, or change, the system in any way, there will be effects—intended or unintended. That's why green is complex—it's all about chains of effects. Learning to recognize and anticipate these effects is how we improve the success of green decisions. Your historic site or history museum is a system, too. If you change the system by introducing composting in the staff kitchen or asking if you can create a tour with a focus on energy efficiency in your site's time period, you're introducing change to the system. It takes practice, but museum folk are great at observing, learning, planning, and problem-solving, so you can do this! So can your colleagues. They are smart, thoughtful, interested people, just as you are. Whether they are interested in greening is another matter, but they have the capacity. If you begin to practice sustainability, others will follow. In the meantime, you will be making a smart choice for yourself, your organization, and the planet.

Here's my mantra:

No one goes all green
No one goes green all at once
No one goes all-green anyway (yet)
Let go of the guilt: it impedes progress
Once you start, it just gets easier.

So you can leave those big tasks to the organizations prepared for that work, take on what you're ready for, and set your sights on becoming one of those big-change organizations in the future. The planet is past the time for only simple, local changes; global, collaborative shifts are critical for mitigating impacts of a changed climate for future generations, but we are not *all* ready to make those big shifts. We must all start where we can, now, and keep pressing.

What about a green team, you say? A motivated team with dedicated time to work and money to support that work will effect important institutional change. If you can support that arrangement, it will work for you. You may have better luck encouraging naturally occurring initiatives among staff and using the momentum to tackle specific projects as they present themselves. Or you may have one employee well suited for this work who naturally incorporates green practices and can be named as point person for change. Let your institutional culture, and everyone's natural talents, guide your management planning. You would do this in any other work, so it applies here as well. However you proceed, eventually everyone has to be on the green team. No one can make enough change by themselves.

Prioritizing

So if you've unplugged a few items, taught your printer to print double-sided, and adjusted the thermostat, you are ready to move on. How do you choose among all the other options? Here are four themes to consider as options for selecting where to start or work next: mission, systems, geography, and conundrums. Each is an opportunity to filter, or triage, your choices. When you are faced with an opportunity or a choice, tackle systems and conundrums with high impact, and use mission and geography for making sure your decision is the most appropriate for your organization and your situation.

Mission

We'll start with mission as the clear priority. Your mission is the institutional focus that provides tone and messages. Our work includes education,

preservation, public engagement, and community building. Start your green work where environmentally thoughtful choices support your mission. We have the unfortunate habit of thinking that to be more sustainable, we have to do something new and/or complex. That is one way to go about it, but it certainly isn't always necessary.

Educational commitment is an example of how you might look at your mission and use it to prioritize your green work. If you interpret agricultural history, then when you choose which animals to keep and use, they should align with the period of your site and with the sustainable commitment to protect heirloom breeds. If you interpret the history of a region, then your exhibits may focus on human experience of the environment, from floods to the best growing season, and you have a chance to connect conditions then to conditions now. If you interpret changes in technology, you can follow the design of historic structures based on available resources, transportation of goods, availability of skilled tradespeople, energy efficiency, and choices based on public opinion.

Most of us have a mission to preserve evidence of and information from the past so that it lasts into the future and continues to be instructive to us. How is that supported by environmentally sustainable practice? For example, we care for the historic sites and collections by protecting them, preventing damage and decay, and providing access. So how can you improve your sustainability practices in any of those aspects? You improve the energy efficiency of your system as much as possible, and you manage the byproducts responsibly. Let's use moisture in an historic house as an example. To prevent mold and mildew, we dehumidify spaces or structures, and keep the exterior of the building, its envelope, in good condition to prevent water infiltration. Choose ENERGY STAR appliances and equipment (because they are reliably designed for energy efficiency) for dehumidification, and choose to dehumidify as needed instead of all the time. If you have a built-in system, it is more sustainable to responsibly manage the water byproduct by using it to cool other systems in your heating, ventilation, and air-conditioning setup or, if you have a domestic-sized machine, to water the garden, clean something, and/or recharge the groundwater rather than sending it into the public water system. See, really it's just thoughtful work and all of it in support of mission—caring for collections.

Geography

Local, local, local—but not only in distance; it's also about what is appropriate for your locale. Where you are geographically determines the sunshine your site receives, which affects decisions about solar power generation, solar thermal issues (heating hot water and creating building or landscape

components to collect heat or create shade), and daylighting considerations. Your geographic location affects your climate, which affects your heating and cooling choices, how you will manage snow and rain, and whether you have humidity issues. Your location also affects green decisions if your state or community has sustainability opportunities. For example, energy costs are high in New England, California, and Hawaii, so payback opportunities for energy-efficiency projects are favorable. Arkansas, Oklahoma, and Louisiana have relatively low energy costs, so payback periods are longer.[7] If cost is a major factor in decision-making, the impact looks less dramatic in central states; but if reducing energy consumption is important for a carbon viewpoint, more so than a cost approach, then an efficiency project is appropriate for any locale.

Governments often impose regulations by location. For example, if you want to construct a new building for use as a museum within the City or County of San Francisco, the 2014 Green Building ordinance now requires 8 percent of onsite parking to be designated for carpooling or for fuel-efficient vehicles for new nonresidential buildings.[8] This local ordinance might be the encouragement you need to prioritize a review of sustainable transportation. Do you want to start encouraging staff to carpool? How can you let owners of fuel-efficient vehicles know you provide preferential parking? Maybe you are in a drought-affected area; are there water ordinances? Maybe you cannot capture rainwater onsite and use it to irrigate your landscape. You may be required to let it run off unimpeded. In that case, drought-tolerant plantings are a better choice.

Systems

Systems can be mechanical, human, natural, financial, social—all sorts of formats. Your organization surely has a few that dominate its daily work, its community connections, or its strategic efforts. Which ones are dominant? Which ones are troublesome or the most exciting? These can be effective places for significant change because, as a system, they affect more parts of your work.

Your site may be heavily agricultural, so all aspects of animal and land management are important to daily work, financial allocations, strategic alliances, and public engagement. The systems associated with agriculture, then, become good targets for sustainability changes because they will have significant impact in an area that is already important to you and where you already spend considerable resources. Starting your green work addressing vehicle use, water and chemical use, and waste systems would be smart choices here.

If you've got an old water-powered mill or other equipment in your site's history, you have a marvelous segue into discussions of hydropower and an example of renewable energy. This gives you an alignment for researching appropriate renewable energy sources reflecting those appropriate to the site. If your site's earlier users made good use of nearby resources, isn't it appropriate for you to do so as well? You don't need to divert a river to run your whole institution, but you should explore reviving or replicating the original system to operate aspects of your site in ways that reduce your energy payments and honor the practices associated with the property. If you have conditioned spaces for exhibits, collections storage, and public programs, these systems are a good place to start because they use so much energy yet can be changed to *save* so much energy, and often with just a bit of extra attention and thoughtfulness. We'll discuss this more in the next chapter about energy, but you can get a head start by making sure your institution has had an energy audit. This is always an important early choice in going green.

If your site is a frequent special events venue, then all its aspects are part of a system of practices worth reviewing. Special events generate vehicle traffic from vendors and attendees. They require delivery and removal of equipment and furniture, food, and waste. They require food selection and preservation. They require recycling, composting (possibly), and garbage removal. They involve washing linens and procuring tents. You might need to bring in portable bathrooms and set up temporary heaters or fans. Each of these can be done in sustainable ways. Choosing to start here will have a significant impact, but you don't have to take on all aspects at once; choosing one or two for your next event is a great start. Perhaps you will choose only local foods for the fall fund-raiser, but not for every single event until you have piloted the idea and learned enough through practice. This first event will give you a chance to identify local providers at harvest-time when they have most to offer. You learn what is available and what special arrangements should be made. And you will learn to define "local" as most appropriate for your area. For example, with population density and food options varying by region, a site in New England may be able to define local as fifty miles but an organization in the Southwest might need to select a range of up to four hundred miles.

Or you could choose to increase institutional recycling as your system change. This would require writing recycling expectations into vendor guidelines, educating the vendors and ensuring that they train their staff, possibly providing signs and recycling bins, and arranging for material removal if the vendor doesn't handle this (but they should). Recycling is a surprisingly complex practice. You can ease your learning experience

and improve your results by tackling it in phases and improving as you go. Start in-house or at a small event, not a resource-intensive, complex annual event. Then pay attention to particular recycling streams to see what works and what doesn't. You'll learn quickly that to make recycling far more manageable, you can encourage facility renters to select beer on tap using kegs at the bar instead of providing individual beer bottles. When you reduce the number of bottles you bring onto the site, you reduce your waste and you also save all the energy and materials that go into creating and transporting single-serving containers to your event. You will see quickly that a simple change has a great effect. You're changing part of a system and the ripple effect increases your impact.

Conundrum

Do you have too much of something, or too little? Is there a situation that just doesn't sit right with you? Very often, the early choices in greening

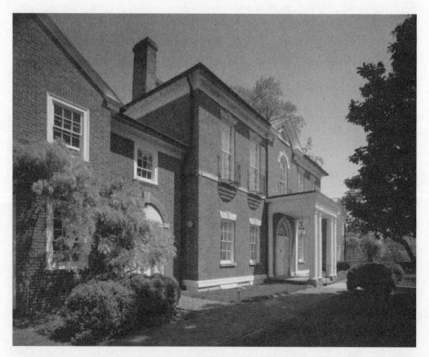

PHOTO 2.1. Dumbarton House won the Washington, D.C., Mayor's Green Award in 2013.
Courtesy The National Society of the Colonial Dames of America.

an institution are made by someone who recognizes a conundrum. He or she isn't currently worrying about a mission-critical situation, doesn't have authority over systems, or works far from projects affected by city ordinances and building design opportunities. These are the folks who decide they are uncomfortable with the number of rubber gloves they routinely throw away, or they wish they could reduce chemical use on the lawns, or they know there must be a good use for that wood in the mid-century (wrong time period) building they just took down but they don't know what to do with it. These folks have a conundrum and it bothers them, and it keeps bothering them. Sometimes that is a good enough reason to set a priority for change. That person will figure out how to recycle the gloves, change the lawn service, and get the construction company to at least recycle the asphalt and the copper wiring from the project. Taking on these conundrums is what will move our field forward because someone has recognized that business as usual isn't good enough anymore. Bravo.

AN HISTORIC HOUSE MUSEUM GOES GREEN

How Dumbarton House Implemented Sustainable Activities within Its Staff Practices and Historic Fabric

໐/໐

Bridgitte Rodguez, membership manager,
Dumbarton House, headquarters and
museum of the National Society of
the Colonial Dames of America

The Journey Begins: Deciding to Go Green

Our journey began with individual staff members interested in operating the museum and headquarters in an environmentally friendly way and as an option for lowering operational costs. During this time, the national green museum movement has continued to take shape and influence the way that museums operate. One of the key ways our executive director came on board with sustainability was the fact that Dumbarton House is an historic building and our parent organization, the National Society of the Colonial Dames of America (NSCDA) is highly invested in historic preservation. At the heart of historic preservation is saving something old

and either maintaining its original function or modifying it to serve a new purpose. The NSCDA has been at the forefront of the historic preservation movement since its founding in 1891. To date, the NSCDA owns or maintains some eighty historic properties across the United States. These properties serve as museums reflecting the history of the building and the area at the time they were built. Throughout the NSCDA's existence, historic preservation has been a core tenet of its mission, and Dumbarton House, serving as the NSCDA's national headquarters, strives to continue to be a leader in the field. Therefore, Dumbarton House decided that the time was right to solidify its standing as a leader in the green museums movement, as well as to institutionalize its current green practices into policies of sustainability. As a nonprofit, we want as much of our income as possible to go toward our preservation and education mission, rather than toward operating costs. If we can operate sustainably as well, then we are not only supporting our mission by freeing up funds, but also being mindful community partners in preserving our environment.

For Dumbarton House, preservation and sustainability go hand in hand. To be stewards of the past, we must make sure it lasts for future generations to learn from; that's why we must operate our historic sites sustainably: so they last. Further, the United States has 5 percent of the world's population and yet is responsible for 22 percent of the world's greenhouse gas emissions. Too often, we attribute that to transportation, not building use, but transportation only accounts for 27 percent of the United States's carbon emissions (2010 Environmental Protection Agency statistics), whereas 40 percent of the United States's carbon emissions come from the operation of buildings. This is a much larger contribution and one, as preservationists, we must be concerned about. What follows is our story on how we integrated sustainability into our staff practices and historic site management.

Tying in to Our Mission: Historic Green Practices

Sustainability is also important to the interpretation of our historic site, which was built in 1800, long before the words *sustainability* and *green* existed in the context as we know them today. However, people at that time lived with a much-reduced environmental impact by the simple fact of a lack of energy and manufacturing technologies not yet invented, so they had to use other methods of achieving their goals. They were more thoughtful, recognizing the cost and time that went into making goods for consumption. Being green wasn't a fad; it was an object of necessity, and not a new idea—there is archaeological evidence of recycling and reusing going all the way back to 400 BC!

Dumbarton House Museum interprets the life of one of its earliest residents, Joseph Nourse, first register of the U.S. Treasury. Living at the house in the early nineteenth century, he practiced many activities that can be called sustainable in the way that we think of the term today. Examples abound of reducing energy and materials consumption by thoughtful design, and reusing and recycling materials; some of these include the following.

Design efficiency:

- Maximizing natural sources of heating, lighting, and ventilation from the building's surroundings
- Constructing homes with thick, solid walls that reduced the amount of energy needed for heating and cooling
- Constructing shaded porches and overhanging eaves
- Building long central passages with doors on either end and rooms on either side to reduce drafts and create cross-ventilation

Energy efficiency:

- Lighting tasks, not rooms
- Lighting candles/lamps only when needed, using moonlight or firelight when possible
- Hanging reflectors on the wall to maximize candlelight
- Using bed curtains to maintain heat while sleeping
- Using fire screens to block drafts

Reusing and remaking:

- Rotating carpets to ensure even wear and reworking sheets to make them last longer
- Making slipcovers to cover old furniture
- Writing on both sides of the paper when sending a letter and using it as the envelope
- Mending clothes to accommodate growing children
- Repairing or replacing individual components when broken, rather than the entire item
- Using old materials to make new items

We can use the lifestyle of the historic residents we interpret to inform our lifestyles today, promoting sustainability in our own lives and those of our visitors. Many of the practices from two hundred years ago translate to what

our visitors can do today; some don't, but the thoughts and ideas behind the actions are very valuable.

Making the Commitment: Creating a Sustainability Action Plan

Two of the first major green steps Dumbarton House took were to purchase 100 percent wind power for electricity usage and add 100 percent carbon offsets for our natural gas usage. Recycling had already been a common practice, but it was increased, as well as purchasing 100 percent recycled paper products, from copy paper to toilet paper. These efforts are not only good for our bottom line but also for the future of the environment in which our museum is located. Other sustainable efforts include addressing problems as they arise, rather than waiting for them to become preservation emergencies. This requires routine maintenance and care for the historic structure and is outlined in our Cyclical Maintenance Plan. As a museum with limited resources and funding, prevention is a more sustainable practice.

Once we had done many small sustainable actions (many of which are listed in the following), we decided it was time to define exactly how sustainability reflected Dumbarton House's mission and identify where it fit in our site planning. To do this, we referenced Sarah Sutton Brophy and Elizabeth Wylie's book, *The Green Museum*. They give the following helpful definitions: "Green refers to products and behaviors that are environmentally benign,[9] whereas, Sustainable means practices that rely on renewable or reusable materials and processes that are green or environmentally benign." Dumbarton House wanted to make a stand, and not just to be green, but make a commitment to becoming truly sustainable. To do that, sustainability needed to be woven through all of our plans and policies.

A draft Sustainability Action Plan to be approved and adopted by the Dumbarton House Board was begun, to eventually become part of our Master Site Plan, which lays out the administration of the entire site. The Sustainability Action Plan allows us to include sustainability in our Strategic Plan—furthering our commitment and ensuring that sustainability was not just the goal of the current staff, but an institutional policy and initiative that will continue on with the site in perpetuity.

We looked at four physical and administrative areas of the site: the interior of the buildings, the exterior of the buildings, the exterior grounds, and staff behaviors and operations. Sustainability for Dumbarton House does not just address the museum or historic areas; it also encompasses the nonmuseum spaces and the operations of the museum and headquarters.

The following are some of the many practices we have instituted throughout the site:

- Reuse packaging materials from orders received: no longer purchasing packing materials to save money and reuse materials
- Take polystyrene peanuts to the UPS Store: polystyrene is not bio-degradable, this way they can be reused
- Reducing paper purchases and use by printing double-sided
- Reusing the back side of single-sided paper
- Limiting print materials and placing information online
- Online giving options
- Signing up for online bills (also saves postage)
- Mail management to reduce junk mail and delivery of multiple copies
- Maintain appropriate thermostat temperatures to lower energy costs
- Replace regular bulbs with CFL light bulbs as needed to reduce energy consumption
- Purchase smart power strips for computer workstations to reduce energy consumption
- Properly dispose of toxic materials such as batteries, CFL bulbs, and ink/toner cartridges to reduce waste impact; some stores even offer rebates
- Donate equipment/materials no longer useful, to limit items going to the landfill
- Institute a site-wide recycling program
- Reuse plastic name badge holders from meetings: limits costs
- Use a filtered water pitcher for staff use: reduces use of plastic water bottles
- Use real utensils and dishes: reduces need for paper/plastic cups/dishes, saving costs and disposal
- Sell items in the gift shop from American-made sources to promote local economy and reduce travel miles
- Purchase items made from recycled materials or that can be recycled and that are eco-friendly: further promotes green commitment
- Rugs at all doorways to catch dirt when people enter: reduces need for cleaning
- Maintain permeable surfaces where currently in existence to reduce runoff
- Use sand instead of salt during the winter: reduces chemical impact
- Plant native plants to reduce water use

The Money Issue

When most people think of going green or sustainability, they think of money and additional expense. However, sometimes the easiest argument for sustainability is the money angle and how it can save organizations money. Our early Dumbarton House resident Joseph Nourse certainly would have approved: he served, after all, as the register of the U.S. Treasury and was responsible for keeping track of the United States's finances. He was not only thrifty by nature, but by default for the time period. People in 1800 valued resources, not because they were trying to be green, but because life was so much less convenient than today. Labor and resources were so much more costly. This same attitude can apply today; we may not have to spend hours to make the paper we use, but it costs us resources to purchase that paper. So if we can extend the usefulness of that piece of paper, or anything, then we can use our money to further our mission. As we all know in the nonprofit world, it is much easier to fund-raise for mission-based needs than it is for operating costs. It should be up to us as the stewards of our sites to find ways to make the funds from our donors go as far as possible toward our missions.

Next Steps: The Heating, Ventilation, and Air-Conditioning Study

While we were picking up all the low-hanging fruit to make Dumbarton House more sustainable, we were also applying for a Sustaining Cultural Heritage grant from the National Endowment for the Humanities to research our current heating, ventilation, and air-conditioning (HVAC) system. Specifically, we wanted to asses our HVAC system's existing optimal functionality, what it is lacking, and whether it would be more beneficial to repair or replace the entire system. Replacement of the HVAC system with an entirely new system is certainly not low-hanging fruit and, for a site of our size (approximately ten thousand square feet), not an inexpensive venture. Our HVAC system is, however, a very big part of our energy use. In fact, today, most of our energy in the United States is used from heating and cooling buildings for human comfort—the same as it was two hundred years ago! The difference is, now, that the cost to the environment and to our bottom line is so much more. Therefore, it is important to find economical ways to deal with comforting not only our visitors, but also our staff and collections, which all require different levels of temperature and humidity control.

If we as a museum were to be truly sustainable, move into the twenty-first century, and focus our efforts on our mission, researching and planning for an upgraded HVAC system was a necessity. The National Endowment for the Humanities grant helped us fully understand our current system so that we could use it better while we work on a plan to upgrade the entire system.

Marketing: Putting Our Green Activities on the Map

Our institution also saw sharing what we were doing with others as an important part of supporting sustainability. This marketing helps spread the word about how any institution or individual can become sustainable, and opens up new avenues for funding and visitation. Green is not a destination and does not exist in a vacuum. Once you start implementing green practices, you can't forget about it. There are new and ongoing green initiatives at board meetings, staff meetings, in our museum newsletter, and in fund-raising materials. You may also want to tell your visitors what you are doing: create a page on your website for sustainability and promote green initiatives through existing marketing channels including social media. Another avenue to consider is to apply for grants to research further sustainable activities appropriate for your site and to get involved in the green initiatives of your local city and community. This last point resonated powerfully for Dumbarton House. We are located in the District of Columbia, and the city has become wholly committed to becoming the greenest city in the country. Each year, the District Department of the Environment holds the Mayor's Sustainability Awards and in 2013, Dumbarton House was one of nine recipients—the first museum or historic site recognized. This recognition further promoted our efforts on a city-wide stage and opened up new partners for us with similar sustainable activities.

Conclusion: Rounding Out the Journey

While we were going through our "green" journey, it seemed overwhelming at times, and I would often get a sense of guilt at not being able to get some green initiatives off the ground. I turned for some inspiration to *The Green Museum*. I share with you here a few of the author's thoughts that I found most helpful to put in perspective our sustainability and green goals.

Green in museums is the best example of museums as community partners;

Green can save you money that you can spend on carrying out core responsibilities, and green keeps the environment clean and safe for your objects, buildings, and visitors;

The environmental sustainability of your institution is a mission-based decision; implementation should come from mission-driven decisions made on a daily basis using your institutional policy for green;

To be successful we need to integrate green action with the culture and systems of the museum, or we risk wasting money, time and enthusiasm;

Going green is a journey, not a destination.[10]

By far, the last point is the most important to keep in mind!

To sum up, in order to be effective, you need to have someone on staff be a green leader and advocate—someone who is willing to bring up sustainability at every staff meeting, at every board meeting, and not let it out of the decision-makers' minds. It's not about being pushy, but about proposing how it can be incorporated into activities and actions you are already doing. You also have to be willing to change your habits and behaviors to be a true green leader. This can assist the other staff, board, etc., in how they can easily make adjustments. And finally, think outside the box to make green an everyday part of your work and personal life. Just as running a small, historic site with limited funding requires creativity, so too does making that small, historic site with limited funding sustainable.

Changing Behavior

Now that you have some pathways to prioritization, let's deal with changing behavior in your operations environment. So we'll tackle office situations, engaging staff, and some of the cross-institutional activities. Changing behavior—in ourselves and others—continues to be a challenge for everyone, not simply sustainability geeks or museum folk. For some people, change is triggered by an incentive, for others removing a barrier makes the change more convenient. Some people make a change to bring

their actions more in line with their beliefs and values, including new values they're discovering. Sometimes the change occurs as a result of a new professional or legal standard, a new job requirement, or because of a loss or a shift in the current system. Often, seeing someone else behave in a sustainable way makes it much easier. Let's look at changing behavior in your organization through three styles: encouragement, recognition, and necessity.

Encouragement

It is impossible to identify all sources of encouragement, but there are a few that are commonly recognized as highly effective. Incentives, in the form of goods, services, or opportunities, are direct encouragement; recognition and peer support are emotional forms of encouragement. For some, data and evidence are encouragement. Some types are more appropriate for your green work than others. Using more than one format will help you achieve the broadest response. The people involved in achieving different priorities may respond to different encouragements so, as your program matures, remember to review what works best and to keep adjusting to improve performance.

Effective incentives for employees to reduce fuel consumption by commuting might be preferred parking for carpools and energy-efficient vehicles, discounts on public transportation passes, or time off for accrued carpool days. These all encourage behavior change by offering rewards for appropriate behavior: guaranteed close spots for parking, cost savings for public transportation, bonus time for carpooling. Each requires additional mechanisms though. The institution must select and mark parking spaces, support for public transportation depends first upon access to a stop near your museums plus a financial outlay from the institution (unless the community has a supportive program), and carpooling depends upon a formal or informal network for identifying workers living on similar routes, plus institutional support for recordkeeping and time off. For our incentives to work, you must be well prepared to follow through on your promises.

Choosing the appropriate ones depends greatly upon what's appropriate for your institution, community, and workers. Often the most effective incentives have obvious ties to the behavior you are trying to modify. Be creative and thoughtful. Work with employees to understand for yourself which changes are achievable and what encouragement can help facilitate that change. Often someone who reflexively says no to a change, such as carpooling, is really worried about a hidden aspect. Uncovering the actual barrier may help. Perhaps someone is worried about what to do if they suddenly need a lift home midday, or if they're required to work late and

the carpool has already left: successful carpooling programs have a fund to support an occasional taxi ride, or there is a museum-owned vehicle for such emergencies. Perhaps the barrier is seasonal: maybe folks would bike in the summer and spring, but winter is impossible. You can incentivize seasonal practices with seasonal awards such as letting the cyclists earn portions of a community-shared agriculture program funded or grown by the museum.

Recognition

Awards can be serious or lighthearted, difficult to manage or simple. Choose your potion. Some places reward green behavior monthly or annually with awards for "best idea" and "greatest achievement." Other places encourage staff to make awards to each other as they see green behavior: an observer can leave behind a note or ornament (a paper green ribbon for hanging on an office doorknob, or with Velcro for attaching to a cubicle, for example) just to let the recipient know others appreciate his or her green behavior. The recipient then passes on the compliment when he or she finds a worthy opportunity. Whatever you choose, the lowest maintenance system is the most likely to endure.

Necessity

This combines the concepts of obligation and "necessity as the mother of invention." Lasting change is best reinforced positively, but sometimes initiating change requires pressure. This can be external pressure such as added building codes or waste management requirements enacted by your county, town, city, state, or even the country. Sometimes it's social pressure to join the green building movement using the U.S. Green Building Council's Leadership in Energy and Environmental Design standards. Sometimes it is a financial necessity: you have to start saving and reusing exhibition materials because prices have risen and you can't afford the materials you used to buy. These unwelcome restrictions are often greeted with reluctance, and are aggravated by looming deadlines. They put us at risk of making the easiest choice, or the obvious one, and not investing the time to be thoughtful. Please be careful; any change at your institution demands thoughtful research, planning, and implementation—obligatory or not, green or not.

To implement larger-scale change, departmental or institutional leaders may add sustainable practices to position descriptions and performance evaluation criteria. That is an important step, but like any job responsibility, expectations should follow training and be accompanied by support. So if

you add a responsibility such as green team membership to a job description, be sure you provide the team with guidance on scope, implementation, and expectations, and you provide the time and resources staff needed to conduct green team work. If you ask someone to be the recycling manager, then offer the time and resources to manage the recycling, and work with that person to bring about the change.

Tools to Support Change

We've looked at how to prioritize changes and different motivational approaches, now it's time to think about tools to facilitate changing practices. These include communication, equipment, physical spaces, and money. These are not exhaustive descriptions, but examples to help you begin to recognize how they can be useful when you take on a challenge at your site.

Communication

As with any communication mission, consider your audience and message as you design your delivery format. You can easily raise awareness and provide information by using a physical or virtual bulletin board, or both, to post general updates, kudos, offers to carpool, maps for public transportation, new items added to the green purchases list, and instructions on new recycling rules. Of course someone must be responsible for posting material and keeping it fresh. Once you have multiple initiatives going, share the responsibilities for these updates among supporters. I am in favor of a physical one posted in the break room and duplicated in the staff bathrooms wherever possible. It doesn't use much energy; it comes in a non-computer–based format so everyone has access, and it won't get lost in an email flurry. If your staff is dispersed, an electronic newsletter might be more useful. If your interpretive and facilities staff rarely sit in front of a computer, leaving a hard copy (double-sided on recycled-content paper) of the newsletter in their break rooms may be the better option. Yes, it uses paper to print the newsletter, but without it you may not be able to achieve greater green goals.

Communication beyond staff to the board level or to the public should follow the more formal guidelines you already have in place. Blending green information with regular communiques sends the message that these changes are part of expected practice at the institution, not add-ons. If your institution prepares annual reports, be sure to include your green work. You will learn as you go that the more sophisticated your measurements, the more valuable reporting will become, but in early stages, any measuring and

reporting is important. Very quickly you will be looking back with surprise and pride at the distance you've come.

Equipment

Sometimes the right piece of equipment might make all the difference in facilitating green practice. I hate to encourage acquisition of yet another container or machine, and possible increased electricity use, but consider your situation and what barriers are preventing success. Sensors to automate light, energy, and temperature controls can improve efficiencies beyond what staff practices can do. Even as staff raise and lower blinds in the historic house during a day, they may not be able to also circle back to turn off inside lights as they move along while leading the tour; an occupancy sensor could. Decades ago Colonial Williamsburg Foundation installed sensored lighting in its textile gallery in the Dewitt Wallace Arts Gallery. It had the added advantage of capturing visitor attention as the lights came up on a certain garment or piece of lace. Meanwhile, the display did not risk added exposure to light when no one was in the gallery to see the materials.

Your staff may have already made all the manual changes and implemented all the manual systems to improve efficiency, and the next step is a system that manages the situation when staff is not onsite. Making your heating, ventilation, and air-conditioning system more efficient may require a building management system. Be sure to allocate enough time to investigate options and the cost of implementation, and then to train your staff to effectively operate the system and create reports on energy savings.

Maybe your recycling problems can be attributed to the design of receptacles. Shaping recycling behavior by providing visual clues has become an art. I'll explain more in the materials section, but consider that color, shape, and lid openings matter. Using an available old garbage can or a bin that looks just like all the others will not help you change employee behaviors. Equipment matters.

Layout

Consider how your office and building layouts help or hinder behavior change. If desks occupy the office areas without windows, staff and volunteers will have to turn on the lights to work. The staff at Thoreau Farm, the birthplace of Henry David Thoreau, Concord, Massachusetts, set all desks near windows to maximize daylight. Can you rearrange yours to capture free daylight? Is it possible to place a printer in a central location, or to

realign workstations, so that four or five workers (if you have that many) can share one piece of equipment instead of each having their own and leaving it on all day long? If you have a trash can in your office or staff kitchen, you should have a recycling bin as well (and maybe even a composting bin). Keeping garbage, recycling, and composting bins in separate places simply means that people with waste materials in their hands are likely to use the most convenient bin rather than look for the missing recycling or composting options. Layout creates opportunity.

Are office supplies easily accessible or do staff members find it more convenient to stop on the way in to work and buy more materials than to find and use what is already available? Out on the site, do you hide all your modern equipment and vehicles far from where they're needed, or can they be hidden more centrally so you waste less fuel coming and going? On a much larger scale, do you have collections storage offsite? Is it appropriate to gradually migrate the less frequently used items out there so there is less travel time and fuel use?

By now you might be saying, "well, that's just common sense." You are right; it is. And if you're doing it already, then you are smart and you are more green than you realized. Now, as we move through the chapters, we'll examine change in particular domains, starting with energy, and moving on to collections, preservation, landscapes, interpretation and engagement, and materials.

Notes

1. Raising the temperature setpoint in summer *does not*, however, save energy, if your air handling system uses a subcooling and reheat process to dehumidify indoor air. Jeremy Linden, Image Permanence Institute presentation, September 30, 2014.

2. Accessed July 27, 2014.

3. Robert Barron and Paul Spitzerri in conversation with the author, March 6, 2014.

4. Accessed July 27, 2014.

5. Homestead Museum, "About Us: Who We Are," accessed March 1, 2014, http://www.homesteadmuseum.org/who_we_are.

6. Sheila Bonini and Anne-Titia Bové, "Sustainability's Strategic Worth, McKinsey Global Survey Results," *McKinsey Insights & Publications* (July 2014), accessed June 30, 2014, http://www.mckinsey.com/insights/sustainability/sustainabilitys_strategic_worth_mckinsey_global_survey_results.

7. U.S. Energy Information Administration, *State Electricity Profiles—Data for 2012*, Washington, DC: U.S. Department of Energy, May 1, 2014, accessed June 29, 2013, http://www.eia.gov/electricity/state/.

8. Sarah S. Brophy and Elizabeth Wylie, *The Green Museum: A Primer on Environmental Practice*, 1st edition. Lanham, MD: AltaMira Press, 2013, p. 8.

9. Ibid.

10. California Energy Commission, *Local Ordinances: Exceeding the 2013 Building Energy Efficiency Standards*, Sacramento, CA: California Energy Commission, accessed June 29, 2013, http://www.energy.ca.gov/title24/2013standards/ordinances/.

Resources

Belisle-Iffrig, Katie. *Going Green for the Genius*. Rancho Santa Margarita, CA: CharityChannel Press, 2014.

Hart, Ted, Adrienne D. Capps, and Matthew Bauer. *Nonprofit Guide to Going Green*. Hoboken, NJ: James Wiley & Sons, 2010.

Loveland, Barry A. "Pennsylvania History Goes Green." *Pennsylvania Heritage* XXXV, no. 2 (Spring 2009). http://www.portal.state.pa.us/portal/server.pt/community/energy__impact/4701/pennsylvania_history_goes_green/471379.

Sutton, Sarah. *The Green Nonprofit: The First 52 Weeks of Your Green Journey*. Rancho Santa Margarita, CA: CharityChannel Press, 2013.

@/@

ENERGY CHOICES

Vision

Historic sites and museums make energy choices, today, to benefit themselves and the community far into the future.

The American Association for State and Local History's Standards and Excellence Program for History Organizations is a "roadmap for planning and improvement for the field." The workbook supports historical organizations as they review national standards and take steps to complete projects to progress from basic, to good, to better performance within each standard. The standards demonstrate the importance of environmental sustainable practices, particularly energy efficiency, in the field:

Standard #7 under *Stewardship of Historic Structures and Landscapes* states: "The institution considers and implements sustainable practices of energy conservation in the operations and care of its historic structures and landscapes that are compatible with the site's mission and preservation policies."[1]

Sheryl Hack, executive director of Connecticut Landmarks, points out that rather than consuming energy blindly, we must make conscious choices in energy use that support environmental stewardship of the planet. "Museums have a responsibility to be better stewards, better leaders in areas of environmental conservation, reducing our *energy* footprint and conserving energy. New England is behind in thinking about how we use energy and in our expectations for degrees of comfort. Historically,

it was impossible to keep buildings at seventy degrees, yet that's what we expect today. We need to recalibrate our expectations in order to create a sustainable future."

Energy is a big topic, but the concepts are simple:

- Waste it or save it.
- Choose clean or dirty.
- Buy it. Make it. Share it.
- Interpret it. Hide it.

It is as easy or as complicated as you choose to make it. You can manage it with small changes, new systems, investments, and changes in travel and commuting—all sorts of ways. So you'll have to use the prioritization practice from the previous chapter to help you decide where to start. You won't need a heating, ventilation, and air-conditioning (HVAC) professional or a utility representative for the basic energy decisions. You and your colleagues can make important changes as you get going, and then enlist others as you move on to new levels of institution-led discovery and change.

Please understand, though, that avoiding energy decisions is *not an option*. The world's relationship with energy is changing, and yours must, too. Now. Many energy decisions take a long time to understand and implement, but the rate of change increases. If you wait too long, your choices will be made for you and not in your institution's interests. Prices will go up, options will change, and requirements will change. You job is to control what you can so that your preservation work can be efficient and effective.

Waste It or Save It

Energy use shouldn't just happen; it should be intentional. This first thing you should do is get an energy audit. Since it may take a while to obtain permission and schedule the appointment, here is what you should do while you wait for the audit. Think about how, when you are at home and the power goes out, you keep absent-mindedly flipping switches even though the lights won't go on. We have a habit of using electricity without really noticing it. It's time to notice energy use in all its forms. Just take a moment to look around the space you're in right now. Notice what kind of lights there are, whether there are windows, what kind of equipment there is, how many items are plugged in to a wall or power strip, and what the temperature is like and how it is regulated.

Are you comfortable? Notice if there is a draft or a breeze, and where it comes from and how it feels. Is this a good draft or a bad draft? It may be

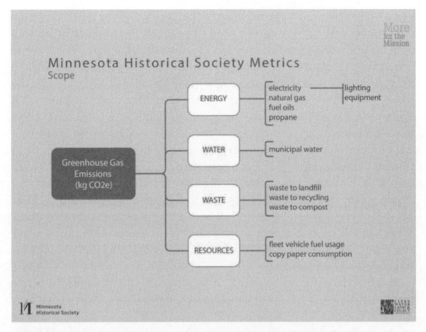

FIGURE 3.1. Flow chart of the scope of the Minnesota Historical Society's sustainability metric. The Society uses kg of CO2 equivalent, which is a measure of global warming potential. Included in this are the Society's energy, water, and waste usage. In addition, the Society looks at other resources on a project-basis, including paper and fleet vehicle fuel usage.
Courtesy Minnesota Historical Society.

something to correct before winter comes. Is the light sufficient for whatever activities occur here? Are there too many lights? Is there enough natural light to use instead? What kind of windows do you have? If they are double- or triple-paned, there may be a lot of heat transfer through the glass when it is cold outside. It may be worth making or buying insulating shades for nighttime and weekends to save energy, especially if you have a classroom or event space with a full wall of older windows. Some of this is under your control, some may be part of shared control within the institution, and some may be completely outside your purview.

Where you *can* make choices, make conscious decisions about what energy you use to heat and cool, to power equipment, and to light spaces. Practice assessing your own office or workspace, and then expand to other areas of the institution. Look at how rooms are used and what equipment is used in them. What equipment do you use? What kind of energy does it

use? Do they all need to be used, on, or plugged in all the time? Certainly the printers and copiers do not need to be on all the time. This can wait until the first person needs them each day. Take the time right now to create a shorthand inventory of equipment in your space. Do you really need them all? If an item isn't in regular use, unplug it from the wall. This will save the energy wasted by the slow seep through the plug. That seep happens even if equipment doesn't have "ready" or "standby" lights. Leave the cord visible so others know what you've done. If the item is used regularly, make sure it is programmed to automatically go into sleep mode within the shortest amount of time reasonable. If you have many pieces of office equipment in a small area, using a smart strip is a big help. The strip has two sockets that are always on for critical functions such as a modem or a phone or a clock, but the other plugs can be turned off with a toggle switch at the end of the day or until the next time they're needed. This consolidates them on a single plug left connected to the wall so there is no need to plug and unplug several pieces of equipment.

Lights are a big energy sink. Are you using the most appropriate energy-efficient lights for your situation? Are lights only on when truly necessary? If you are in a group office, do the overhead lights always need to be on, or can those who work early or late choose to leave the bank of lights turned off, and turn on only a desk or task light? When someone opens the building, whether it's the office, collections storage, or the historic house and outbuildings, is it a habit to flip on all the lights and equipment, or can others just as easily flip the switch as they need later on? Where once it was common to install a single switch for banks of lights covering an entire room, now the systems can be rewired with switches for smaller sections of that same space, and there are sensors that turn on lights as a visitor approaches or leaves an exhibit area, or as someone leaves or enters a room. If you don't have sensors, then everyone *must* learn to turn off lights when they leave a room empty.

Your exhibit areas may not be open to immediate change as you wait for the energy audit, but the same concepts apply if you find yourself planning changes in exhibit areas. You should decide how much energy you want to use to light the space and to run any equipment, and then design the exhibit to those parameters. You will be surprised how much you can do with less energy. Start by considering low-energy lighting options, low-/no-energy exhibit components, and sensors for all equipment. There is an excellent lighting chart in *The Care and Keeping of Cultural Facilities: A Best Practice Guide Book for Museum Facility Management*.[2] Angela Person-Harm and Judie Cooper, both of the Smithsonian Institution, describe the many types of four kinds of lights: white LEDs, high-intensity discharge (such as metal

halides), and both compact fluorescents and traditional tubes. It explains the advantages and disadvantages in museum use for each, but also voltage, the types and what they're called, how much they are likely to cost and how long they last, the color-rending, ultraviolet issues, and even more. Lighting can be a very complex issue, but for many facilities it does not need to be. The staff at Shelburne Museum in Vermont has been experimenting with LEDs in exhibit spaces in historic houses for more than a decade. They share an example of in-house lighting solutions online through the Shelburne Museum blog entry *Looking into the Light*.[3] You may want to check with a conservator before making any changes, and plan to keep it simple unless you have facilities staff with solid experience in lighting, or you use a lighting or exhibit consultant to make your choices.

The Air Mobility Command Museum at Dover Air Force Base in Delaware is a great example of choosing low-energy approaches. The museum has a C-5, the largest military airplane in the world. Director Mike Leister, with the help of a talented vendor, pulled off an energy miracle. Leister wanted visitors to be able to stand inside the aircraft so they feel the magnitude of an airship capable of carrying five helicopters. As you can imagine, the plane is long on space and height, but short on windows and lighting. To light the interior conventionally requires a large, noisy, and expensive power unit to supply the plane's native system and light the more than one hundred interior bulbs. Leister didn't want to use up the original bulbs, or subject the public to such an intrusive system. LEDs became the alternative, long-term solution requiring no permanent changes to the historic aircraft *and* using significantly less power. Now it takes two amps of power to light an interior 141 feet by 19 feet, plus the television monitor, off of a 1 cubic foot generator that is quiet and dependable. It was just a single day's work to install.

This choice was visitor-driven as much as energy-driven. Leister says the goal was to make the space more appealing to visitors so they would linger and appreciate this unique space. It had to be affordable and not require frequent or multiple bulb changes. Some staff were concerned the addition would "junk up the airplane," but the vendor created a system that in no way intrudes on the experience, and all fears were allayed. Now the 1940s music and lighting to warm the space visually convinces visitors to stop and read the interpretive labels, or sit and watch the video presentation. The change solved another problem: "we wanted visitors to be able to take a decent cell-phone picture."[4]

Leister applied the same situation-based approach to indoor gallery spaces. The NoUVIR fiber-optic lighting works well in his exhibits because it provides energy-efficient case lighting without creating heat inside a closed

exhibit space, potentially damaging the artifacts. He has also found that optic fibers sometimes turn yellow and their transmission rates decrease, but the NoUVIR materials have retained the clear color over time. Fiber-optics have the advantage of turning a single source of light into illumination points for many objects by separating the fiber bundles. Leister says it lends itself to case systems particularly well and is a good fit for small museums with limited exhibit and energy budgets, and working in small spaces.[5]

Your energy audit will take you beyond project-specific changes to system-wide approaches. The auditor will assess your current energy use, review your equipment and your site's occupancy and activities, and look for efficiencies and alternatives. The auditor will then create a menu of potential changes and work with you to select the best options and sequencing. This will help you make choices about changes you and your colleagues can make right now, and help you start saving money, and it will have information about options appropriate on a larger scale.

The cost of an audit for a single historic house should be a few hundred dollars, if you cannot get it free through your utility. Increase that amount as your building or campus gets more complex. At the smaller scale, of under a thousand dollars, you will recover the costs in free or inexpensive changes quite promptly; the same may be true of a larger complex, but every situation is very different. Start by speaking with your utility company to see what it can offer you. If the amount is more than you can afford, then propose it to your community foundation or to an existing funder interested in supporting your organization's long-term health. They'll be contributing money so you can *save* money for years to come. Help them see it as a kind of endowment.

Much of what the auditor will recommend first will be weatherization upgrades. The term *weatherization* means forensic identification and repair of the leaks in your buildings. The leaks be small or large, and allow water, air, or both, to infiltrate. When the weather gets in, it can damage your building fabric and trigger your heating, cooling, and conditioning systems to do more work than necessary, consuming much more energy than necessary. In 2011, Historic New England implemented a number of small measures to increase energy efficiency at the Pierce House in Dorchester, Massachusetts. It's a seventeenth-century wooden structure with a stone foundation and multiple additions. Blower door tests conducted before and after changes helped demonstrate where to make improvements in the building envelope and the success of the work afterward. Closing air through repairs and repointing, and installing indoor storm windows helped reduce air leakage by 30 percent.[6]

A blower door test is an unintrusive test that has incredible value. If you have an historic house, this is on your must-do list. An energy auditor

will set up a portable frame and plastic membrane in an exterior doorway. Within the setup is a fan. With the house otherwise closed up, the auditor will run the fan to pull air through the house and push it out through the fan. The pressure change will not be enough to blow papers around or disturb objects, but it will be enough to draw in air through gaps in your building envelope. With an infrared camera, the auditor can examine the walls and ceilings, basement and attic ones as well, to see where warmer air in summer or cooler air in winter is being pulled into the building. Now you know where to insulate, seal, or repair the structure to save energy.

The National Park Service's Preservation Brief #3 "Improving Energy Efficiency in Historic Buildings" is a perfect introduction to energy efficiency in historic homes and other historic buildings. "Sound energy improvement measures must take into consideration not only potential energy savings, but also the protection of the historic property's materials and features."[7] Energy efficiency does not, yet, trump preservation standards. Hopefully, it never will have to. As we will see with collections care in the next chapter, building preservation is a balance of available technology, expertise, and funding in support of institutional mission and responsibility.

It took five years, but Connecticut Landmarks winterized all twelve properties based on a 2007 assessment of buildings from basements to rooftops. The result has significantly decreased annual utility bills, increased comfort for residents and staff, and created more stable environmental conditions for objects. A grant of $115,862 from the Institute of Museum and Library Services supported assessment of the properties' preservation needs and development of a guide for managing moisture and prioritizing preservation work. Just think of the energy savings when the structures were improved to reduce moisture infiltration, and the heating, ventilation, and air-conditioning systems could be adapted or redesigned for so much less moisture-management demand. With a forty-thousand-dollar Strategic Technology grant from Hartford Foundation for Public Giving, the organization upgraded its information technology infrastructure that improved usefulness while decreasing energy use and system cost.[1]

Notes

1. "The Connecticut Landmarks Triennial Report 2010-2012," accessed July 26, 2014, http://www.ctlandmarks.org/sites/default/files/72315_CTLandmark_Report.pdf.

After the energy audit, you will have baseline data for energy consumption, taking into consideration current uses, effectiveness of current systems, quality and extent of insulation, and locations of air infiltration. From this, the auditor can create a prioritized list of efficiency opportunities based on cost. If your auditor is not a preservation professional, you will need one to help you interpret the auditor's recommendations and identify preservation risks and advantages. Start with the items that, with the least cost, achieve the greatest energy savings with the least preservation impact.

You are likely to have a list starting with reducing infiltration through walls and around windows and doors. The next step will be reducing energy use with more efficient lights and equipment, installing storm windows, repairing seals on air ducts, and considering options for installing or upgrading insulation (particularly in attic floors and basement or crawlspace ceilings). Work to upgrade energy systems follows work to reduce energy demand in the building, or when you are nearing the end of the equipment's working life and must plan a replacement. Few of these changes, however, are as simple you might expect. Making changes incorrectly or incompletely can damage your building or complicate your energy demands, so proceed carefully and only with professional advice from the beginning.

A note about historic windows: this topic is significant enough that a national collaborative of researchers, architectural historians, and historic tradespeople developed standards for window preservation for sustainability. Historic windows are character-defining features of our historic properties. If they have become damaged or have decayed, they allow air infiltration, which requires inefficient use of mechanical systems maintaining environmental conditions. If they are single-paned, they also allow more heat-transfer than insulated, multi-paned windows. The most sustainable choice is to repair these windows and insulate storm windows that respect historical appearance. In the process, you maintain historic character using original materials or replacements in kind, you create jobs and encourage the continuance of historic trades, you keep materials out of the landfill now and in the future when any modern replacement window is thrown away, and you begin saving energy for your site. When a window has become so degraded it cannot be repaired, the same craftspeople can manufacture a new one for you. It is not inexpensive, but it pays dividends for people, planet, long-term profit, and your program.

During your energy audit, take a tour of your HVAC system, and then repeat the tour every six months with whoever manages your system. (If you are the site director, invite the staff and board on regular tours.) Plan a stand-up meeting in front of the system. Bring along a colleague so three of you know the drill. Bring along a board member. Learn the name and

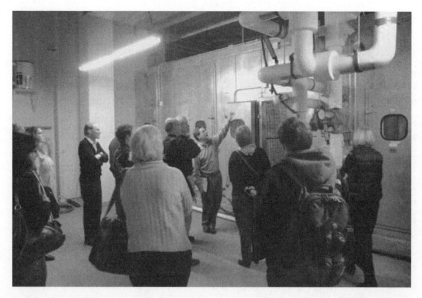

PHOTO 3.1. Minnesota Historical Society photography of tour of HVAC system.
Courtesy Shengyin Xu.

purpose for each piece and what troubles they are likely to have. Learn whom to call when something doesn't work. Learn the maintenance schedules, life spans, and replacement costs. Change a filter yourself, if that is possible; learn how to test or start the backup generator and then instruct someone else in it to be sure you know. Take a look at the ducts in the attic and the basement. Make sure you know intake from exhaust, your types of fuel and your energy source, the design mechanisms, the maintenance and replacement references, the age, and the alternatives. And ask about backup systems and safety mechanisms.

If you understand the equipment, you can have a useful conversation with your HVAC team or your provider, or the fire department if necessary. If you don't already know the system well enough to explain it to your board, then you're not truly attending to the second-most-expensive piece of superstructure you rent or own. Since your system affects your building, the most expensive piece, it's really worth understanding. Get involved in your system: you own it, you fund it, you depend upon it. Don't ignore it. If you are the director of a major agency or museum complex, you may have delegated this job. Don't do this completely. This knowledge will help you in a crisis and will help you make important funding, planning, and design decisions that affect the costs of operating your building. It may also help you

manage equipment outages and energy issues related to a weather disaster. And when there is a disaster, you will need to be comfortable and confident in decision-making for your building, your collections, and your systems.

Now that you know the system, you are ready to consider some complexities. Because "all-on/all-off" is one of the most prevalent energy-wasting designs and habits, the energy-delivery profession is slowly switching to on-demand energy systems. Just as with ceiling lights in a floor of offices or an exhibit gallery, environmental controls must respond to demand and not remain always on. So now, motors designed for new, or replaced in existing, HVAC systems, have variable speeds or frequencies directed by sensors. As the system calls for more or less air circulation, for example, the motors respond instead of running all the time. Very often, this means the working life of the motor is longer and the maintenance and replacement costs are lower. You certainly get optimum air supply but your energy draw is less.

In your exhibit galleries or lecture room, when many people fill a space, they breathe in oxygen and breathe out carbon monoxide (CO, not the CO_2 or carbon *di*oxide of greenhouse gas fame). Building codes require fresh air additions to certain standards. In a conditioned airspace, that means either the system is always bringing in outside air through ducts or it brings it in as needed. If you have a sensored system, it comes in only as needed. That's the most efficient way. Even efficient air circulation requires a great deal of energy: bringing in outside air requires drawing in the outside air, whether warmer or colder, filtering it, then heating or cooling it, and possibly adding or removing humidity, before pumping it into the room. It also requires moving the old air out of the room and pushing it through the system to either recirculate it or push it out of the building. Pushing air through a filter requires more force than just moving air, so the fan has to rev up a bit. Higher-quality filters improve air quality, but require more fan energy to move the air through the filters. Heating and cooling and humidifying and dehumidifying the air require energy as well. With all that effort, any efficiency can have an important impact.

Most systems, sensored or not, monitor and manage temperature and relative humidity twenty-four hours a day, not just during open hours, but some museums and sites are testing system setbacks where staff either reduce the temperature parameters, and therefore the demands on the system, during evenings and closed times, or they turn the systems off completely, and leave the building undisturbed, during unoccupied hours. The Canadian Conservation Institute and the Institute for Image Permanence have studied this extensively for spaces containing collections. (There is more about this in the next chapter, but you need conservators' guidance on this topic for collections areas.)

Regardless, these are complex systems. If you have a large site, you can consider a building management system or building information management system to help manage and measure performance. These systems use sensors and controls connected to a computerized interface to automate lights, heating, air intake, and air exhaust throughout your building. If you have a complex building, multiple HVAC units or zones, or multiple sites and too few staff, it is worth talking with providers to explore installing such a system or designing one during additions or adaptations. If you are unsure, speak with colleagues at other institutions of similar sized buildings and ask about their experience. The bonus of the right systems choice is not just energy efficiency, but also improved control and reduced staff time for management.

Do not assume that a complete system upgrade or replacement is your only path to efficiency. Most sites and even newer museums are unlikely to undertake a completely new system. Begin with a mechanical system review so that you understand what you have and how it works. Then you can consider and schedule repairs or upgrades, or simply different ways of using the system. Begin simply and use the management and decision-making skills you already have to make good decisions. You may choose to wait a few more years to replace the boilers, but at least you will know what you want when it is time. And then if a surprise breakdown—or a flood or other disaster—shuts you down, you will already know what replacement is the best choice.

Your energy audit gave you a baseline for energy use, now use that to help you budget your energy consumption. You budget your money; do the same for water and energy. If you manage the energy budget for your existing spaces as part of business as usual, you will:

- Catch problems earlier.
- Solve those problems more effectively.
- Develop team communications that improve planning and response when a decision is needed—even during a crisis.

A meter helps you track energy use directly; submetering helps you track energy or water use for a system within a building or for components of buildings. Ideally, all your buildings are metered, and if you are installing new equipment on a large scale, your vendor is likely to spec the system with a meter of its own as part of the package. Most of us have a single meter onsite, maybe two, depending upon how old the building is. Go find your utility bills; they are your monthly map to energy budgeting.

Arrange for a staff member or volunteer to put at least two years of past metering data into ENERGY STAR's Portfolio Manager, and then keep your records up to date. Portfolio Manager is a free online system that will

help you compare energy use month-to-month and year-to-year. You will be able to easily see anomalies in energy and water use. This can help you make informed decisions about energy levels and system effectiveness. Is there a spike in energy use one month, but it was neither so cold that you ran the furnace nor so hot that you ran the air conditioner? What could be the problem? Did the water use spike, too? Does this mean there is a leak somewhere and the pumps were running all the time? Maybe you should look into this. Did you just install new variable frequency drives? Can you see electricity use drop as much as expected? Maybe there should be some follow-up by the installer.

Mapping energy use also helps you anticipate seasonal costs. If you know how much oil a building generally uses, based on weather, you may be able to anticipate peak uses and make purchasing decisions based on historical increases in cost. You may plan to buy oil in August rather than mid-September to beat the seasonal rate increases. You may choose to shift building uses based on high-energy costs by season, by energy type, or by time of day if your utility charges you more at peak periods of the day. You can track your use by monthly bills, by reading the meter yourself, or by installing a meter that sends its reports right to your building management system. It's the same concept as taking your temperature and relative humidity readings (T/RH) readings by visiting the meter in each gallery or installing a system that sends the data to your computer.

What matters is the frequent and regular comparison of use over time and alignment of consumption with activities and weather. As closely as possible, someone on staff should check reports monthly and compare the energy or water use to the day, types of weather, and types of activities that occurred at that site. (Water use affects energy consumption because you need pumps to move the water and heating and cooling to keep it at the right temperature.) You may find that the energy use for the number of guests you get in that building for the winter doesn't make financial or energy sense, and you may choose to relocate a program, offer it less frequently in the wintertime, or postpone it to a warmer month.

And as Mike Leister did, you may choose to budget the amount of energy for your next exhibit, and then use metering to help measure the results. You can use that data to include exhibit energy costs in grant application budgets. Walt Crimm, of Walt Crimm Associates, says "shedding load is your best bet toward maintaining conditions and sustainability."[8] By reducing your energy consumption, you save money that makes long-term institutional sustainability easier. If you are considering producing your own energy, the systems designers will tell you to first reduce how much you use and then build to support that reduced level of energy use. To build

solar panels or put up wind turbines or dig geothermal wells to support unbridled consumption would be expensive and wasteful, not to mention not very environmentally sustainable. Green is not just less harmful for the environment; it also resists wasting what the environment has to offer.

Clean or Dirty Energy

Clean energy is produced without pollution or harmful emissions, *and* from renewable resources. Our current energy system does not offer many clean, highly efficient, highly sustainable energy options, so we're still faced with difficult trade-offs.

Burning wood consumes energy from a renewable resource, but its combustion produces carbon, so it is not a clean energy. Clean coal is an oxymoron. Coal is a carbon-based fuel and burning it releases carbon into the atmosphere, as does burning wood. Hydropower is a clean energy because there are no byproducts and the flowing water is renewable—it keeps flowing unless weather or dams change its levels or course. Generating solar, wind, or water power may not create emissions, but there are emissions associated with collecting the energy, building the plant and systems to collect, convert, and transport it, and then to decommission the system at end of life. There are environmental costs in any energy system. That is why often energy formats are compared by emissions per kWh of energy produced: gCO_2/kWh, the grams of CO_2-equivalent per kilowatt-hour of electricity generated.[9] If you are exploring clean energy, the National Renewable Energy Laboratory's work to collect, assess, and select the best data for relational comparison is the best option for making clean energy choices.[10]

Let's examine geothermal energy. Geothermal energy is clean, and direct geothermal heat is considered renewable. Some places in the Western United States can use the geothermal for direct heat by capturing underground hot water and piping it into their buildings' hot water heating systems. Direct geothermal heat may also be delivered through a district or localized delivery system. Ground-source geothermal, and the wells and pumps to deliver that heat, are not considered either energy generation or renewable because, over time, the temperature of the ground used as a heat sink may change. Its cooling ability in warm seasons will be diminished if the well areas warm. If the well field and system are sized appropriately, this is avoidable, though. Geothermal is also not scalable the way electricity is scalable. Geothermal is, however, an extremely important energy efficiency solution worth considering if it is available to you.

In most parts of the country, geothermal systems use the ground as the source: the temperature of the earth is an indirect heating or cooling agent.

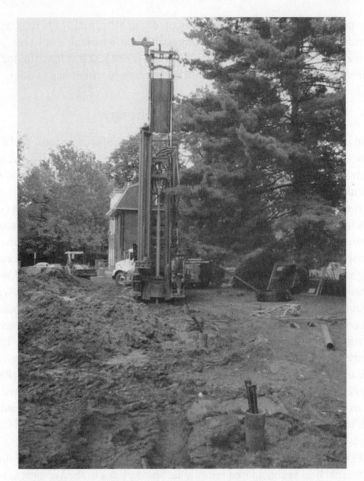

PHOTO 3.2. Connecticut Wells drilling one of the eight wells that measure 6 to 7 inches in diameter and 450 feet deep.
Courtesy Connecticut Landmarks.

The geothermal constant of fifty to fifty-five degrees will not completely warm a building, but it can transfer the energy (measured by the temperature) of the ground to help heat and cool your building. This kind of system uses ground conditions that are cooler than the outside air in the summer and warmer than the outside air in winter to raise or lower the temperatures of the air, water, or glycol used as part of environmental control. There are three parts to the system: the loop of tubes that reaches into the wells dug in the earth, the exchanger that transfers the temperature (energy) from

one medium (the air, water, or glycol inside the tubes that has been heated or cooled) to the next (the air or water used to condition the building air), and the heating and cooling distribution system in your building.[11] It is not available everywhere, though. The U.S. government's Department of Energy's National Renewable Energy Lab has a great map of geothermal potential if you're wondering about geothermal.[12] Looking at the map, you can tell instantly that geothermal is not for you if your site is in the top half of Vermont, the top third of Michigan, along a good chunk of the West Coast, or pretty much all along the Appalachian Mountains of the East Coast.

Geothermal installations are complex and physically very disruptive to the landscape. Installation involves digging multiple wells, laying great lengths of loops in frost-proof settings, and then bringing the connections through trenches to the building. Installers have greatly improved the process by reducing the degree of ground disturbance and planning for managing topsoil, water, and mud, but it can still be a muddy mess. Depending upon your site's history, you may need to conduct archaeology before construction begins, so perhaps you can use this energy upgrade as a trigger for much-needed research. One great advantage: the system does not include the large noisy air handlers you may be used to. This is good for neighbors, too.

The headquarters for Connecticut Landmarks has a system of eight geothermal wells, each 450 feet deep, and with a closed-loop system serving two historic structures in one campus setting. The loop for each well runs down into the earth, up into the systems transfer unit, and back around into the earth in a closed system. This system was installed in 2010, after advance archaeology, using a $120,000 capital grant from the state and a match from a private foundation. This recent experience was quite positive, but these installations were not always so straightforward.

When Dan Snydacker arrived at the Newport Historical Society as the new director, he recognized that there was no central, interpretive home for the city. Through a planning grant from the National Endowment for the Humanities, he worked with advisors, board members, and community members to create a plan for that home. A "confluence of developments led to the selection of the Brick Market," he says. This remarkable colonial structure, a stunning example of architecture using Palladian components, was desperately derelict yet still the ideal place. The Newport Historical Society committed to the project, earned a $375,000 National Endowment for the Humanities grant for implementation, and began the work. As you can imagine, though, such a gorgeous historic structure, easily viewed from all sides in its central location, was not the ideal building for exterior chillers or cooling towers. Such obvious technological intrusions on the setting

would be inappropriate. And then the costs of operating a traditional HVAC system mapped out as prohibitively expensive.

So Snydacker began exploring an option suggested by the architect: geothermal heat pumps, entirely hidden from view and, mercifully, silent. As Snydacker says, the stakes were quite high for finding an affordable adaptive reuse of this building. Using a geothermal heat pump to mitigate the amount of conditioning for temperature and humidity would offer significant energy and cost efficiencies in operating the building. However, this was 1990: geothermal systems were not common. The project did experience some significant challenges, but ultimately succeeded beautifully.

Though this was early in the development of energy efficiency systems, there was thoughtful consideration of the building's orientation and siting, and the effects of the sun's movement during the day on the temperature of the masonry structure. To compensate for fluctuations during a day, the system was designed with two components that could respond to heating and cooling as needs changed over the day. The problem was with the controls. Snydacker describes the system as being "overdesigned and undercontrolled." The two halves were in competition with each other and for three or four months it was impossible to balance the system. This was a time when system commissioning was not a common practice, no one thought to question the engineers, and certainly there were no manuals left for the owners after installation, Snydacker explains. The backup electric heating system had to be deployed to maintain conditions for objects in general and loaned treasures in particular. During this painful time, any cost savings for the first year were completely erased, but at about month four the facilities manager, retired Navy Chief Petty Officer Charles Morgan, suggested to Snydacker that they turn off half of the system. Snydacker explains that Morgan threw the circuit breaker on one part of the system, it balanced itself, and "all the predicted benefits from the system began arriving in spades."

Snydacker believes strongly in commissioning, and sees it as a particular value in the U.S. Green Building Council's Leadership in Energy and Environmental Design program. "Think of the blood, sweat, and tears it would have saved Newport Historical Society," he says. If an engineer, one not responsible for designing or repairing the system, had tested it to make sure it was designed appropriately and that it worked according to expectations, the problem-solvers would have been working to fix the system before anyone knew there was trouble. If that had been the case, the energy savings, and cost savings, for those first months of operations would have been very substantial.

Now let's change scale and go back to examining wood heat using traditional woodstoves, not the newer, cleaner pelletized systems. Let's examine

wood heat because it might be something you use at your site in a rustic cabin or a barn workshop, and because it presents an easy example of how to examine complex options. There are pros and cons, and you must weigh them against your mission and institutional goals, but there are times when it may be quite appropriate.

PROS	CONS
Often a local source	Creates particulates that remain suspended in the air
Usually supports the local economy	Releases greenhouse gases, primarily CO_2
Often less expensive	Requires physical strength to load the fuel
Often sourced from waste	Requires lots of storage space
Excellent interpretive tool	No automatic controls to fuel the system
Excellent interpretive experience	

If this were a carbon-, or greenhouse gas–only discussion, the answer would be "no—wood-burning is not an option." In addition to carbon, there is the physical pollution. The problem with particulates is that they hang in the air near ground level where people breathe them. And they blow around instead of settling, so your wood burning may be sending particulates to a neighboring site. The Environmental Protection Agency is proposing new standards for woodstoves: 1.3 grams per hour of particulate released in a new woodstove versus what the pre-1988 models offered at more than one hundred grams per hour.[13] That shows you the difference between current expectations and older rates—now think what an open fire generates, or what your 1860s stove spews out. While it may not be appropriate to stop using wood fires and old stoves for occasional interpretative practices, if you plan to add stoves for heating, you'll need to follow new regulations.

If the use of wood is considered more broadly, it has additional sustainability values. Wood is considered a renewable resource if you plant where you harvested. Before harvest, the trees store carbon, provide animal and insect habitats, and keep the surrounding area cooler via their leaves. When you harvest the wood, the trees provide jobs, probably local ones; they then

provide heat, educational opportunities, and pleasure. A working fire that provides an extra service, such as drying food or materials, baking food, lighting, boiling water for washing, or for humidifying the air, *and* adding to interpretation, has more positive impact. That has great value as long as it is part of a thoughtful energy management plan that reduces energy consumption and greenhouse gas emissions in other areas.

Your job is to sort through these conundrums and be responsible about choosing energy, and to work toward using the cleanest energy possible when you do consume. No, very few of us have training in this, but we do know how to do our research, inquire of colleagues, and ask for advice from experts. As alternative energy choices improve, choices will get easier, but it's still important to consider as many now as possible. You may be working toward a new building in the next five to ten years. It will certainly use energy differently than buildings do now. You may need to be proactive to protect space in the design for a solar installation, support community incentives for alternative power, select the cleanest wood-energy boiler, or perhaps encourage development of a shared energy system with neighbors. Energy changes take a long time and are not easy to manage whether or not you trigger them. The more you learn and manage now, the easier it may be on your institution in the next decade.

Buy It. Make It. Share It.

Buy It

If you are not yet in a position to generate your own clean energy, while you explore the possibility and remain open to future possibilities, you can purchase clean energy. All providers are required to purchase and resell a certain amount of alternatively generated energy, so when you buy, you can buy traditionally generated (coal, gas, or nuclear) power, or you can opt to buy whatever alternative they offer, often power that is generated through a mix of formats: wind, solar, water, and biofuel. Check your next energy bill; you will probably see a purchase option there. It may cost more than conventional formats, but it is available.

There are regional exceptions for availability, such as utility-provided direct geothermal in some Western and Southwestern states, and utility-provided hydropower in New York and other Northern states, where non-carbon-based energy sources are already part of the business-as-usual power system. As we saw in the case for the previous chapter, Dumbarton House in Washington, District of Columbia, buys 100 percent wind energy for its site. DTE, the energy provider for much of Michigan, has a Green Currents

program where businesses can opt in to purchasing energy from renewable sources, a mix of mostly biogas captured from cow manure and landfills, but also some wind power. So take time to look at your bill, or look at your provider's website, and explore the options for energy choices—then budget it.

Make It

Most energy-generation options are cleaner than coal-fired power plants, wood fires, and natural gas. There's direct natural energy capture and conversion (solar, hydro, wind), there's biofuel use (biomass burning or digestion), and there's cogeneration (one energy-generating process produces another form of energy simultaneously or as a byproduct). Whatever you choose to explore, start by learning what your utility offers as free or low-cost support, explore state and national alternative energy incentives and grant programs, and definitely work with the best professionals you can afford. These are complex decisions involving new partnerships and new technologies. The process is likely to be incredibly worthwhile if you commit enough attention to it.

As domestic and industrial-sized alternative energy systems improve, it becomes much easier to consider generating energy on a small scale. You could perch a domestic-sized turbine on a building or a promontory, or on the light poles in your parking lot. You can start with solar hot water for restrooms. This is solar thermal heating, as opposed to solar-powered electricity generation through photovoltaic cells. Solar thermal is the most efficient solar energy approach because it is direct heat transfer. If you heat your building with hot water, then a solar thermal system can passively preheat the water that you'll finish heating with oil, wood pellets, gas, or electricity. It will take less oil gas or electricity to bring that warm water to steam level if you've already boosted it with free solar heating.

Solar generation is the most common large-scale format because of federally funded and state-sponsored programs to incentivize adoption. Most photovoltaic systems now in place have either been partially funded through these programs or are part of a utility's compliance with mandates to generate or purchase target percentages of renewable energy. Do you have substantial roof space to host a photovoltaic installation? Your utility may be interested in installing, or contracting to install, a system and committing to delivering green energy to your institution at a discount in return. Mystic Seaport: The Museum of America and the Sea in Connecticut participated in a similar agreement. With a new photovoltaic system on its Collections Research Center, it can now count on about 10 percent to 15 percent of its energy being sourced from solar power.[14]

Hydropower is generated by moving water. It is kinetic energy, as is wind energy, using its movement—whether from tides, waves, or running water from dam releases and regular flows from creeks, rivers, or waterfalls—to mechanically transfer captured energy to your site, or to generate electricity for your site. A water wheel or water turbine, which turns gears and axles and belts to make your mill, looms, or lathes work, is direct, mechanical energy. The turbine might instead be attached to a turbogenerator, which generates electricity, and that electricity, properly connected, can run parts of your museum exhibit, or even other portions.[15]

Windmills historically pumped water to the surface for feeding livestock. Today windmills, or wind turbines, strategically placed, harvest the energy in wind, convert it to electricity, and transmit it to an energy distribution company. These can be built on owned or leased land, on a series of hills or along a ridge, or in open water. There are domestic-sized systems that can stand alongside your historic windmill, line the roof edges of your museum, or stand out in your fields. This all depends upon local ordinances, local wind generation, and your preference.

Share It

District energy is an old concept still active in many cities but showing potential in neighborhoods and rural communities. At one point, Hanford Mills, now the Hanford Mills Museum in rural New York State, generated electricity for a very local power grid. Think of that today. Is locally generated power going to be part of some museums' repertoires? If energy is part of your interpretive mission, it could be.

Local energy's most valuable characteristics are (1) shorter transmission distance reduces the cost of transmission and energy losses along the way, and (2) localized energy outages are usually more promptly repaired because the system's managers tackle outages locally, not across an entire region. Your system is their priority.

Major universities and hospitals, city government complexes, and major multi-building facilities such as zoos are connected to shared central heating plants or systems. Some cities have systems supporting buildings in the core of the city. This is the case with the Maryland Historical Society in Baltimore. A single site can generate energy and distribute steam through piping or electricity through transmission lines to associated buildings. According to the National Trust for Historic Preservation, these local energy, district energy, or distributed energy systems are increasingly considered as energy management solutions for cities renewing their older systems, new construction projects looking for reliable energy sources,

and even old neighborhoods interested in building their own clean energy districts.[16] These systems also offer opportunities for smaller-scale clean-energy upgrades. It's easier to retrofit your local oil-generated steam system with biofuel than to revamp a major regional electrical plant.

For example, a Midwestern history museum was approached by a vendor to participate in a community solar garden. It is a new kind of partnership authorized by the state which facilitates investment in solar projects up to one megawatt in size by renters, homeowners, companies, and nonprofits that may or may not have a suitable solar site themselves. The "shareholder" receives a discount on their power bill and the satis-faction of going solar without having to build their own system. After a period of negotiations between the state and local utilities, the solar garden idea is heating up, and vendors are offering a variety of interesting options for involvement. No one is sure how it will all fall out, but the idea holds promise for community-based energy that fits the scale of most history museums and historic sites.

Interpret It. Hide It.

In other chapters there are examples of historic interpretation of energy uses, but this is a pitch for interpreting modern practices. With all the con-sternation about how to make museums relevant, talking about modern energy efficiency at your site is a great solution. Any member of your audi-ence may be interested in seeing and understanding how your energy sys-tem works—how and why you turn lights off and on using sensors, or how your solar panels work and where you've "hidden" them. Previously, we discussed setting up a domestic-sized turbine next to your nineteenth- or twentieth-century version already standing over the old well. Don't just set it up; talk about it! If you don't have a turbine, your energy company prob-ably has loaner wind power test kits you can use to demonstrate modern wind power on a domestic scale, or to test to see if such a system is cost-effective for you, and use as a segue to inviting the public to borrow a kit for themselves to test for wind potential at their homes. Historic energy discovery, transmission, and use, plus all the stories of cultural changes, have parallels or contrasts in today's public discussions. Translate that into the story of your site wherever and whenever you are able.

Interpret this even if you're hiding energy production or it isn't vis-ible to the public. If your staff does not want to interpret solar panels in an historic area, then an interpretive sign near the parking lot or the mod-ern restrooms can introduce the topic and describe to visitors what you're doing, and how and why. If you're sending your animal waste off-property

for conversion through a biodigester, a well-placed interpretive panel or an informed guide can tell the public how and why. This sort of interpretation may be easier in a museum space instead of an historic structure. It is incumbent upon you to share your energy efficiency and clean energy practices to the best of your ability. If you have a wood lot you selectively harvest offsite, let the public know. They'll be pleased to learn how you're being resourceful as you struggle with energy costs just as they do. We know that a good portion of the visiting public sees museums as "other," and only as special event destinations; too few see us as a part of the fabric of their lives. Let's at least establish that we share the same fabric of living.

State Historical Society of North Dakota has just finished a major expansion with a goal of Leadership in Energy and Environmental Design Silver standard. From triple-glazed windows to geothermal wells, with motion-activated lighting, and, of course an automated building management system, it's a very energy-efficient space.[17]

Its mission is "to identify, preserve, interpret and promote the heritage of North Dakota and its people." When it began to consider an expansion to its existing facility, the Historical Society recognized the need to build

PHOTO 3.3. The north side of the North Dakota Heritage Center expansion features large areas of ultra high-performance glazing in select areas to naturally daylight the galleries and prevent museum fatigue between galleries. Exterior materials were specifically chosen for their lasting and durable nature, including limestone panels and a granite base.
Photo credit: Loren Ahles.

a lasting and resilient building to assure a sustainable, permanent home for its collections and growth of its exhibit space. The state's northern climate is very challenging, requiring extra care to provide climatic stability for the preservation and protection of the collections. The new Heritage Center addition has a high-performance building envelope to manage the high level of temperature and humidity control within versus the dramatic temperature swings of a typical North Dakota winter. "The average extreme winter temperature to design around in Bismarck is [twenty] degrees below zero," says HGA Architects project mechanical engineer Leighton Deer. "At that extreme, superinsulated envelopes are required, and careful attention must be given to issues concerning condensation resistance and humidity control."

To address these challenges, the team designed for a continuous layer of insulation throughout the building's perimeter. This sounds obviously critical, but it is still complex. The moisture-control membrane inside the wall cavity works with the building's humidity requirements "to ensure continuity of the insulation and weather membranes while avoiding dew points that would cause condensation within the cavity wall," says HGA Architects project architect Adam Luckhardt. The roof's average R-value, or insulation rating, is thirty, so that the whole envelope of roof and wall systems work together to assure a high performance throughout the addition.

From the early stages of design, natural light in the museum's common circulation and gathering spaces was important as an enhancement for the visitor experience. Overhead skylights bring daylight into the heart of the addition, and the glassy Northern Lights Atrium is a light-filled gathering and event space. These areas cannot become a weak point in the building's envelope, so the team worked closely "with curtain wall and glass manufacturers to assemble a high-performance glazing system that would sustain the Heritage Center's interior temperature and humidity requirements," says Luckhardt. "By utilizing ultra-high performing curtainwall and quad layer suspended film glazing, we were able to achieve the transparency of the design without sacrificing thermal performance" of the envelope.

"Harnessing and managing lasting energy sources" was an important design issue for the HGA Architects architectural team and the North Dakota Historical Society. In a building that lasts one hundred years or more, the team says, the biggest expenditure is not in its initial construction cost but in the energy it takes to run and maintain the building over its lifetime. For a museum with critical temperature and humidity concerns in order to preserve and protect its collections, the lifecycle cost of the energy is even more important. The Historical Society considered multiple sources for renewable energy early in its planning, including wind,

solar, and geothermal systems. Ultimately, a geothermal ground source heat pump was designed and installed underneath the museum's expanded parking lot. "The system was a natural fit for this project and climate," says Deer. "Ground source heat pumps use the stable earth temperatures for efficiently and cost effectively heating and cooling the building—which is significant for energy intensive facilities like museums. The system is estimated to use 30 percent less annual energy than traditional systems and pay for the additional investment in approximately fifteen years. In addition, we were able to fit all of the wells needed to provide for the building within the footprint of the parking lot that was going to be built anyway, allowing us to use this same land for double duty."

The energy controls and monitoring systems in the galleries are equally innovative and state of the art. The building automation system has been carefully tailored to provide curator control and monitoring over temperature and humidity within all key storage and exhibit areas of the building, so that any changes in the system are brought to staff attention before the potential for long-term damage to the collections occurs.

And there's a bonus: the North Dakota Geological Survey is using the building automation system to monitor the geothermal system to further their mission for investigating the geology of North Dakota.[18]

Beyond Heat and Light

Energy efficiency is not just about light and temperature. Transportation and water use are major aspects of the energy system in the United States.

Water

Your energy efficiency here comes from limiting your consumption and reusing what you have. You can capture water and reuse it. If you make water, most likely it is through condensation in your climate control systems—large or tiny ones. Your HVAC may use water in a cooling tower or may capture condensation from a steam heat process, and your dehumidifier in the back room may have a bucket you have to empty on the herb garden by hand. Whatever the scale, your green job is to recognize water as an asset and plan to divert it to a use or to storage instead of letting it get dumped down a drain or into a sump pump. With a complex heating and cooling system, your maintenance and engineering advisor can help you consider options and schedule how to implement your choice. For the domestic-sized humidifiers, you and your staff can be creative—but be safe.

Due to fire concerns, only operate these dehumidifiers when a staff member is present.[19]

Pay attention to how you use water; perhaps conduct a water audit just as you do an energy audit or an equipment audit, and then share efficiency ideas with the staff. Model responsible water use and provide tips and reminders in places where water is used. We've already reviewed water use for washing vehicles and equipment. How about washing surfaces such as the covered picnic area near the parking lot? How do you use water from domestic demonstrations including cooking and washing clothes? What about water use in processing the vegetables you may sell in a community-supported agriculture program? Avoiding the all-on concept is key here. Running a hose as you spray off the cement pad in the picnic area or wash the vegetables is wasteful. A water bucket for swishing with a broom saves water, and a watering tub for dunking dirty vegetables does, too. Using a tub for washing makes it easier to contain the used water and simplifies transporting it to a natural area. From the tub, you can scoop water into a bucket to water plants, or simply open a cock to let it the water percolate into the ground instead of running through pipes and sewers and sanitary systems. If the water does not contain hazardous wastes, you're safe splashing it outside, but do alternate your splashing spots to distribute the water and avoid scouring the topsoil and washing it away in one area.

If you have a tenant in an historic house, or a curator, as the parks often call them, ask them to limit water use, too. This means using a bucket to capture the first cold water from the shower and using it to flush toilets or water plants, and taking reasonably short showers. Saving water, like saving energy, is really about mindfulness.

Transportation

This is about how goods, staff, volunteers, and visitors get to you, the transportation you use onsite, and the transportation you use offsite for work, sales, and waste. Let's start with how people and goods get to you. Not too much of this is under your control, but you can encourage sustainability. Group tour buses and public transportation increasingly use compressed natural gas (or CNG) vehicles. These require specialized fueling stations. I'm not suggesting you install one, but you can make sure users know which compressed natural gas stations are closest to your site so they can feel confident traveling to you. You can provide preferential parking for these vehicles and those using biofuels, and for high-efficiency vehicles or carpoolers. Designating preferential parking (and promoting it on your website) brands you as a conscientious organization while giving old-style drivers new ideas.

If you don't have public transportation access, perhaps now is the time to work with your community to eventually provide it. Carpools for staff and volunteers are always to be encouraged, of course. In rural locations, this might not be as easy to achieve, so focus your energy where you'll get the best return on this effort. If you call cabs for visitors, consider regularly using a company using alternative fuel vehicles. For product and supply deliveries to your site, you may not have much control over the fuel, but increasingly the major carriers are choosing efficient and cleaner-energy vehicles. Even for-profits don't like paying for fuel, and they certainly recognize the value of the green brand.

Onsite, how do people get around? If you have a large campus, can you use bicycles or golf carts? Can the carts be solar powered? Do you encourage staff to take the time to walk where needed onsite so they experience more of what is going on, have some physical activity in their day, and save energy? Are you a rural site? Maybe it's appropriate for staff to ride a horse or travel in the oxcart for some aspects of onsite work. One doesn't have to be in historic costume to ride a bike, so why do we limit riding horses and driving carts to costumed interpreters?

And offsite, there is professional travel in-town and around the state or country. Just think what a promotion it would be if you ran a few errands in a horse-drawn carriage with your logo on it! Okay, few of you will have that option, but it's an example of how to think about mission and green at the same time.

If you are actively greening transportation, then you are likely to consider buying an electric vehicle. However, providing a charging station for it, and for visitors with electric vehicles, has a few twists to it. Let's start with the energy source: if you have a carbon-based source of electricity, then you're not reducing anyone's carbon footprint; rather you're displacing the carbon emissions from petroleum-generated travel to possibly coal-generated emissions from a power plant. So if you're choosing an electric vehicle for climate reasons, be sure to provide comparable clean energy sources that you either generate or purchase. Then recognize that if you purchase the clean energy, you'll likely pay extra to the utility in more than a few ways: during the vehicle purchase, the energy purchase, the energy distribution and delivery, and any surcharges. Your energy costs may also fluctuate based on the time of day you charge the vehicle. Peak electricity times—when the public is using the most energy—often have peak electricity costs, depending upon your provider and your plan. These are all questions the energy company can answer when you meet with them—at no cost—to discuss installing vehicle charging stations. This is still worth exploring, and it's certainly worth getting sponsorship for the vehicle and its

associated costs. Do plan for vehicle replacement by specifying the highest-efficiency options. Museums keep their vehicles a long time; make sure you don't get stuck with a low gas mileage model as fuel prices climb even higher.

But cost isn't the only consideration; if you live in an area where many visitors will have electric vehicles, then providing access to charging stations is an important visitor amenity and may become a necessary visitor service. Maybe you could make it a perk for members! If you do a little audience and employee research here, it will help with decision-making as you determine the potential demand for this service. At a minimum, it will demonstrate situational awareness, enabling you to serve a wider customer base and a growing green one.

Whether you travel across town or much farther, you get to make the choices. If you rent a vehicle, you can choose an energy-efficient or hybrid one. If you are traveling as a group, take a shared van instead of separate vehicles. Choosing train transport over a single-use inefficient vehicle is often an option. And you can always purchase carbon offsets (see terrapass .com or carbonfund.org). It is easy enough to make that a policy without much extra financial cost at all. Why not start there?

Conclusion

You can count on a complex energy picture developing around you in the coming years. You're going to have to watch, prepare, and adapt. Even better, try to anticipate. Anticipate price fluctuations by preparing either to budget for these costs or to budget your energy by timing your use, anticipate future shortages by preparing now to generate or prepurchase your own energy, and prepare for format changes. Right now, there are risks in choosing a single new energy source if you're making alternative choices or new technology choices, but then there aren't many options yet either. Depending upon where you are, regulations may change significantly, or technology may prove less dependable than described, or less available. If you have the opportunity, consider blended systems with flexible operating capacities, and redundant systems that keep you and your collections safe at lower energy levels, when energy availability changes, and when old parts just cannot be found or made to work anymore. Energy is no longer constant or inexpensive, and cannot be taken for granted.

Energy options are going to proliferate, as will opportunities for our organizations to foster thoughtful energy choices and options among our neighbors. The Bakken Museum in Minneapolis, Minnesota, has a mission to "inspire a passion for science and its potential for social good by

helping people explore the history and nature of electricity and magnetism." Steadily, over the years, the staff has included energy efficiency and energy alternatives in its discussion of electricity, innovation, and human impact. They have a traditional solar installation, and have offered an annual "Green Energy Art Garden" in collaboration with local artists that has innovated new ways to use art to intrigue visitors with the possibilities of renewables. They created a temporary exhibit called "Absolutely Horseless: Advertising the First Wave of Electric Vehicles" that drew attention to striking parallels in the challenges facing EVs in 1900 and today. They're the one that has been approached by a vendor to facilitate a solar community garden. At this writing, they are still considering their options, but they are excited by the opportunity to enlarge their solar footprint and to potentially inform and engage their visitors in this great, statewide experiment.

It is now possible to be responsible for your own energy sources and energy use. So why don't we do more of it? You wouldn't farm out collections care; you wouldn't delegate interpretation without reviewing content, delivery, and results; you don't delegate climate control to outsiders. Why would you delegate responsibility for the energy that protects your collection? An uninvolved partner such as your utility provider may or may not be ready to spring into action in an energy emergency. Perhaps you think this is a little alarmist. Let's try this: it's called The Five Whys and was pioneered for mechanical engineering by Sakichi Toyoda but has been adapted for all sorts of assessment situations. It is a valuable tool for identifying challenges buried in the usual clamor of language, assumptions, and excuses.

Start with an assumption, and ask "why" five times to pare away the components of the assumption until you reach the core issue. Here's the assumption: museums allow nonmuseum practitioners to provide and manage the energy critical for mission priority practices such as controlling indoor climate, for lighting exhibits and galleries, and for keeping the doors open and offices running.

1. Why? Because the utilities are better at it.
2. Why? Because it's their responsibility.
3. Why? Because we can't do it.
4. Why? Because they have the infrastructure to make and deliver the energy.
5. Why? Because we don't choose to generate our own energy.

Hmm . . . why not?

It is time to challenge the assumption that others should be responsible for the energy we need to do our work. How do you take responsibility for your own energy?

1. You limit your demand.
2. You produce what you can.
3. You tie into a network, preferably a very local one, to share and borrow as needed.

Notes

1. American Association for State and Local History, *StEPs Workbook: Standards and Excellence Program for History Organizations* (Nashville, TN: Author, 2009).

2. Angela Person-Harm and Judie Cooper, *The Care and Keeping of Cultural Facilities: A Best Practice Guidebook for Museum Facility Management* (Lanham, MD: Rowman & Littlefield, 2014), 55–60.

3. Shelburne Museum, "Looking into the Light: II," accessed September 28, 2014, http://shelburnemuseum.blogspot.com/2011/11/looking-into-light.html.

4. Mike Leister (Director Air Mobility Command Museum) in interview with the author, March 5, 2014.

5. Ibid.

6. Historic New England, "Storm windows reduce air leakage by thirty percent," accessed September 13, 2014, http://www.historicnewengland.org/about-us/whats-new/storm-windows-reduce-air-leakage-by-30.

7. Jo Ellen Hensley and Antonia Aguilar, *Preservation Brief 3: Improving Energy Efficiency in Historic Buildings*, Technical Preservation Services, National Park Service (Washington, DC: U.S. Department of the Interior, 2011), 1.

8. Building Museums Conference presentation, March 2012.

9. EDF Energy, "Measuring energy's contribution to climate change," accessed July 5, 2014, http://www.edfenergy.com/energyfuture/the-energy-gap-climate-change.

10. National Renewable Energy Laboratory, "Life Cycle Greenhouse Gas Emissions from Electricity Generation," accessed July 5, 2014, http://www.nrel.gov/docs/fy13osti/57187.pdf.

11. Sarah Sutton Brophy and Elizabeth Wylie, *The Green Museum: A Primer on Environmental Practice*, 2nd ed. (Lanham: AltaMira Press, 2013), 138–39.

12. Billy J. Roberts, "Geothermal Resource of the United States," October 2009, National Renewable Energy Laboratory, accessed July 4, 2014, http://www.nrel.gov/gis/images/geothermal_resource2009-final.jpg.

13. "Feel the Burn," *Wall Street Journal*. February 1, 2014.

14. "Mystic Seaport and Altus Power Announce Completion of New Solar Power System Installation at Museum to Provide More Than 250 mWh Annually,"

Altus Power America Management press release, March 2013, accessed September 8, 2014, http://www.altuspower.com/mystic-seaport-and-altus-power-announce -completion-of-new-solar-power-system-installation-at-museum-to-provide-more -than-250-mwh-annually/.

15. Energy Quest, "Chapter 6: Turbines, Generators and Power Plants," *The Energy Story*, California Energy Commission, accessed July 4, 2014. http://www .energyquest.ca.gov/story/chapter06.html.

16. Tom Osdoba, Liz Dunn, Hendrik Van Hemert, and Jaxon Love, "The Role of District Energy in Greening Existing Neighborhoods: A Primer for Policy Makers and Local Government Officials," Preservation Green Lab, National Trust for Historic Preservation and Center for Sustainable Business Practices, University of Oregon, 2010, accessed January 1, 2014, http://www.preservationnation.org/ information-center/sustainable-communities/green-lab/additional-resources/ District-Energy-Long-Paper.pdf.

17. Claudia Bergin in interview with the author, February 14, 2014.

18. Contributors from HGA Architects staff are Leighton Deer, Adam Luck-hardt, Rebecca Celis, and Amy Bradford Whittey, September 30, 2014.

19. Jeremy Linden, Image Permanence Institute presentation, September 29, 2014. Recall information for makes and models recalled for fire hazards can be found at http://www.cpsc.gov/en/Recalls/2014/Gree-Reannounces-Dehumidifier-Recall/.

Resources

American Institute for Conservation of Historic and Artistic Works. Sustainability. http://www.conservation-us.org/publications-resources/sustainability/led-light-ing#.VCio9WddV8E. A resource for lighting choices.

Brophy (Sutton), Sarah, and Elizabeth Wylie. "Museums and the Future of Water." *Museum* (March/April 2014): 34–41.

California Energy Commission. "Energy Quest." 1995. http://www.energyquest.ca.gov. This grade-school interactive website has an Energy Story section that works like a textbook with clear yet technical explanations of energy, energy systems, and equipment.

Environmental Protection Agency. "Burn Wise." http://www.epa.gov/burnwise/. Burn-wise, a program of the Environmental Protection Agency, guides clean use of wood-burning stoves and furnaces and suggests approaches to improving regula-tions for their use.

Environmental Protection Agency. *"Climate Change: Greenhouse Gas Emissions."* http:// www.epa.gov/climatechange/ghgemissions/. Environmental Protection Agency's greenhouse gas emissions primer.

Leeke, John, and Bob Yapp, eds. *Window Preservation Standards*. United States: Window Preservation Standards Collaborative, 2013. Frankfurt, KY.

National Park Service. "The Secretary of the Interior's Illustrated Guidelines on Sustain-ability for Rehabilitating Historic Sites." U.S. Department of the Interior. http:// www.nps.gov/tps/standards/rehabilitation/guidelines/index.htm.

National Park Service. Technical Preservation Services, *Preservation Brief 3: Improving Energy Efficiency in Historic Buildings*. Washington, DC: U.S. Department of the Interior. Last modified December 2011. http://www.nps.gov/tps/how-to-preserve/briefs/3-improve-energy-efficiency.htm.

National Park Service. Technical Preservation Services, *Preservation Brief 39: Holding the Line: Controlling Unwanted Moisture in Historic Buildings*. Washington, DC: U.S. Department of the Interior. Last modified October 1996. http://www.nps.gov/tps/how-to-preserve/briefs/39-control-unwanted-moisture.htm.

Nouvir Lighting. "Fiber-optic lighting solutions capable of almost eliminating photochemical damage." http://www.nouvir.com.

Osdoba, Tom, Liz Dunn, Hendrik Van Hemert, and Jaxon Love. "The Role of District Energy in Greening Existing Neighborhoods: A Primer for Policy Makers and Local Government Officials." Preservation Green Lab, National Trust for Historic Preservation and Center for Sustainable Business Practices, University of Oregon, 2010. http://www.preservationnation.org/information-center/sustainable-communities/green-lab/additional-resources/District-Energy-Long-Paper.pdf.

Whole Building Design Guide Historic Preservation Subcommittee. "Sustainable Historic Preservation | Whole Building Design Guide." National Institute of Building Sciences. Last modified December 2, 2013. http://www.wbdg.org/resources/sustainable_hp.php#rcas.

◎◎

THE IDEA

Environmental Sustainability in Collections Care

Vision

History organizations use their collections and conservation expertise to care for collections while embracing rapidly advancing preservation understanding as it relates to safe and energy-efficient conditions for our most valuable cultural artifacts.

The Standards and Excellence Program mentioned in the previous chapter also has a standard for collections care that identifies environmental sustainability. Standard #7 under *Stewardship of Collections* states, "The institution is aware of issues associated with environmental sustainability and takes steps to conserve resources and protect the environment at the level appropriate for its capacity."[1]

There has been a great deal of change in the field in the last few years that affects your collections care decisions. But before you begin thinking about how to green your collections energy use, make sure you are caring for the right stuff. Before you decide to install or upgrade your environmental monitoring system, or you change your heating and cooling systems, have you done an inventory and completed a deaccession process? You must be sure you are putting energy into the right items before you

upgrade or build a system. If you deaccession thoughtfully, you are more likely to be managing and caring for the right amount of materials—a much more efficient way to operate. The bonus is that the inventory and deaccessioning processes will help you identify, or confirm, the types of items in your collection and how they are currently stored. This will help you define T/RH parameters for caring for your collection, which may help you save energy.

Now it is time to review or put in place a monitoring system for environmental conditions in collections areas. Finding a system that is compatible with staffing routines and your storage arrangement will ensure a successful start-up for monitoring. This investment allows you to make the most energy-efficient choices as you protect your collection and manage personnel and mechanical systems for appropriate collections care.

During the last decade, our understanding of the effects of environmental conditions on collections objects and the management of climate control systems has advanced significantly. We have debunked the principle of fixed environmental set points for temperature and relative humidity and begun to implement new practices across the field. This has required nothing less than a sea change in our approach to environmental conditions for collections. The process of letting go of a set standard for collections environments of seventy-degree temperature, plus or minus two degrees, and 50 percent relative humidity, plus or minus 5 percent, sometimes called the plus/minus dilemma, is transforming the field. We have come to recognize that the base of that standard was a systems-design approach rather than a collections-need approach. We have begun to develop technology and practices that support a more thoughtful, more appropriate, and more energy-efficient approach to providing appropriate environmental conditions for protecting our collections and sustaining our work to protect those collections.

The International Institute for Conservation of Historic and Artistic Works (IIC) said it best:

> While many factors influenced what became standards, the narrowest range of conditions and the greatest insistence on them, came when energy was relatively cheap, global climate considerations were not yet mainstream discussions, and the technology of HVAC [heating, ventilation, and air-conditioning] systems was focused more on control than efficiency. Given the looming energy crisis, the global economic downturn, and the rising awareness of green technology equating to good stewardship of our natural resources, responsible and efficient environmental control has become essential.

To advance this, the IIC worked with the American Institute of Conservation to host a roundtable discussion, in London in 2010, to review the adherence to these strict standards as a condition of art and artifact loan agreements.[2] Major collecting and research institutions have brought their weight to bear on this conundrum, and the result is a growing field-wide reassessment of what to consider as appropriate conditions for collection preservation, and the development of a significant amount of data reflecting the actual response of materials found in collections to the temperature and humidity conditions in which they are stored over time. This reassessment has stimulated a wide range of learning, which is being shared through books, articles, and conferences.

Ideally, the system should aggregate information so that you can study conditions in collections areas and make informed decisions about storage locations, collections care, and energy use. The Image Permanence Institute's (IPI) system for monitoring conditions and aggregating the information for thoughtful decision-making is perhaps the best there is for this type of work. It is based on fifteen years of testing and research on the impact of environment on the rate of decay for collections materials (metal, paper, skin, fur, wood, paint, etc.), and on an understanding of the way mechanical systems maintain and affect storage environments. IPI continues to build on this body of knowledge and share it with the field. The National Endowment for the Humanities (NEH) continues to sponsor two-day conferences around the United States on sustainable preservation practices for managing storage environments. The stories in this chapter most often include work from IPI. The IPI's *Guide to Sustainable Preservation Practices for Managing Storage Environments* is a must-have for every institution holding a collection.

John Mayer, curator at the Maine Historical Society, adopted IPI's system when he needed to upgrade environmental monitoring equipment. Energy efficiency—or at least this possibility—"was an unexpected (but welcome) benefit" of a collections project at the Maine Historical Society. The existing environmental monitoring system using HOBO data loggers (Onset Computer Corporation, Bourne, Massachusetts) was being phased out by the provider. With no technical support, and data loggers needing retirement, curator John Mayer began looking for the next-generation approach to monitoring climate conditions. The existing HOBO system had proven to be very economical, easy to implement, and offered reliable accuracy; finding a replacement might be a challenge, but Mayer hoped that a digital or perhaps wireless approach would offer him a new system with improved ease of use.

The research process involved a survey of available systems, talking to vendors and colleagues including the institution's consulting conservator, and to Richard Kerschner at Shelburne Museum, whom he knew from

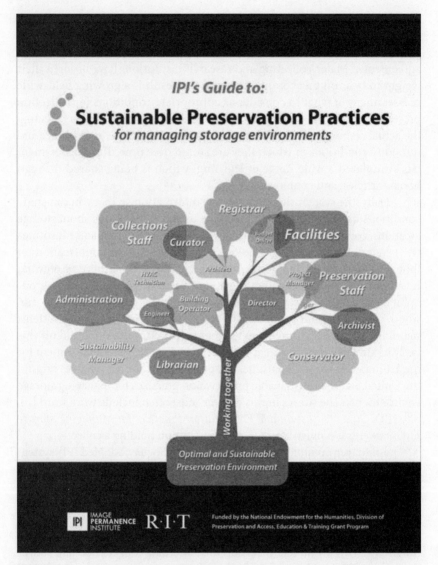

FIGURE 4.1. Image Permanence Institute (IPI) sustainable preservation practices handbook cover. It is the go-to book for the field.
Courtesy Image Permanence Institute.

previous work. This led Mayer to the IPI. Their PEM2 data logger partnered with the eClimate Notebook web portal was strongly recommended. Mayer was concerned initially that such a program would be time consuming to use and perhaps too complex technologically. Instead, he discovered it was easier to use, took less time to collect and upload data, and produced reports more easily than the old system. The reports from eClimate Notebook increased everyone's understanding of environmental conditions, performance of the HVAC system, and how those conditions affect collections. The data loggers record temperature and relative humidity at specific and constant intervals; Mayer collects the data on a flash drive monthly and uploads it into eClimate Notebook. The software can convert the collected data in a variety of ways that interpret the effects of climate conditions on the collection.

For example, one critical measurement is the dew point. Dew point represents the temperature that water in the air will condense on surfaces. It matters more than temperature or humidity, but it isn't something any of us finds on the recording hygrothermographs tucked into corners or hidden behind period room furniture. It's a complex calculation. Air can hold more moisture when it's warm than when it's cold, but that doesn't mean the amount of water it actually holds will change when the temperature changes—just the capacity will change. So we're dealing with *absolute* humidity if we're measuring the amount of water actually present in the air. If we're measuring *relative* humidity, then we're measuring the relationship, the comparison, between the amount of water air *can* hold and how much it actually is holding. (The pneumonic for remembering this is "actual for absolute; relationship for relative.") When you change temperature, which is what is easiest for any of our mechanical systems to do, you change how much water the air *can* hold, not how much is in it. If you change the temperature to the point where the air can hold less water than what is in there, you drive the air to a new dew point and the water that the air cannot hold any longer condenses out of the environment. Knowing when you'll hit dew point is what matters. Mayer can tell that using the IPI data. The software illustrates exposure to risk and how collections materials could be degraded (or stabilized) based on environmental conditions. The Dew Point Calculator, free at http://www.dpcalc.org/, is a marvelous tool for assessing risk of natural aging, mechanical damage, metal corrosion, and mold to your collection based on temperature, relative humidity, and dew point. Go online right now and adjust the sample temperature and humidity to see how risk level indicators change based on conditions. IPI's system is a time-weighted preservation index that helps you quantify effects of conditions on your collection. It is an incredibly valuable tool for the collections manager, and it is immediately available using the software. This is as valuable as a budget for

the chief financial officer, attendance numbers for the education director, and gift income totals for the development director.

The system at Maine Historical Society has been in place not quite a year, so there isn't enough data yet to guide significant changes, but "the value of a monitoring program," Mayer says, is that "you build an understanding among your staff about your buildings and collections environments." He can take the eClimate Notebook reports, automatically formatted into a PDF, and share them electronically. The more information available to staff, "the easier it will be to build knowledge to apply to varying situations and make informed decisions about collections care," he says. Where before only two staff members would look at this data regularly, Mayer and the facilities manager, now the librarian and the director, can be easily informed and included in the discussions. This leads to a greater understanding and a willingness to allow adjustments, which improve energy efficiency while upholding collections care standards.

Already, the monitoring program documented some ways that the HVAC system is not working as intended, allowing Mayer and the facilities manager to investigate and make repairs that, at a minimum, made this expensive system work better. The building manager found places in storage areas not properly sealed, and also used the monthly charts to fine-tune the HVAC systems with our equipment maintenance company. This is a common early benefit of a monitoring system. Even before a significant time period, you have a window into operations that allows you to make smart improvements right away. The purchase, installation, and training was funded by a $5,300 Preservation Assistance Grant from NEH. The grant covered the costs of equipment, a five-year subscription to eClimate Notebook, and consulting support for setup plus a six-month review.

The NEH's Sustaining Cultural Heritage Collections grant program funds the next levels of work at historic sites and history museums (and other cultural sites) through planning and implementation grants. The program encourages an integrated approach to assessing environmental conditions and systems, and to designing and implementing solutions. For case studies mentioning planning projects supported by NEH, see the National Society of the Colonial Dames of America's Dumbarton House project in chapter 2, and the Minnesota Historical Society project in the following. Or, to read more about these projects and others, including implementation projects at the Litchfield Historical Society in Connecticut, Winterthur Museum, Garden, and Library in Delaware, and for the State of Georgia, consult the program page at the NEH website for successful proposals and white papers provided by grant recipients.

MINNESOTA HISTORICAL SOCIETY, DYNAMIC DATA, AND REAL-TIME SUSTAINABILITY

Shengyin Xu and Matt Hill

"With an environmentally sustainable approach to our organization, will we be able to truly power our mission."

—Matt Hill, Manager, Arts and Cultural Heritage Fund,
Minnesota Historical Society and early Green Team member

Introduction

The Minnesota Historical Society (MNHS), with its mission of "Using the power of history to transform lives," is committed to institution-wide sustainability for its twenty-six historic sites supporting over seven hundred staff, twenty-four thousand members, and seven hundred thousand annual visitors.[1] Since 2005, it has proudly reduced energy in its largest museum building, the Minnesota History Center, by 50 percent. In addition, energy, waste, and water reductions since 2010 will save the institution $1.8 million in overall utility costs by 2015, while reducing greenhouse gas emissions by 15 percent. These outcomes are due to the dynamic integration of data to guide program strategy and tactics. Utilizing energy, waste, and water consumption tracking, as well as other resources measures, this sustainability approach balances costs, environmental impacts, institutional mission, and serves as a model for historic sites, museums, and other cultural organizations.

Staff Start-Up to C-Suite Effort

In 2006, a group of concerned and interested staff from various sites and departments across the institution gathered around a desire to address sustainability in their work areas. This informal "Green Team" group had many early initiatives including composting and managing paper resources, but quickly recognized the need to shift toward institution-wide change. When a funding opportunity arose in 2008, the group was able to leverage a grant of $125,000 to create a formal institutional sustainability program. With resources and institutional approval to proceed, the Green Team looked to address "the institutional use of energy" but also saw it as the opportunity to "strengthen the financial bottom line of budgets in the current economic times ... and provide ... lasting benefits."[2]

With the formalized program, sustainability needed to be considered at an institutional scale. Given the wide range of ages, scales, and types of buildings and sites that the MNHS owns and operates, a natural fit for managing sustainability was to incorporate a consistent metric that would cross-cut the entire operations. The use of greenhouse gas emissions as the primary metric for sustainability allowed the Green Team and sustainability program to set targets, establish baselines, and demonstrate success of initiatives. It also introduced a new process of decision-making that would be much more rooted in data.

As the sustainability program gained momentum in proving success of building upgrades and engaging staff in energy, water, and waste efficiency, the organization began to consider the role of sustainability *before* buildings were built or renovated. The organization made sustainability an integral function of a new facilities and risk management division rather than a separate grant-funded initiative. As part of that shift, sustainability is now combined with capital projects planning. The move allows the program to not only be involved in exploring initiatives for existing buildings and structures, but also to embed sustainability in the early planning and design for new construction, major renovations, and asset preservation projects.

In addition to the extensive facility and operational initiatives, this approach also looks to engage staff and visitors in sustainability, and has created an ongoing campaign titled "More for the Mission" since 2011. The campaign helps to cultivate staff and visitor buy-in for building and operational changes, and encourages staff to participate by changing their consumption patterns at work. The result is an overwhelmingly positive response from staff and significant impacts. For example, at the time of this

publication, the "Take the Stairs" campaign leveraged a planned shutdown of one of the elevators for a system upgrade to present energy, caloric, and time savings by using the stairs. After three months, staff surveyed estimated a 37 percent reduction in elevator use for health, convenience, or environmental reasons. Continuing the campaign beyond the elevator upgrade will also be an important engagement opportunity, as the potential for reducing annual elevator use by 20 percent could save $2,400 in electricity bill costs. This is a shift any historic site, museum, or cultural organization with an elevator can make.

Data-Driven Dynamic Sustainability

One of the primary steps for any history and cultural organization interested in sustainability is to bring a consistent, organization-wide approach to their range of programs, facilities, and collections. Consistency allows for data to be analyzed and benchmarked across diverse activities, spaces, and objects. As many sustainability professionals and academics note, "meaning emerges through analysis. The utility of data for conveying information to different stakeholders broadens and becomes more powerful as data are condensed."[3] As an organization, MNHS agreed to move forward with greenhouse gas (GHG) emissions, measured in kilograms of carbon dioxide equivalent, as the primary metric to track and communicate institutional progress toward sustainability goals. The metric was selected for its wide adoption by cities and large-scale organizations. Its popularity is underscored by the presence of literature and protocols for calculations, including the publications and resources by Intergovernmental Panel on Climate Change, calculators and tools by the World Resources Institute, and data and resources from the U.S. Environmental Protection Agency.

In addition to GHG emissions, the MNHS sustainability program also tracks capital costs, maintenance costs, and operating cost savings. Using these metrics encourages the inclusion of other program-centric metrics, such as visitor attendance and potential educational impacts, information that is readily available as part of an ongoing program evaluation effort.

Sustainable Operations is a Moving Target

Across the MNHS's twenty-six historic sites, there is a wide range of structures, building materials, and collections assets. MNHS sites accommodate a multitude of activities, such as living history, classroom activities, lectures,

research, interactive exhibits, and historic artifact displays, to name a few. The Minnesota History Center site also houses sophisticated storage formats and conservation laboratories, in addition to typical museum visitor services, retail spaces, cafés, and event rental spaces.

In combination, these various activities, different building types and system capacities, and the operations of historic sites and museums demand a data rich and dynamic operational strategy. However, a big challenge still remains in achieving a consensus for the specific standards that satisfies concerns about short-term risks, long-term preservation of collections and buildings, as well as energy efficiency.

To answer the challenge, the effort to reduce set points at one of our sites, the Charles Lindbergh Boyhood Home, a National Historic Landmark in Little Falls, Minnesota, demonstrated the challenge of arriving at the actual set points that would achieve both preservation standards and energy efficiency. The initial effort to adjust set points at several of the MNHS sites began in facilities, but expanded to include staff from collections, conservation, and exhibits. Once this interdepartmental team came together, it became clear that even five degrees Fahrenheit change had significant value in terms of sustainability. For a low cost implementation (e.g., staff time), the potential savings in one year was about five hundred to six hundred dollars. Supplemented with tools such as eClimateNotebook, the team came to the conclusion that the adjustment from sixty degrees to fifty-five degrees during unoccupied hours would be acceptable for the building and the collections, and would provide an incremental step toward energy efficiency at the site. Following the Lindbergh Home discussion, many of the other sites' set points were negotiated in a similar manner: balancing energy savings potential with long-term preservation and facilities maintenance concerns.

While the effort to transition to more sustainable building operations began incrementally, it has made significant progress toward convincing MNHS staff of the value of data for organizational planning. These early energy-reduction proposals have become a larger discussion of a comprehensive maintenance protocol for all MNHS sites. Sustainable operations are an ongoing effort, with challenges embedded in the process as evolving tools and more stakeholders being incorporated. However, the early heating set point discussion was a small stepping-stone toward this larger, much more effective planning action.

To date, a single protocol approach of operations is still widely utilized for its simplicity: operate museums at seventy degrees and 50 percent relative humidity in all cases and at all times to protect historic collections, materials, and archives. However, attitudes have been shifting away from

this approach. Studies from 1979 by the Canadian Conservation Institute have been concluding that seasonal adjustments of these set points can provide acceptable conservation environments and help reduce energy consumption.[4] The specific extent of these variations continues to be debated, but there is strong evidence that wide fluctuations of temperature and some short-term fluctuations of humidity have little impact on long-term preservation horizons of collections. The Image Permanence Institute's research has shown that it is sustained high temperatures and shifts of sustained high humidity to sustained low humidity that may cause significant problems for long-term preservation of materials.[5] To take the research into practice, MNHS, through the support of a grant from the National Endowment for the Humanities, is investigating multiple protocol approaches to systems configurations for collections and historic building materials that achieve both long-term preservation and energy reductions.

Lighting Is Not "One-Size-Fits-All"

Lighting was one of the first questions that MNHS staff asked about in the early stages of the sustainability program. Unlike heating and cooling systems, lighting is a more approachable and accessible system for most people to address. However, the professional opinions about the technology had opposing views on this subject and thus required additional study to best determine an approach. Through an energy efficiency–focused lighting study, the data for MNHS surprisingly showed variations in payback periods of three years (return on investment of 33 percent) to over fifty years (return on investment of 2 percent). While any project that has any energy savings returns may be worthwhile, with limited resources to invest in all projects, the payback periods that were less than ten years were prioritized. In particular, those that were five years or less were considered the "low-hanging fruit."

The wide range of lighting issues presented to MNHS underscored the importance of data and analysis. Utilizing GHG emissions, cost, and occupancy figures, different lighting options were evaluated. For example, Split Rock Lighthouse Visitor Center, with a relatively high visitor rate for the eleven-thousand-square-foot building, was a candidate for not only more energy efficient lighting, but more effective lighting of the space. There were many dark pockets and ineffective existing lighting strategies within the public spaces of the Visitor Center. The lighting study investigated an LED light bulb retrofit. With the existing fixtures able to accept an LED bulb replacement, the investment cost for the project was relatively low at four thousand dollars. The savings payback was about three years (33 percent return on investment). After installing these light retrofits, an unexpected

benefit was the reduction in directional heat from the light compared to incandescent bulbs, which reduced the cooling requirements for the space.

Comparatively, the Minnesota History Center, a modern museum building with 480,000 square feet of exhibits, collections storage, conservation laboratories, classrooms, retail, cafés, and offices, also wanted to reduce energy at a large scale by investing in efficiencies throughout the large building. The study for the History Center looked at lighting projects that could range from three hundred thousand dollars in investment costs to as little as two thousand dollars. The data helped prioritize the three hundred thousand dollar project, which included a major upgrade of all 2×4 fluorescent office lighting at the History Center. The scale of the project alone contributed to the high price tag, but the annual energy savings potential was twenty-six thousand dollars, which is a payback period of twelve years (return on investment of 8 percent). This payback was just outside of the ten-year criteria, but the existing light fixtures were also twenty years old and the timing aligned with a larger need to consider obsolescence phasing. More importantly, the metrics helped justify the higher investment cost by clearly articulating the opportunities in energy and cost savings.

Despite the success of the two lighting projects in securing support and funding for implementation, there were lighting projects that were deprioritized because of the data. Prior to the lighting study, there was a lot of interest in lighting in the collections storage areas. While not a high occupancy space, the areas still required a high quantity of light fixtures for staff access to collections. The data from the study indicated that the cost for the upgrade would be significant—over $100,000—yet the annual savings was estimated to be only $4,700 a year for a payback period of more than twenty-one years (return on investment of 4 percent).

Investigating both the data as well as other performance issues around lighting produced very mixed conclusions for a best practice; it really depended on the context of the lighting installation. As such, one of the long-term goals of the project is to produce tools and resources that allow nonsustainability professionals to estimate lighting impacts, thereby helping them evaluate their own projects. The goal of this tool is to one day extend this resource to other history and cultural organizations to support the most sustainable lighting strategies.

A Continuing Journey of Collaborative Design

A key focus of the MNHS efforts is to communicate that sustainability is not a onetime effort. History and cultural organizations must recognize that their facilities and operations are always evolving and changing, and often

external factors are continually shifting sustainability targets and goals. While this may be daunting, data and collaborative processes make it manageable and also offer higher-quality project outcomes.

MNHS sustainability efforts have not only implemented a wide range of building, operations, and engagement projects, but have also allowed for different methods of working on interdisciplinary and collaborative teams. The examples of sustainable operation, set points, as well as lighting upgrade decisions, each had different teams and departmental representation. Each used many communication tools, ranging from different meeting formats to collaborative production of documents and data analysis. As such, the efforts discussed help to reveal that these programs work when short-term projects and engagement initiatives are matched up with long-term strategies and planning, regardless if it relates to facilities, operations, or mission.

While data is central to the MNHS's sustainability program, another common thread through the program is the importance of collaborative processes. Inherently, sustainability reflects on the need to not only replace equipment or upgrade buildings, but also approach institutional projects holistically. As Achim Steiner, leader of the United Nations Environment Program, said, "What we need is a new ethic in which every person changes lifestyle, attitude and behavior."[6] The National Endowment for the Humanities also recognizes the importance of deploying a broad set of skills and knowledge bases to these sustainability and preservation challenges. Their Sustaining Cultural Heritage Collections Grants note that "only interdisciplinary teams can solve … complex preservation challenges,"[7] such as the ones they support with their grant program.

Concluding Thoughts and Next Steps

As history organizations continue to integrate sustainability into the priorities and operations of the organization, there will be an ongoing need to refine these processes to be more transparent and accountable to the data. Any history or cultural organization must recognize that these processes take time on the front-end, but often help build support and make implementation more effective. Ultimately, the long-term outcomes of the program will not only be energy- and waste-reducing initiatives, but new processes to work across departments and with new partners.

In the short term, there is more work to be done with both existing buildings and continuing to engage staff and visitors in the institutional sustainability projects. In the long term, there are many new efforts to be undertaken, including scaling-up building efficiency projects, purchasing

and contracting with sustainability criteria, and the continued reinforce-ment of the use of metrics to support decisions. The long view is an ongoing effort, one that recognizes and integrates participation with sustainability in daily operations and broader strategic planning.

Notes

1. Based on fiscal year 2013–2014 data collected by the MNHS and shared via https://sites.google.com/a/mnhs.org/evaluation-resources/dashboards/operations.

2. MNHS Green Team, "A proposal for adopting institutional sustainability practices at the Minnesota Historical Society," Internal draft document, 2009.

3. Shields, D. J., S. V. Solar, and W. E. Martin, "The role of values and objec-tives in communicating indicators of sustainability," *Ecological Indicators* 2, no. 1–2 (2002): 149–60.

4. Michalski, S., "The ideal climate, risk management, the ASHRAE chapter, proofed fluctuations, and toward a full risk analysis model," Contribution to *Experts' Roundtable on Sustainable Climate Management Strategies in Tenerife, Spain*, pro-vided by the Getty Conservation Institute, 2007.

5. Image Permanence Institute, *IPI's guide to: sustainable preservation practices for managing storage environments*. (ver. 2). (Rochester, NY: Author, 2012).

6. As quoted by Robert Ivy in "Shifts in the architectural climate." *Architectural Record*. (December 2007). Retrieved from http://archrecord.construction.com/com-munity/editorial/archives/0712.asp.

7. National Endowment for the Humanities, *Sustaining Cultural Heritage Col-lections Guidelines* (CFDA Number 45.149), 2013, http://www.neh.gov/grants/preservation/sustaining-cultural-heritage-collections.

The IPI, along with the IIC, the American Institute of Conservation, and the Canadian Conservation Institute (CCI), are just four organizations that promote the new approach to understanding the impact of the environment on collections. The IPI has shown how and why conditions of 50 percent relative humidity and 70 degrees Fahrenheit, even with a bit of fluctuation, is not a necessary standard for storage climates, and is a wasteful and expen-sive use of energy resources.

What affects collections most is prolonged exposure to heat or cold or humidity, not short-term fluctuations. According to the IPI's *Guide to Sustainable Preservation Practices*, "Sustained high temperatures have a much more significant impact on the stability of collection materials than do temporary spikes or wide fluctuations of temperature,"[3] and "Periods of

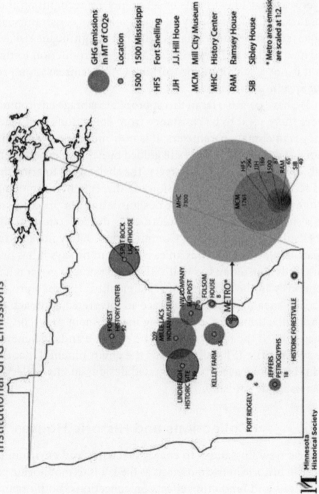

Minnesota Historical Society Metrics
Institutional GHG Emissions

Minnesota
Historical Society

Map legend:

GHG emissions
in MT of CO2e

○ Location

1500 1500 Mississippi

HFS Fort Snelling

JJH J.J. Hill House

MCM Mill City Museum

MHC History Center

RAM Ramsey House

SIB Sibley House

* Metro area emission bubbles
are scaled at 1:2.

Map labels:

SPLIT ROCK LIGHTHOUSE 121

FOREST HISTORY CENTER 92

MILLE LACS INDIAN MUSEUM

NW COMPANY FUR POST 170

FOLSOM HOUSE 8

METRO*

LINDBERGH HISTORIC SITE 145

KELLEY FARM 54

FORT RIDGELY 6

JEFFERS PETROGLYPHS 18

HISTORIC FORESTVILLE 7

MHC 7361

MCM 1061

HFS 156
JJH 118
1500 97
RAM 65
SIB 40

MAP 4.1. Map of annual greenhouse gas emissions for each of the Minnesota Historical Society's sites. The bubbles represent the relative magnitude of emissions, measured in kg of CO_2 equivalent. The sites within the Twin Cities metropolitan area are at a 1:2 scale relative to the sites in greater Minnesota. These maps give the Society a snapshot of performance across its network of buildings and facilities; they also help communicate our efforts to staff and encourage new conservation programs. Courtesy Shengyin Xu.

sustained high humidity in the summer and sustained low humidity in the winter are much more significant in terms of preservation than sudden or short term fluctuations in [relative humidity]."[4]

The field's research on collection materials' responses to different conditions is significant. The CCI describes "classes of control" for environmental conditions found in buildings ranging from "AA" with precision control to "D" with moisture control only.[5] Each category of building below "AA" introduces increasing levels of risk to the collection, risks that we understand more fully and can predict quite accurately. The CCI website describes specifics of ranges for temperature/relative humidity, and seasonal and short-term allowable fluctuations, noting that "The larger seasonal adjustments in set points are recognition that even major museums must face energy and sustainability constraints, and that these suggested temperature changes are not a significant risk." The material provided on the CCI website is a helpful introduction to these concepts, but it is not a substitute for working with a conservation professional on your specific conditions.

We have come so far in this approach to storage environments that now, where there used to be resistance from collections staff when discussing changes to climate parameters, it is now more common to find resistance among HVAC professionals still guided by habitual expectations of set point goals as simple and defined targets. The challenge is to bring these engineers and technicians into a discussion of different environmental parameters, recognizing the change in the design-definition process, and sharing in the responsibility for a best solution for the collection. At the Pennsylvania Historical and Museum Commission in Barry Loveland's architecture department, this work was an easy sell, and he says it has become easy to work with consultants as well. "The profession in general has moved tremendously in the direction of sustainability." For each project, it's critical to create a team willing to embrace an integrated approach to designing a smart collections care, or building management protocol. It may be time consuming at the outset, but will be effective and efficient over the life of the system. The IPI staff calls this the environmental management team, and it's a crucial aspect of integrated design, quality collections care, and sustainable stewardship.

Collections and Historic Houses

Historic New England is to energy efficiency and environmental sustainability in historic house museums as the IPI is to monitoring environmental conditions and predicting effects on collections. Both organizations have

been thoughtfully supported by the Institute of Museum and Library Services and the NEH in their research and in developing programs to share with the profession. Historic New England staff shared their findings at a roundtable held to foster a dialogue with professionals on improving relative humidity control in historic house museums in New England. The roundtable attendees developed some important basic guidelines that are useful for historic house museums everywhere:

- Design environmental controls and HVAC systems that are understood by those responsible for the day-to-day site management.
- Keep it simple, especially the controls.
- Use local contractors who understand the proposed systems.
- Require as-builts (documentation of how something was built as opposed to how it was designed) from all contractors (equipment as-builts and control as-builts), and create a system manual.
- Review and update system documents at least annually.
- Do not install any systems unless there is staff expertise available to monitor and troubleshoot the systems after the project is completed, and funds are available to maintain and update software as required. Staff turnover can be very costly unless the new staff member is well versed in the systems.
- Continue reliable temperature and relative humidity monitoring after the systems are installed.
- Design systems to fail to a safe mode (i.e., heat turn off instead of overheat).
- Include minimum and maximum set safety points for temperature and relative humidity with failsafe mechanical cut-offs.[6]

These principles reflect a functional and commonsense approach to managing building environments. The Pennsylvania Historical and Museum Commission is testing "low-tech" mechanical system enhancements at historic sites that improve controls and environmental conditions without structural or major mechanical changes. At Hope Lodge in Fort Washington, Pennsylvania, staff installed dehumidifiers and air transfer fans to move air vertically between floors within the building. They use digital controllers and sensors that monitor environmental conditions and to sense temperature and relative humidity levels in spaces and between floors and to control the dehumidifiers and fans "to regulate the temperature and relative humidity as close to the desired range as possible." With furnishings and collections throughout the spaces, this allows for less intrusive yet effective control.[7] It aligns with Jeremy Linden's statement that the field's goal is

"optimal preservation that achieves the best possible preservation of collections," which includes historic structures, "at the least possible consumption of energy, and is sustainable over time."

Each of us, in our complex and overextended work situations, is more likely to achieve *and sustain* quality programs with the simplest or most-direct approaches to collections care. Working with an interdisciplinary team of professionals from outside and staff from inside your museum, you can analyze and understand current systems and then consider a phased approach so that you can learn and make changes in stages. Just as in greening an entire institution, begin with the low-hanging fruit and move through change in stages. Michael C. Henry, of Watson and Henry Associates, at a conference presentation on this work, pushed for steady, simple steps when he said, "Go for the base hits: fill the bases, then go for the home run." Sally Zimmerman, of Historic New England, and also on the panel, said, "Best is the enemy of the good." Big and fancy is not your goal; careful and thoughtful is.

Most sites have collections items stored or displayed in a mix of more modern storage or exhibit areas, and historic structures. For energy efficiency and environmental management, the biggest challenge for historic house museums, says Henry, is "the need to condition the interior environment for conservation of collections" while also "dealing with authenticity for environment and preservation of the building fabric. . . . Do we trade authenticity for visitor comfort? How do we balance an opportunity to tell an environmental story versus what protects an object? Perhaps in today's world, an authentic environmental experience is as valuable as seeing the actual object."[8]

The Historic New England staff is working with this conundrum of balancing the importance of historic settings with past assumptions of environmental control standards.

> The essence of a historic house museum and a goal of our historic property interpretation is for the public to experience, in a real and personal way, the way the lives and stories of the individuals and families who made New England what it is today. Despite the fears of a potentially unstable environment for the objects, it is important to think about the objects in the following terms:
>
> - It is important for us to leave the objects in situ as the family owned and used them. In fact, removing the objects to a "museum environment" would be pointless for a large number of the objects

because their real value is in context next to the other items used by the family.

- These objects have been exposed over their lifetime in the structure to conditions that have always been unstable when compared to a traditional museum environment.
- The majority of objects have a low risk of damage due to the conditions at the houses.[9]

Understanding construction materials, building orientation, the landscape setting, roof and window design, presence of porches and cupolas, and use of awnings and shutters and transoms can help you understand how the building was designed to be energy efficient in its original setting, and how you may be able to use that to your advantage now. Depending upon your interpretive situation and the objects in these spaces, you may be able to take advantage of these passive approaches to creating comfortable spaces. It may mean restoring transom hardware so you can open them for air circulation—and talk about them with your visitors. It may mean restoring the shutters and using them to block sunlight so you can cool the room and add light protection for the collection—and talk about shutters with your visitors. These affordances may be the least expensive and the least complicated approaches to energy efficiency and the greatest opportunity for audience engagement through an authentic experience.

Let's imagine a situation: an 1860s house, closed up for air conditioning, with no air movement through open windows and doors, is not an authentic experience. Does the public learn how a window and its weighted sashes was designed to work? Do they notice the transoms and their value for air circulation? Probably not. These management choices are made in the name of climate control and do not reflect the way the house was used or lived in. Have the objects in this house been exposed to open air conditions for significant periods of their existence? If so, then they are unlikely to be compromised by any thoughtful changes now. Is there an opportunity to improve the visitor experience if environmental standards are relaxed appropriately? There is, if you can use the structure and its original design intent to help the visitor understand how the building and its components were designed to function in the regional environment where it was built.

This does not mean, at all, that you should throw open the windows and doors, and abandon environmental climate control. It means you have new tools and knowledge to make better choices. It is not simply about target numbers, so avoid what some call "mindless monitoring"—monitoring for the sake of monitoring, not for decision-making. Consider your choices

using professional values and accurately collected data based on collections needs, building history, and the desired visitor experience. *Then* make a decision. The answer is very probably more environmentally sustainable than the work you do now.

As professionals, we must choose based on a mix of often competing, but sometimes complementary, conditions: energy consumption, conditions needs for objects, selection of objects based on energy and conditions, interpretive needs, display opportunities and alternatives, and, of course, institution and/or site mission. As professionals, we use our expertise and those of others to make the best decisions possible for our mission, our collections, and our institutions as we can at the time given the resources and the knowledge at hand. We are responsible for making thoughtful choices, not choices blinded by rules of thumb. Henry has been known to point out that, "If you use recipes, you might overlook the opportunities."

Microclimate Thinking

The environmental consultant William P. Lull of Garrison/Lull Inc. says the goal for collections staff is to implement "progressive environmental control"; systems that are responsive to the collection's needs are the most appropriate for the institution.[10] We have reviewed macro collections conditions and historic house conditions, but have not yet explored microclimates and passive environment management solutions. Sometimes, the most sustainable solutions of all, from energy and cost viewpoints, are passive micro- and buffered climates. An acrylic case with silica gel, an archival storage box, a framed sealed package, and a fireproof safe all provide affordable passive, buffered climates appropriate for certain objects. Costs are limited to original materials and installation, not ongoing energy expenses. The objects are subjected to micro conditions that do not change at the same rate as the exterior or macro conditions change. So, if the temperature or humidity changes in the exterior space, there is a delay before the change reaches the contained materials, if any change occurs at all.

Where you have collections that require more protection from environmental changes than an existing HVAC system can provide, a microclimate may be a solution. Some call this "containerizing" collections. Compact storage, or high-density mobile shelving, often used for efficiencies of space use, is a larger-scale example of a microclimate. A shelving system such as Spacesaver (Fort Atkinson, Wisconsin) creates microclimates for collections when the shelving units are closed against one another. Some systems are designed so that most sections close tightly as staff and visitors access a few

sections, and can be programmed to automatically open slightly between all shelves to allow air circulation at night, if appropriate for the collection. For many institutions, though, these large-scale mechanical options are not realistic. Instead, we use fireproof safes for some archival materials, we add silica gel to acrylic cases donated by larger museums changing their exhibit furniture, and we use metal shelving for archival storage in the best location possible. Fair enough; just remember, if your document boxes have handholds in each end, and are stored on open shelving, the box interior is not a microclimate!

Whatever your choices, these, as with environmental control systems, are complex and require onsite analysis by object conservation and building preservation professionals. What you read here cannot substitute. This chapter merely prepares you to work with your professional advisors.

Notes

1. American Association for State and Local History, *StEPs Workbook: Standards and Excellence Program for History Organizations* (Nashville, TN: Author, 2009).

2. "The Plus/Minus Dilemma: The Way Forward in Environmental Guidelines," The International Institute for Conservation of Historic and Artistic Works, May, 12, 2010, accessed September 13, 2014, https://www.iiconservation.org/node/1234.

3. Patricia Ford, *IPI's Guide to Sustainable Preservation Practices for Managing Storage Environments* (Rochester, NY: Image Permanence Institute, Rochester Institute of Technology, 2012), 14.

4. Ibid., 15.

5. Conservation Institute, "Classes of Control," January 9, 2014, accessed September 14, 2014, http://www.cci-icc.gc.ca/resources-ressources/carepreventiveconssoinsconspreventive/controls-niveaux-eng.aspx.

6. Historic New England, "Roundtable looks at simplified environmental control systems in historic house museums," accessed September 13, 2014, http://www.historicnewengland.org/about-us/whats-new/roundtable-looks-at-simplified-environmental-control-systems-in-historic-house-museums.

7. Barry A. Loveland, "Pennsylvania History Goes Green," *Pennsylvania Heritage*, Spring 2009, accessed September 15, 2014, http://www.portal.state.pa.us/portal/server.pt/community/energy__impact/4701/phmc_conservation/471379.

8. Michael C. Henry in conversation with the author, July 11, 2014.

9. Historic New England, "Environmental Conditions in Historic House Museums," accessed September 13, 2014, http://www.historicnewengland.org/preservation/preserving-historic-sites/property-care-white-papers/environmental-conditions-in-historic-house-museums.

10. Building Museums conference presentation, 2012.

Resources

Grattan, David, and Stefan Michalski. "General Care and Preventive Conservation." Canadian Conservation Institute. Last modified August 13, 2013. http://www .cci-icc.gc.ca/resources-ressources/carepreventivecons-soinsconspreventive/index -eng.aspx. The CCI is a Special Operating Agency of the Department of Canadian Heritage. It is chartered to promote the proper care and preservation of Canada's cultural heritage and to advance the practice, science, and technology of conservation and in so doing supports United States heritage professionals in similar work. Its representatives often participate in the NEH-funded Sustainable Preservation Practicing for Maintaining Cultural Heritage Collections conferences in the United States.

Historic New England. "Energy Efficiency and Sustainability at Historic New England— Historic New England." http://www.historicnewengland.org/preservation/energy -efficiency-and-sustainability. Historic New England has a landing page for its energy efficiency and sustainability projects and research. It includes the Property Care White Papers, updates on speific projects, and links to past articles prepared by the staff. It is a marvelous resource.

Image Permanence Institute. "Image Permanence Institute Environmental Monitoring, Image Stability Evaluation and Sustainable Preservation Practices." Rochester Institute of Technology. https://www.imagepermanenceinstitute.org/. The IPI is a nonprofit, university-based laboratory devoted to preservation research—the world's largest independent laboratory with this specific scope. The IPI provides information, consulting services, practical tools, and preservation technology to libraries, archives, and museums worldwide.

IPI's Guide to Sustainable Preservation Practices for Managing Storage Environments. Version 2.0. Rochester, NY: Image Permanence Institute, Rochester Institute of Technology. 2012.

❦

REDISCOVERING CONNECTIONS

Buildings, Land and Water, Plants and Agriculture, and Animals

Vision

Historic sites and museums protect and manage their settings in ways that care for and renew the buildings and the ecosystems of land, water, plants, and animals. They model and encourage embracing technology, science, and culture to repair the broken links between heritage and nature.

This chapter has a great deal of material about plants, animals, and the landscape. Please read these pages even if you don't have any of these resources to interpret—you still have connections to them. For example, we all have too many spinning wheels—why are there so many? Did every woman get up and walk away from them at once? Well, when mill manufacturing took over processing fiber, there was a sea change. How did that represent change in the relationship between humans and the environment? Was the new model more environmentally sustainable or not? Why? Has it changed much since?

Surely your collection contains photographs of nineteenth-century families posing in the farmyards with their horses, chickens, and cows. Someone, sometime, left your institution a county fair ribbon, or two, and winning recipes to go with them. Your photograph collection also probably reveals historical experiences with drought and deep-snow conditions, floods, and best-harvest-ever moments. Or what about glimpses of changing agricultural practices allowing you to compare how plow designs changed or how farms shifted from animal power to tractor power? Maybe you have more modern images depicting crop circles—the irrigated kind that dot the brown landscape with green but only where the long arm of the machine reaches. Whether or not you have animals and plants, your record of buildings and landscapes, and peoples' interaction with them, are valuable for interpreting the relationship between humans and the world they live in.

Buildings

Our buildings are often our most prominent features, yet as we have professionalized management, we have lost touch with some of their original design elements and become overburdened by the modern systems we have added. Managing historic properties appropriately means protecting them, and it also often means using them traditionally—both culturally and physically. Much like a machine, disuse contributes to deterioration. We let our professional practices of climate control lure us into artificially implementing new climate systems and conditions that do not reflect the building's heritage. We've forgotten about paperweights and window sashes, transoms and awnings. We don't let them do their jobs anymore. There's something lost in that. A great deal about environmentally sustainable practice is really reexamining how and why we do what we do. As we saw in the chapter on collections care, the climate control we strive for may not be necessary, possibly not even appropriate, for some structures.

Dan Snydacker, previously of Newport Historical Society, is anxious about institutional sustainability for museums and historic sites because "our built environment consumes an increasing amount of our energy, and yet our buildings are something we can fix quickly and efficiently. We should focus on using passive systems that our older buildings have built into them, and we should remember those old systems in those buildings." Sheryl Hack, executive director at Connecticut Landmarks, states that, "Museums have a responsibility to be better stewards, better leaders in areas of environmental conservation, reducing our footprint and conserving

energy. [New England] is behind in thinking about how we use energy and in our expectations for degrees of comfort. Historically, it was impossible to keep houses at [seventy] degrees."[1]

So how do you connect your present-day responsibilities to your visitors, collections, and structures, with historic use? The challenge can be divided into what works *for* you and what works *against* you. Physically use the building components that work *for* you; interpret what works *against* you. For example, if you have a site where the collections and the structure have long been exposed to temperature changes, breezes, and particulates in the air, and you can safely operate windows, shutters, and transoms, make it a part of your interpretive practice to use these affordances appropriately: open windows for cooling, use a paperweight to keep materials in place, or open a louver as the sun passes to the other side of the building. This is an act of interpretation and can be appropriate and valuable. However, if doing so works against care of the site, then interpret (describe and explain) those actions instead of completing them.

Here is another example for keeping cool. Air conditioning is for people and objects, much less so for structures. Very few were built to be cooled with electromechanical systems. What trade-off do you choose? Is there an opportunity to keep the structure cool in summer without air conditioning? Air conditioning is artificial but relatively invisible. A fan placed near a doorway in a nineteenth-century building is more intrusive, but it certainly consumes less energy than air conditioning. And a reproduction fan in a 1930s building would be a bonus for interpretation and limited energy consumption.

Your site may not have a planned landscape associated with it, and as a result any trees were cut down to make sure you were visible from the street. Well maybe it's time to thoughtfully add a few deciduous trees to provide shade and keep the house cooler in summer while allowing sunshine for warmth in winter when the leaves fall. It is energy efficient to plant that tree now to block summer sun and keep the building cooler in a few years from now than to leave the building barren like this. You may even be able to demonstrate that the original owners did the same if they valued trees over a view from the road. You, the staff, and your consulting professionals will decide if these approaches are appropriate for your building. If it suits your site, use it; if not, don't.

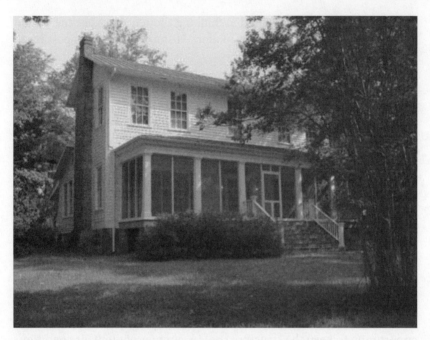

PHOTO 5.1. Andalusia Farm is 544 acres of contiguous habitat with 14 historic structures. The main farmhouse, where Flannery O'Connor lived and wrote all her published work, was built in 1850 in a classic "two over two" vernacular style. The four rooms are united by a tall central hall and reflect climate sensitive design with high ceilings, tall window openings, and a broad south-facing overhang for shade. Over a hundred year period, subsequent additions were made, including the installation of an attic fan in the 1950s. Today the house is operated without air-conditioning and, with solar gain mitigation and cross-ventilation strategies, kept fairly cool for its middle Georgia locale.
Courtesy The Flannery O'Connor—Andalusia Foundation, Inc.

DOWN ON THE FARM

(Re)Greening Flannery O'Connor's Home Place

Elizabeth Wylie, Executive Director,
The Flannery O'Connor—Andalusia Foundation

> "I am largely worried about wingless chickens. I feel this is the
> time for me to fulfill myself by stepping in and saving the chicken
> but I don't know how exactly since I am not bold. I only know I
> believe in the complete chicken. You think about the complete
> chicken for a while."
>
> —Flannery O'Connor

One of the best writers of the twentieth century wrote almost all her published work at Andalusia Farm, in Milledgeville, Georgia. Open to the public as an historic site since 2003, visitors come from all over the world to see the place that inspired Flannery O'Connor. Andalusia Farm was the writer's home from 1951 until her death in 1964 from lupus, an autoimmune disease. This is where O'Connor was living when she completed her two novels and two collections of short stories and numerous essays, all important and influential contributions to twentieth-century literature. O'Connor's writings have been translated into many languages and have been made into plays, films, and other media, and her work enjoys a worldwide following. Visitors to Andalusia come from across the globe. Our visitor log includes entries from Rome and Paris, the United Kingdom and Canada, Iraq and Japan. These folks are joined by visitors from all over the United States. Current strategies to grow our visitation and support base

include extending the visitor experience through preservation and conservation activities that demonstrate mission fulfillment and promote, for our guests, a deeper connection to the writer, her themes, and her characters.

The nonprofit organization that owns and operates the site stewards hundreds of acres with twelve historic structures ranging from simple sheds and barns to the main house, where the writer lived with her mother, who ran the farm. The 544 acres of contiguous open space is characterized by rolling hills, red clay, pine trees, and hardwoods typical of this part of the state. The property is divided into a farm complex (during the O'Connors' residence, it was a dairy farm and beef cattle were raised in the latter years), hayfields, pasture, manmade and natural ponds, and forests. Tobler Creek, a spring-fed waterway that feeds into the Oconee River, intersects the property. The core of the farm complex consists of the main house (a classic two-over-two 1850s farmhouse), the Hill House (a tenant house, perhaps the oldest structure on the property), the milk processing shed, water tower, pump house, a peafowl aviary, and the main cow barn, most of which have been restored/rehabilitated in the last ten years. Other buildings on the property exhibit varying degrees of disrepair resulting from the farm's closure in 1975, eleven years after the writer's death. Efforts are under way to rescue these threatened structures. The middle Georgia climate is subtropical and characterized by hot, humid summers and mild, dry winters. There is no air conditioning on site.

Trigger Story

I moved from Boston and arrived at the farm January 6, 2014, to be the organization's second executive director, and to push it to the next level in its maturation process. Expanded programming and visitor engagement are part of a suite of strategies to build our donor base and enhance visitation. Environmentally responsible practice is also on the agenda, as we seek to do the right thing while opening up new pools of funding. This is adding conservation to preservation to complete the stewardship circle. At this point, our green story is an aspirational one as we look to what can and should be done to minimize resource use, mitigate impacts, and restore natural systems.

In my first few weeks on the job, we felt the effects of the 2014 Polar Vortex, the cold wave that broke records across the country. It was in the single digits in Georgia, the propane heaters were blazing at the farmhouse, the pipes burst (thankfully there was no permanent damage), and we were worried about the farm's peafowl huddled in their outdoor aviary. The 1850s farmhouse, with no insulation and historic single pane windows, was cold!

Staff and birds survived, and I began hatching a plan to institute and educate about sustainable practice.

Getting Started

Now I say "plan," but this effort to date is not so much the classic, baseline assessment, planning, and implementation but rather, by necessity, a kind of brushfire approach wherein practice areas are tackled as we are able. With only two full-time staff, we have to make do with available resources. This is not to say we aren't committed to sustainable practice, rather it illustrates the situation so many museums find themselves in (i.e., little time for planning, mostly just doing). So we decided we would just "do" and get started, doing what we can as we are able.

First up was removal of the two window air conditioning units in the farmhouse. Not only had they leaked over time and damaged the windowsills, but there was massive air infiltration. Once the units were removed and the windows fully shut, freezing conditions in the house eased somewhat and slowed the rate at which we were burning through propane. Energy use is one of the most obvious functional areas to target for reductions. This small step was indeed small but it was a step. Now summer is here and we have not reinstalled the air-conditioning units. This of course reduces electricity demand but also provides us with an opportunity to educate about living without air conditioning. This is a quickly disappearing lifeway; we see it as part of the preservation story at Andalusia. We have begun to operate the house the way it was designed to operate in this climate with high ceilings and cross ventilation. Many of us remember our grandparents keeping shades or shutters closed during the day to minimize heat gain and then opening up the house late in the day to vent out. We have resuscitated the 1950s attic fan and many of our visitors remark on the memories triggered by the sound of the fan. Screens and screen doors have been rescued from the barn (or in some cases made) and reinstalled so we can fully open the house up for cross-ventilation while keeping out flying pests.

After the spike in water use due to the burst pipes, our water use has been minimized. Georgia, like so much of the country, has been experiencing drought. There is one bathroom on site, and its fixtures and faucets are in line for low-flow retrofitting. We are planning to install composting toilets as part of a rebuild of a shed structure that was partially crushed when a tree fell on it during the winter storms. The toilets will meet a critical need for more restroom facilities onsite and will offer both an educational opportunity and a source of material for a planned industrial composting operation. Last year's rains eased conditions, and this year is also looking

better but that should not encourage complacency. We do not irrigate or use sprinklers for the flower beds around the main house. Flowers, shrubs, and the lawn grass have proved remarkably hearty. We have reduced the frequency with which the grass is cut to keep it longer and able to hold more water. In the historic kitchen, we still use the sink to wash dishes. By using a simple dishpan, we can reduce running the faucet while washing. We have moved toward using (and washing) dishes, glasses, and metal cutlery for all hospitality. Again, this is in sync with our preservation mission and interest in demonstrating historic (and sustainable) lifeways. And we have given the supply of polystyrene cups to a local artist who runs workshops for art making from recycled materials.

Composting is a critical part of waste stream management, and we have begun on a small scale. All kitchen scraps and peafowl waste go into a "tumbling" composting barrel. Ultimately, this will become part of a larger operation that will turn organic material into compost. Removing organic materials and putting them to work is the first wave of managing waste; the second is recycling. This has been tremendously challenging. In the town of Milledgeville, there is residential curbside recycling. It is mixed stream but only certain items are allowed (newspapers, cardboard, aluminum and tin cans, #1 PETE and #2 HDPE plastics, and brown, green, and clear glass) and the farm is just outside city limits. We are therefore not inside the pickup zone and must take our recycling to the convenience center. The center has limited hours (hours we need to be manning the farm for visitors) and the same limited range of items it will accept. Six months in, I am only now just getting into a recycling rhythm and our new housekeeper is playing a role.

Surprise Opportunities

Housecleaning had not been a high priority when I arrived. After visiting another local historic house, I made note of their gleaming surfaces and dust-free air. I inquired about their housekeeping practices and was referred to their freelance housekeeper. She is now our once-a-month housekeeper. I taught her about green cleaning practices and products, and now the air quality in the house has improved. One frequent visitor who has asthma took me aside to comment on the dust-free environment. When the housekeeper saw our over-full recycling bin, she told us she lives near the county recycling center and would take our recycling. So now she is our housekeeper *and* recycling manager! Any materials that aren't allowed in the county convenience center are periodically loaded in my car and taken to a larger center in Atlanta (two hours away). Between composting and recycling, our waste stream is down to a minimum, with very little going to

the landfill. Next up? Educating our visitors with signage on the composter (kids love to turn the tumbler!) and clearly labeled public waste bins.

Education of course is a big part of sustainable practice. As many people (and businesses) as possible must adopt sustainable practices for the positive impacts to make any difference in the climate change faced by coming generations. Recently, I had a conversation with a volunteer who, as part of a group of "master gardener" students, wanted to use a chemical weed killer in the cleanup of our long-neglected flower beds. When I said that wasn't good practice, she looked at me blankly as if she had no idea what I was talking about. The next time she and her group were out, I shared information about the harmful health and environmental consequences of these chemicals. She was stunned and is sharing the information with her group. This happened just three days ago but has given me the idea that the program where they are taking their classes might need a nudge to cover sustainable gardening practices in their curriculum. Minimizing chemical use is good practice and has come into play with the pest control company on contract at the farm. Operating under a preexisting contract, the company was observed spraying something around the house. I asked the fellow carrying the big can and sprayer hose what it was and he just said "chemicals." I then asked for product specifications on everything he is under contract to dispense on the farm. Now we are studying the sheets and researching alternatives. Minimizing chemical use in every aspect of operations (inside and out) is important, and finding eco-friendly options sometimes involves relaxing your tolerance on what is acceptable, especially in a rural setting, while not harming people or collections. We are currently cultivating a feral cat who has been hanging around the farm. We hope to include it in our integrated pest management plan.

Continuing the Journey

We have a tremendous opportunity, with hundreds of acres, historic farm structures, and an unparalleled literary brand to weave together all themes—past, present, and future—to tell the story of the mystery of nature, creativity, and respect for the world in which we live. At Andalusia, the vestigial farm operation is just barely peeking out around the edges. Yet it is clear, from Flannery's essays, and letters and stories from local folks, it was an ongoing concern. There was also an underpinning of thriftiness and a certain do-it-yourself aesthetic. This attitude emphasized repair and reuse, and all aspects of the farm operated in sync (row crops fed the cattle, chickens and other fowl helped keep ticks and chiggers at bay while providing eggs and meat). Postwar farm policies and practices (increased use

of chemicals, industrial food production, monocultures, etc.) resulted in consequences we are just beginning to grasp today.

We expect to expand composting significantly, turning organic material into a resource by bagging it and selling it under the Andalusia brand. Currently, pilgrims to the farm purchase small jars of red Andalusia dirt. We figure there may be a market, then, for Andalusia (immaculate) compost and are seeking out expertise and partners to help with the project. The County Extension Service has been our first stop, and building the composting bins looks like a perfect project for an Eagle Scout. If there is one thing we have in abundance, it is organic material so we thought we would try doing something low cost with a return and some educational value. This idea is part of a larger strategy to find any number of ways to use enterprise to generate income from our major asset, the land. But not everything is saleable. We look out over an overgrown meadow now choked by scrub pine and dream about meadow restoration and creation of a robust bee habitat. There is no longer any debate about bees being in trouble, and we can do something to help with restoration. You may even be seeing Andalusia honey at the local farmers market.

These are all themes we can bring forward today in our programs, and interpretation, to explore connections to Flannery's writings and to understand middle Georgia midcentury farm life.

What about what you cannot change? Has the house been moved and lost the original orientation that captured warmth from the sun, or shelter from the wind in winter? This is an example where conditions work against you, so interpret what would have been instead. Explain the situation to visitors and describe why orientation matters. That discussion reconnects the house, and the visitor, to the building's history.

Historic New England conducted a multiyear energy efficiency project at The Lyman Estate in Waltham, Massachusetts, focusing on energy upgrades and weatherization work, including repairing historic windows. The effort earned Historic New England the Massachusetts Historical Commission's 2013 Preservation Award. The organization has created an internal mandate "to retain and preserve historic materials and craftsmanship." By respecting the building's history and fabric, by promoting historic trades, the work has resulted in up to 66 percent decrease in energy costs.[2] Historic New England has a large audience of historic home owners, and even

a special membership program for them. Much of its work is directed to teaching historic home owners stewardship of their own homes, and the Property Care White Papers available on the website are invaluable for heritage professionals as well as historic home owners. Helping to keep home owners comfortable in historic houses, and keeping the upkeep affordable, is critical for creating and maintaining a nation of thoughtful stewards. This program is an important example of how museums and sites can use buildings to reconnect the public to cultural resources that they can protect and share. President and Chief Executive Officer Carl R. Nold explains that, "Under our strategic agenda, Historic New England considers environmental sustainability to be of the same high priority as heritage preservation, so conservation efforts are incorporated into our work wherever possible. This contributes to our financial sustainability, and models best practices for the communities we serve."[3] Now *that* is how this good work is done.

Land and Water

A mill, with its physical connection to landscape features, and agricultural or commercial processes, is a marvelous setting for interpreting connections to land and water over time through historic uses of the landscape for human needs. It is also valuable for present-day connection and adaptations. The volunteers at the Aldrich Memorial Association are caretakers of the Robinson Saw Mill in Calais, Vermont, and they have a big job: fighting the effects of time. Well, we all do, but some of us see it pile up literally. At the Mill, it's the silt behind the dam that builds up with time. The dam manages the water used to run the 1803 mill. Silt is bad news for waterwheels and turbines because it fills up the capture pond, reducing the water volume: less volume equals less power generated. Reed Cherington, treasurer, says old photographs show how the pond used to be double the size it is today. Volunteers no longer give even short demonstrations because *any* water flow drags the silt downstream to the mill's neighbors. To make matters worse, the penstock, which directs the water from the sluice gate and dam down to the turbine, is leaky. The water diverted through gaps in the penstock reduces the water power for turning the late nineteenth-century turbine and saw. And when they don't have much water in the pond, and lose some of it through the penstock, even renewable energy runs out—at least until another rainstorm or big melt refills the pond. That was true for all of the mill's history, but with so much less efficiency now, it's a big problem. Dredging the pond and fixing the penstock requires a lot of work, but it would reconnect the historic building to the pond and the creek, and restore an opportunity to educate the visitors about the historic

relationship between water power and the fabric of the nineteenth-century community—not to mention an example of carbon-neutral energy use.

The volunteers are working with consulting engineers on a plan to dredge the pond and upgrade the penstock, Cherington says. The cost is expected to be at least fifty thousand dollars—much more than the association has raised before, but they are off to a good start: a "complete stranger," Cherington says, read a newspaper article on the project and contributed ten thousand dollars. The work involves collecting and removing silt—costly even though a nearby neighbor will accept the silt—and dredging a downstream neighbor's pond, plus permitting and reconstruction. Most of the silt is coming from nearby uncurbed, unpaved public roads as are common in rural Vermont. Due to lack of funds, there are no plans to change the road design or to pave it, but a community project to improve plantings along the roads could make a big difference. The right grasses would be silt barriers without being a maintenance problem. Perhaps that can happen eventually. In the meantime, the project revives the historic connection of buildings and water, and industry and local energy.

That landscape, however, was altered by man. Why is it important to restore the dam and return the site to a more altered state? That depends upon your site's mission. Would I counsel returning to an historic but highly damaging condition? Of course not. And local and national laws would not allow that. At Plimoth Plantation's Plymouth Grist Mill, they have added baffled fish ladders that allow the herring and alewives to move from the sea up to spawning territory.[4] When the colonists started damming the waterway for mill power, they started obstructing the fish migration. The fish were a diet staple and an agricultural fertilizer, but the colonists recognized the importance of providing upstream access. Today's device is modern, but the approach is historically appropriate.

So, what is your role in land regeneration? Museums and sites do some of their best green work when they heal the landscape or repair a break in a natural chain. This is achievable by any one of us on a small scale, and will be critical service actions for museums and sites with significant landscapes and large open spaces. At The Henry Ford in Dearborn, Michigan, there is work on, and adjacent to, the Greenfield Village site to restore an oxbow in the Rouge River. Decades ago, the river was corralled into a cement channel to manage flood damage and the oxbow was blocked off. Well the new channel works for flushing water and protecting property, but it also flushes the fish right out of the river! The sterile channel has no public appeal and provides no ecosystem services that could naturally benefit the landscape or any kind of life around it. Over the last decade a network of watershed communities (Alliance of Watershed Communities) has been cultivating

an awareness of the importance of natural systems for biodiversity and effective flood mitigation, and fostering a collective effort to restore water quality. The engineering has been the responsibility of the Army Corps of Engineers. National and international events of Katrina disaster response and the Iraq War pulled the Corps off the project at times, but it is back on track now. With the National Oceanic and Atmospheric Administration's interest in restoring riparian zones, there was support and core funding for planning and implementation. The project is now in its third phase of designing the oxbow final cut. When it is open, the oxbow will provide refuge for river fish and other creatures during times of flooding, and the landscape will be a restored wetlands habitat and flood zone. The museum will eventually provide narrated river cruises. In the near term, they use the landscape for education and recreation programs. The ecosystem will be restored to a more natural condition while welcoming public uses.[5]

At Blithewold Mansion, Gardens, and Arboretum in Bristol, Rhode Island, restoring the connection with water means reworking the connection to the Narragansett Bay. This thirty-three-acre site with its mansion and outbuildings sits right on the Narragansett Bay. The lawn and gardens run right down to the water's edge. Blithewold's executive director has long been involved in community aspects that support the town of Bristol. Now there are regional changes bent on reversing decades or centuries of development that have adversely affected ecosystems. Blithewold's executive director, Karen Binder, is in her second term on the Town of Bristol's Comprehensive Planning Review Committee. This time the planning process considered "the whole force and impact of coastal climate change on Bristol Harbor," and is adapting its zoning rules accordingly. Four years before, when they worked on the plan, climate change was not part of the committee discussion.[6]

The staff and volunteers there understand that the traditional museum role as educator/conservator includes the house, the open space down to waterfront, and the shoreline and its viability. Through a comprehensive master planning process, the museum's team identified a waterfront plan including rehabilitation of the shoreline now overrun by invasive species. The plan calls for replacing the quarter-mile barrier of poison ivy, loosestrife, bittersweet, and other invasives with salt-tolerant shoreline plantings that are a more adaptive buffer than short grass lawn or weed plants that have crowded out the natives. They'll build a handicapped accessible marsh path bringing visitors right down to the water but through more natural vegetation. By reconnecting the historic house and its designed landscape with the natural waterfront, Blithewold's comprehensive master plan honors the historic life ways at the estate, reintroduces high habitat value, improves

storm water management and waters-edge resiliency, educates visitors in sustainable property management and responsible development in their communities, and supports the regional commitment to shoreline health.

Plants and Agriculture

Blithewold's gorgeous lawn is an important historic feature, and it serves as a valuable institutional resource for weddings, performances, and special events. It's historically correct for this property. But lawns are not so for every property. Was your lawn there "in the beginning" or is it something more recent? Lawns should not just "happen." Just as the field reexamined foundation plantings of ornamental shrubbery as Colonial Revival imaginings, perhaps lawns need the same review. Public appreciation for more naturalized landscapes is growing, though at least one major outdoor museum

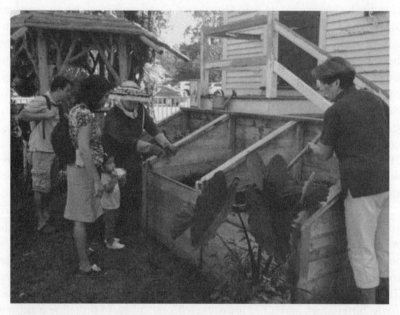

PHOTO 5.2. Master Gardener (far right) and a museum 1870 garden role-player work in consort to teach organic gardening practices to families at Strawbery Banke Museum.

Courtesy John Forti, now director of horticulture for the Massachusetts Horticultural Society where many of these same ideas will be carried out.

reports that its reduced mowing approach brought visitor complaints. If you have a large lawn area that is not necessary for your historical setting (or for any safety reasons), do consider slowly moving away from such a large intensely managed landscape, or at least be sure you are using it to your full advantage. After the initial replanting and maturation of a more native landscape, you will save more money by not mowing the grass than you will spend on two or three pruning and weeding sessions annually. What you create will also provide habitat and visual pleasure.

At Connecticut Landmarks Bellamy-Ferriday House & Garden in Bethlehem, Connecticut, the site horticulturist offers a monthly landscape workshop. One offering was "Plants for Bees, Hummingbirds, and Butterflies," teaching how to "maintain a balanced and diverse garden community, with bees, hummingbirds, and butterflies specifically in mind." The program description says, "With growing concern for the loss of pollinators in gardens, find out about the varieties that will attract these necessary friends, from host to nectar plant." This is because heirloom varieties are often known for greater nectar and pollen production, which makes them a better food source for bees, butterflies, and other pollinators. If the museum and its visitors create garden spaces for these plants, they are supporting biodiversity and pollination for flowers and vegetables. The Bellamy-Ferriday program also highlighted Bethlehem's Monarch Butterfly Waystation, a joint project with the Bethlehem Land Trust. The open space at the Bellamy-Ferriday House & Garden plus the land of the Bellamy Preserve create a swath of plants offering pesticide- and fertilizer-free habitat for resting and breeding. During the program, guests could purchase chemical-free plants propagated from the Ferriday Garden.[7] Every site with landscaped areas can make this change; hopefully the changes will include interpretation.

GREEN FROM THE GROUND UP

Reclaiming Our Sustainable Heritage and Cultural Landscapes

John Forti,[1] Curator of Historic Landscapes,
Strawbery Banke Museum, an Outdoor Living History Museum
in Portsmouth, New Hampshire

"The cost of a thing is the amount of what I call life which is required to be exchanged for it, immediately or in the long run."
—Henry David Thoreau (1817–1862), Walden

Trigger Story

Just as I was arriving at Strawbery Banke Museum from Plimoth Plantation, a new generation of studies was showing that our food was traveling 1,500 miles on average,[2] that children knew fewer than ten animals and plants in their own backyards (but over one thousand corporate logos), and that they knew more about the rainforest than the woodlands where they live.[3] At the same time, I took heart from insightful museum patrons, the local foods movement, and youth engagement with the emerging farmers markets. Among all groups, I saw generations hungry for connection to each other, and the meaningful lessons of sustainability and place that museums could offer. I began to broaden my perspectives on connecting

the past to the future, by building programs and designing gardens that I hoped would inspire a vibrant link to sustainability.

Beginning Activities: Planting Seeds of Green

Many museums, particularly open air museums, have experienced decreasing visitation for decades. Perhaps fearing that we might be getting left behind in our technological world, I observed many museums adopting the more sensationalistic and conflict-focused style of "storytelling" and exhibitry from corporate media competition. However, recent studies indicate that our audiences often visit us to disconnect from technology and to reengage with authentic experiences of place-based learning.[4]

I believe that now, more than ever, our communities look to museums to teach from our strengths (in our case at Strawbery Banke, historic landscapes and collections) and to curate cultural conversations around our common heritage. Museums' communities are very supportive when we create initiatives that help us learn, together, why sustainability is worth celebrating. Community members also begin to consider themselves stakeholders when we remind them how history can inform strong and healthy environments, resilient communities, and sustainable futures. When we explore place-based histories, we also help to teach the stewardship and sustainability previously known in my region as Yankee thrift.

Strawbery Banke Museum is an open air living history museum dedicated to teaching about community, preservation, and change over time. The mission of the Department of Historic Landscapes is now to "teach from the past in order to help create a more sustainable future."

Shortly after I was hired, I began to offer daily garden/sustainability tours, and helped to found a local chapter of Slow Food USA, which partners with many of our museum programs. We turned underutilized space into community gardens, established an informal heirloom seed lending library from our gardens, and began the process of making our museum a certified organic gardening site. I also began to lecture widely on related topics and design children's gardens to help bring messages of sustainability beyond our own museum campus.

Middle Activities: Green Audience and Stakeholders— Collaboration That Brings the Greening Home

It can be difficult to accomplish what once-larger staffs and research teams could build, but our weakness can become our strength. Instead of working

alone, savvy museums convene experts and collaborate with partners to foster interdisciplinary exploration (scientists, artists, artisans, historians, families, universities, farmers, herbalists, organic growers, sustainable landscapers, and local economy groups) to create exhibits, events, and connections to help guide communities in well-rooted conversations around sustainability. These partnerships often help to bring focus back to the preservation of traditional crops and diets, and all broaden our scope and ability to reach new audiences.

Some of our most popular programs at Strawbery Banke have come about when building alliances with organizations such as Slow Food, local universities, organic gardening groups, sustainable agriculture groups, Cooperative Extension groups, garden clubs, and herb societies. Not only do they help provide greater depth to our programming, but in many instances, these groups provide a frontline volunteer presence that helps us to maintain and interpret our historic and cultural landscapes. Similarly, sustainable energy and environmental organizations help us to reexamine our site with new eyes and build lessons of sustainability into our daily tours and programming.

Special events are made even more engaging when we work with local brewers, distillers, and vintners who are eager to collaborate with us to create drinkable lessons of sustainability (like sourcing local grains and brewing tasty drinks and bitters with heritage hops, herbs, and fruit from our historic gardens). Now, when patrons come to Strawbery Banke, they are frequently able to eat and enjoy a "taste of place." They relish heirloom salads made with plants gathered from, or inspired by, the gardens on our site. Visiting families regularly take home heirloom seeds that are a part of our outdoor living history program, where they learn seasonal historical foodways that translate skills from the past for the twenty-first-century home and garden. We now regularly call upon media food personalities, authors, and local celebrity chefs to help us orchestrate high-visibility events that enable us to bring together farmers, chefs, and foodies. We use taste education to help us deliver feel-good events that also shift community dynamics and build working models for a healthier local environment.

In my experience, regional Slow Food groups offer some of the most valuable partnerships with museums around the country.[5] Their mission is to celebrate good, clean, and fairly grown food for all. Each regional chapter becomes expert in the place-based food, agricultural, and artisanal process that helped to sustain the region in the past. Even more important, Slow Food Ark of Taste biodiversity programs provide resources to preserve ecological farming practices, heritage breeds, and provide taste education. Slow Food Presidia and Earth Markets partner meaningfully with the artisanal

crafts that help forward-thinking museums rise to meet an eager generation of agricultural craftsfolk. They also help to demonstrate that the value of artisanal production is, by its nature, an ever-evolving model for regional sustainability and a strong local economy. The Slow Food in Schools initiative also offers valuable models for connecting kids and families to the many lessons inherent in seed to table programming.

At a recent Slow Food International meeting that I attended in Italy, Dr. Sylva, president of the Food and Agricultural Organization of the United Nations, introduced 2014 as the "International Year of Family Farming" and said:

> Diversity is fundamental to food security. There was a time when humans ate [twenty-three thousand] vegetables and cereals, but today we rely on fewer than [twenty]. The way the green revolution teaches, we can work to rebuild our food production and consumption model, while preventing waste. Strong local markets safeguard regional diversity, but also lessen our ecological footprint.[6]

When we partner with our community and organizations like this, museum gardens and landscapes can become models that remind us that we are all part of a delicious and nutritious movement to preserve our cultural inheritance.

Where We Are Now: The Grass is Greener on Our Side—Preserving and Enjoying the Artisanal Skills of Farm and Garden

"Tell me and I forget, teach me and I remember, involve me and I learn."

—Benjamin Franklin

When food is manufactured outside our foodshed, we lose our regional biodiversity and agricultural best practices. Most food we consume requires enormous shipping costs in cash and carbon, to say nothing of the health, environmental, and geopolitical costs of our dependency on the petrochemicals used in the production of agribusiness food. Museums with historic foodways and agricultural programs have a great deal to bring to the table around these topics of sustainability. By helping our audiences to better understand the value of gardening and local agriculture, we help families to discover paths to sustainability right in our own backyards.

And it's not just the food. Throughout history, farm and garden crafts have been seen as a natural outgrowth of the land, and enrichment for our lives and local economies.

History reminds us that while we have done much to shape our local landscapes, we are also shaped by them. Both positive and negative examples of how we have lived on the land remind us that our quality of life is dependent upon our stewardship of the environment. By sharing the cultural fabric that makes our regions unique (natural resources, related trades, architectural styles, personal adornment, tools, seasonal observations, and lifeways), we are able to utilize place-based wisdom that time has proven sustainable. When we revive and adapt practices from the past, we help preserve and celebrate regional biodiversity, seasonal diet, personal health, festive holidays, and an artful life inspired by nature.

In an effort to teach sustainable lifeways to a new generation, I am leading the development of a "Center for Heirloom Garden Crafts." Portsmouth, New Hampshire, has a strong local foods movement, and Strawbery Banke's new center will distinguish the museum as a valued leader in the emerging artisanal crafts movement throughout the region. We will restore a building onsite to house the center. The restoration process will demonstrate how adaptive reuse can meld with sustainable technologies to revive the skill sets that supported earlier generations. Programs will provide inspiration from agricultural crafts of the past and help participants contribute to a more sustainable and meaningful future for themselves and their communities. As program director, I will coordinate training for garden staff and curate a series of visiting artisans to integrate old and young, shaman and scientist, backyard gardener and Big Ag, rich and poor, native and immigrant, and historic and contemporary crafts that link us to local sustainability. Artisan mentors will once again teach the pride of craftsmanship in a throwaway age—crafts that provide consumers with fresh, local, healthy, and sustainable regional alternatives worthy of investment in their children and our future.

The center will combine an heirloom seed lending library with exhibits on sustainable landscapes and regional biodiversity. An exhibit on local food and medicine will engage visitors with history and science. Hands-on crafts will demonstrate the best of place-based models for sustainability to remind our visitors why they should care about sustainability ... and why they should want to support a nonprofit!

When the Center for Heirloom Garden Craft is complete and the work of the committee is done, we have agreed that the group will morph into a Green Museum Sustainability Committee so that this model and philosophy extends out into all facets of our museum programming and into our community.

Summary

It's easy to talk about changing a light bulb, but one of our greatest sustainability issues revolves around the food we eat. Teaching artisanal foodways with a dose of restoration ecology can help us to share fun, flavorful, and inclusive messages of sustainability with a wide-ranging audience. If we begin close to home, local/seasonal food can offer a meaningful intersection with the environment, and our museum cafés and shops can provide our patrons with a way to support sustainability with their forks and dollars. When properly planned, our historic foodscapes can support mission-based teaching and offer sustainable groceries served up with a dose of regional food security.

Hindsight

Museums have spent decades trying to model themselves after industrial-era business organizations. As we observe the cultural shift toward green and earth-friendly industry, perhaps we, too, must learn that that those organizations that survive and garner support will be those that operate sustainably and work to enhance public health, education, and welfare.

Surprises

When we plant the seeds of sustainability, everyone in our community of support is eager to help cultivate and support them.

Notes

1. John Forti is also a consultant, lecturer, and "The Heirloom Gardener—John Forti" on Facebook, www.jforti.com.

2. Natural Resources Defense Council, *Food miles: How far your food travels has serious consequences for your health and the climate* (Health Facts). Washington DC: Author, 2007, accessed May 8, 2014, http://www.food-hub.org/files/resources/Food%20Miles.pdf.

3. No Child Left Inside Coalition, http://www.nclicoalition.org. See https://www.youtube.com/watch?v=wRR1feHqZPY for a related 2008 video.

4. Reach Advisors Study "Museum Audience Insight," accessed May 8, 2014, http://reachadvisors.typepad.com/museum_audience_insight/2009/01/technology-and-museums.html.

5. Slow Food USA website, www.slowfoodusa.org.

6. Forti attended this event in the fall of 2012 as an international delegate, accessed May 8, 2013, http://www.fao.org/family-farming-2014/news/highlights/details-press-room/en/c/231112/.

References

Slow Food USA. www.slowfoodusa.org.
Reach Advisors' blog *Museum Audience Insight*. www.reachadvisors.com.
National Resource Defense Council. www.food-hub.org.
No Child Left Inside Coalition, now located at the Chesapeake Bay Foundation. http://www.cbf.org/ncli/landing.

Cultivating and interpreting heirloom plants is an important opportunity to support biodiversity and historic context. Just as agriculture practices have become so industrialized, so have the plantings. *From Seed to Seed: Seed Saving and Growing Techniques for Vegetable Gardeners* is the handbook for those interested in growing and protecting their own selection of heirloom plants. The plants that have a history of adaptation to local conditions are the most likely to do well at your site; often, these are carefully cultivated by farmers and families in the region. The local food movement is a backlash against agro-industrial growing programs using hybrid seed bred to make mechanical harvesting easier, create longer-lasting vegetables capable of surviving long distance shipping, and scheduling predictable ripening times. An heirloom variety is more likely to be a little less uniform and to ripen at a variety of times, which eases the canning schedule for the home processor. Without seed saving, or valuing local food resources, biodiversity in food plantings is threatened. Where museums and sites encourage heirloom plantings, they can slow and perhaps stop this loss.

In 2012, Plimoth Plantation took over a lease of on a 1970s replica grist mill. The working mill sits on an original mill site in the original Plimoth Colony in Massachusetts.[9] Today's Plimoth Plantation open air museum is not located on the original Plimoth Colony site because Plymouth grew up exactly where it was first laid down. The replica site for the museum needed to be somewhere outside of town. Now the mill's location offers the museum an interpretive outpost in town, and it allows staff to "take history a little beyond the main campus," says the Miller Kim VanWormer, leaving the colonial period to talk about change over centuries and how that affected the environment, and the people, around the mill.

Milling grain was a new craft for the museum; when VanWormer took the job, she had years of experience at Plimoth Plantation as an interpreter and a manager, but not as a miller. Luckily, the Society for the Preservation of Old Mills (www.spoom.org) has a roster of people who train millers.

There are a host of skills and knowledge to be acquired, such as understanding the technology of water power and water-powered equipment, and the engineering of dams and flumes and penstocks, and, if you're producing for consumption, understanding licensing and registration, managing sanitary conditions and preventing pests, and creating packaging. Mason G. Maddox Jr., their mentor from Colvin Run Mill in Great Falls, Virginia, hosted them for four days of learning safe operation and food handling, and milling history and process. He's also been to Plimoth to help them, as have some millwrights doing repairs. "I've got them on speed-dial," VanWormer says.

VanWormer says she had always enjoyed food and gardening, but didn't know she'd fall in love with milling or that the technology and gears and mechanical parts of milling would be so interesting. The heirloom corn hooked her, and the rest simply opened a whole new world for her, one she loves learning about and teaching about. She comments that teaching history or science or nature alone really "artificially tears apart subjects, but here it's all together and part of the same story."

They currently grind organic corn, using the whole meal, to turn out fine corn meal, and a more coarse version to be sifted for samp to be used for grits and polenta. The Mill is undergoing organic certification so that it can carry the U.S. Department of Agriculture organic label. And they are working with local farmers to test varieties of Flint corn. Roy Calais Flint corn is part of the Ark of Taste, a program that includes heirloom plant saving.[10] Plimoth had bred a variety of Floriani Red in the early 1980s to reproduce the look of corn, by how it grows with the white inside. Florian Red is another they have contracted with a farmer to grow. It has the highest protein content, she said, and is "now the darling of the foodie world." The year 2014 was the year for growing seed stock for future seasons. The goal is to use only locally grown, organic, heirloom varieties of corn. "That's what we really believe in," she says.[11]

In Ohio, the Cayuga Countryside Initiative is working hard to save historic working farms before they and their structures disappear. This part of the state, during "an era of increasing industrialization," became "an undeveloped island sustaining the preservation of American farm life," but that way of life finally gave way to large-scale and monoculture farming. In response, the National Park Service's Countryside Initiative program is working to rescue and restart living, working farms that represent the rural heritage of the Cuyahoga Valley, while also protecting area natural resources. Through the Countryside Initiative, the National Park Service "keeps alive the idea of the family farm." Since 1999, it has been working with a nonprofit partner, The Cuyahoga Valley Countryside Conservancy, to rehabilitate eleven farms, and soon three more.[8] If you listen to the

interviews online, you'll hear that Darwin Kelsey, executive director of the Cuyahoga Valley Countryside Conservancy, says, "One of the first things we had to do was … inventory the dead carcasses of old farms and see how many body parts could be stitched back together." There were eighty-five left. "There was an anxiety or angst about preventing the disappearance of … something very valuable, very fundamental about our society was disappearing." The ways of farming for food had changed to industrialization, and it is critical to protect both the natural and historic character of this landscape. Now those farms are contributing to sustainable agriculture and the return of local food sources. This effort to protect history required reconnecting people and practices with the landscape. That restorative approach is gaining currency in the field as a social responsibility of history museums and historic sites. It nearly always requires strong partnerships, which, of course, spread the good for all.

Animals

For those introducing or enhancing livestock programs, the Livestock Conservancy's book *An Introduction to Heritage Breeds: Saving and Raising Rare-Breed Livestock and Poultry* is your guide to selecting the most appropriate animals. The authors explain that, "Agriculture has changed more in the past century than in the last [ten thousand] years. In both developed and undeveloped countries diversified farming [was] based on adaptation to local conditions."[12] It is being replaced by process and procedure standardizations that use confinement and manufactured feed, and animal selection for very specific traits (meat or egg production, for example). Animals bred and kept for their adaptability and suitability for the local environment in the past have begun to die out as we become more adept at, and accustomed to, providing artificial environments to protect animals less suited for local climates. As the specialized breeds become harder to locate, other breeds become the default choice, and the cycle continues.

The term "heritage breed" focuses on unique adaptations in an animal based on local conditions. These were usually quite versatile, multipurpose animals often requiring less intensive management. Well, in a time of changing climate and decreasing genetic diversity, it's clear that a broad gene pool predisposed for adaptability is a good idea. Think about it—if you wanted to have livestock on your site, wouldn't the stock best suited for your region and your mission make the most sense? The cattle, goats, sheep, swine, and poultry that have adapted to the landscape and living conditions of your area are the ones who will have the best survivability, physical comfort, and resource productivity for the least effort. Hopefully we'll all

become familiar with names such as Milking Devon and Belted Galloway cattle, Spanish Black turkeys, Dominique and Dorking chickens, Cayuga ducks, Dorset Horn and Navajo-Churro sheep, Golden Guernsey goats, Red Wattle and Tamworth pigs, and Cleveland Bay horses. These are not static breeds, and they're not all native to the United States, and not all represent your historical message. But where they are appropriate for your work, their added value is their adaption to local conditions, and their contribution to a diverse population.

Just think how what we value brings to the work of improving genetic diversity. Think what living history farms and historic properties could do for the genetic pool of livestock and poultry if even a quarter of the 19,500[13] or more historic sites or houses, historical societies, historic preservation groups, and history museums in the country participated in some way in conserving heritage breeds. The Livestock Conservancy is your resource and ally in this work, and it can help you connect to individuals and other groups in your area to strengthen your work. The Conservancy's annual meeting is an opportunity to educate yourself and make connections. As with all aspects of sustainability work, heritage breed work is best done as part of a team so that you improve your understanding and maximize productive impact.

Accokeek Foundation in Maryland is a member of the American Livestock Breed Conservancy. American Milking Devon cattle, Black Spanish turkeys, Buckeye chickens, and Hog Island sheep and Ossabaw hogs are part of the preservation program at Accokeek. It has long cared for heritage breeds of livestock and chickens, and cultivated heirloom vegetables, but largely as a "stealth" operation, says Andrea Jones, director of programs and visitor engagement. It hasn't been interpreted with emphasis, but visitors do want some explanations. Jones is introducing more sign-based interpretation and more programming highlighting the value of protecting and breeding these animals for genetic diversity.

Certainly, some museum leaders are pulling more than their portion of the weight on this: The Colonial Williamsburg Foundation and Mount Vernon in Virginia, Plimoth Plantation in Massachusetts, Accokeek Foundation, The Farmer's Museum in New York, and Historic New England, but we would all benefit from a broader effort. If you can safely and responsibly care for these animals, or partner with a farmer to do so, and strengthen performance of your mission while increasing public engagement, then it's an opportunity to be taken seriously.

But don't think you have to do it yourself. If you don't have the staff and volunteers necessary to pull this off, there's probably a young farmer near you who needs land and a good partner. Caring for, protecting, and

supporting heritage breeds is not just for specialists or history museums, it's also for small-scale farmers interested in livestock raising—at their farm or yours. If you're interested in promoting sustainable living among your members and community supporters, or interested in finding a farmer to manage this aspect of your site for you, this topic is a perfect opportunity for public engagement. If you're getting questions about "what kind of chicken should I keep?," does your answer include an appropriate heritage breed? If not, you're missing a great opportunity to connect your visitor with history and restore sustainable livestock options in your community.

Notes

1. Sheryl Hack in conversation with the author, July 24, 2014.

2. Historic New England, "Historic New England wins trio of awards," accessed September 13, 2014, http://www.historicnewengland.org/about-us/whats-new/2013/06/03/awards-aplenty.

3. Carl R. Nold (president and chief executive officer), email with the author, September 24, 2014.

4. "Alewife Love Part II," accessed July 18, 2014, http://blogs.plimoth.org/milltale/?p=403.

5. Robert E. Hanna (senior director, facilities management and security) in interview with the author, September 12, 2014.

6. Sarah Brophy (Sutton) and Elizabeth Wylie, "Museums and the Future of Water," *Museum*, March–April 2014.

7. Connecticut Landmarks press release, July 17, 2014.

8. National Park Service, "The Countryside Initiative—Cuyahoga Valley National Park," accessed September 4, 2014, http://www.nps.gov/cuva/historyculture/the-countryside-initiative.htm.

9. Plimoth Plantation, "The Plimoth Grist Mill," accessed July 28, 2014, http://www.plimoth.org/mill.

10. The Ark of Taste is a catalog of foods facing extinction. The Ark works to identify and promote these foods to keep them in active cultivation and production, and to reinforce biodiversity. Slow Food USA, "Ark of Taste in the USA," accessed August 21, 2014, http://www.slowfoodusa.org/ark-of-taste-in-the-usa.

11. Kim VanWormer (Plimoth Plantation's Plymouth Grist Mill) in interview with the author, August 1, 2014.

12. Excerpted from a book review by the author, "Book Review: An Introduction to Heritage Breeds: Saving and Raising Rare-Breed Livestock and Poultry," *Sustainable Museums* (blog), July 28, 2014, http://sustainablemuseums.blogspot.com/2014/07/book-review-introduction-to-heritage.html. Sponenberg, D. Phillip, Jeannette Beranger, and Alison Martin (The Livestock Conservancy). *An Introduction to Heritage Breeds: Saving and Raising Rare-Breed Livestock and Poultry*. North Adams, MA: Storey Publishing, 2014.

13. Museum Universe by Discipline, Museum Universe Data File, Institute of Museum and Library Services Q3, 2014, accessed July 12, 2014, http://www.imls .gov/assets/1/AssetManager/MUDF_TypeDist_2014q3.pdf.

Resources

The Association for Living History, Farm and Agricultural Museums. http://www .alhfam.org.

The Center for Rural Affairs is a private nonprofit linking farmers without land to land-owners looking for farmers. Your historic site may find a farming partner here to bring activity to your land and to contribute food to the community. http://www .cfra.org/landlink. Accessed January 1, 2015.

Historic New England. "Property Care White Papers." http://www.historicnewengland. org/preservation/preserving-historic-sites/property-care-white-papers.

The Livestock Conservancy. www.livestockconservancy.org. A nonprofit focusing on "preserving and promoting rare breeds of livestock."

Sponenberg, D. Phillip, Jeannette Beranger, and Alison Martin (The Livestock Conservancy). *An Introduction to Heritage Breeds: Saving and Raising Rare-Breed Livestock and Poultry*. North Adams, MA: Storey Publishing, 2014.

Seed Savers Exchange. "Organic, Heirloom Garden Seed Info & Store." http://www .seedsavers.org. A nonprofit conserving and promoting America's culturally diverse but endangered garden and food crop heritage for future generations by collecting, growing, and sharing heirloom seeds and plants.

@/@

SHARING THESE CONNECTIONS
Historic Interpretation and Community Engagement

Vision

Historic sites and museums interpret topics and practices that encourage environmental sustainability through learning from the past and in the present. They engage individuals and communities of all types in the unique ways that sites and collections can support.

Contemporary history" is an oxymoron, so it is no surprise that contemporizing relevancy has long been a struggle for historic sites and history museums. But wait, we've also been preaching the importance of the lessons of the past for teaching the present and preparing for the future, haven't we?[1] We can't argue both sides and expect to make any sense. Let's use history the way we're trained to: to interpret the human condition as it adapts to life on this earth, doing it well or badly, and changing over time. Temporal comparisons are often our most obvious education tools and a great place to start. John Forti, now director of horticulture at Massachusetts Horticultural Society and previously director of horticulture at Strawbery Banke Museum, Portsmouth, New Hampshire, has a few great examples: "a museum where a windmill had stood for

centuries, hosting a community forum on wind turbines. Another museum . . . unable to appropriately replicate the scale of agriculture for the site [instead] contracted out land to farmers eager for meaningful connections and farmland."[2]

The stories here are about interpreting energy, food, history, and botany, and about engaging the public in learning about food, plants, the land, and the animals on it. It is about how history museums and historic sites can stand up for food, agriculture, economy, climate history, and biodiversity by participating in the activities they've interpreted for so many years. This chapter is also about using the opportunity of the sustainability discussion to make connections to the public. When the institutions are connected to a broad and stable community network, when they're actively a part of community activities as supporters and problem-solvers, not simply educators or entertainment venues, that's when real sustainability can begin to take hold.

Michael C. Henry, principal engineer-architect at Watson & Henry Associates in New Jersey, often consults on projects funded by the National Endowment for the Humanities' program for Sustainable Cultural Heritage Collections, and for the Heritage Preservation's Conservation Assessment Program. He calls sustainability "institutional survival and thrival." In the "world of historic sites, the sustainability concept that requires the greatest attention isn't merely environmental, and only partly financial or economic sustainability, but largely social sustainability. . . . If you have social sustainability, that will underpin environmental sustainability. The value of a heritage resource to the community is a necessary asset to develop early, perhaps even before environmental sustainability." This is a challenge for historical organizations because, he says, "as conservation professionals, we are materially and object oriented . . . we see value in *stuff*. . . . Building social relationships on local, community, and regional levels doesn't come as naturally to us." Yet "focusing on social sustainability is a priority. It empowers a community to take care of a site. . . . We need to get the message to the heritage community: their means are limited and especially if there is no [active] community connection."[3] Just getting by financially doesn't allow us to care for collections and properties, to interpret them, and provide for the long term. Sustainable practices can help the financial aspects of your institution, but community engagement is the real foundation for long-term futures. For this reason, sustainability as a public trend is a gift to history museums and historic sites working to secure their connections to community. Your future depends on these connections.

Opportunities for relevance truly are unlimited. The modern home-steading movement is nearly as strong as the homeschooling movement; how can you use this to connect with your visitors? Consider something as basic as food preservation. In the beginning, drying and storing food was necessary for sustaining life if foraging and hunting did not provide a constant supply. For a long time, decades in some countries, centuries in others, jarring and then canning foods was common practice in family groups, then canning and jarring shifted to factories and industries until industry shifted its focus to fighting World War II, and then family groups were asked to can and jar again. The War Administration put out posters of American women in aprons showing off their canned vegetables with "Of Course I Can" (get it?) as their motto. Gradually, after the war ended, home canning began to fall out of favor. Not until a brief period in the 1970s and then starting in the early twenty-first century did canning come back into favor and possibly soon into vogue, this time for health, independence, personal choice, and food security. That's a great history story, and a great sustainability one, too. Is it one your museum can tell? One it can tell and build upon with exhibits, programs, fairs, oral histories, and new collections?

We are still in the very early stages of learning to reduce impact, and it will be a long time before humans have no negative environmental impact, but what do you do about a practice, such as canning, that has unsustainable aspects to it? What about the visitor who wonders about canning at home and asks the question "but it takes so much energy to can, . . . how can that be green?" Fair enough; assessing the trade-offs for canning is much like examining the pros and cons of wood burning we reviewed in chapter 3. You start with energy use and how to make it more sustainable by increasing the efficiency of the process (using less to do more) and cleaning the energy source (reducing its carbon dioxide emissions from direct use, generation, and transport). So filling the canning pot to maximize heating that water for as many cans as fit, that's a start. Running the stove off cleaner power such as solar, wind, or hydro-generated electricity is more green, too. Natural gas is cleaner than electricity from a coal-fired electric plant, even one meeting new standards. Now, how do you compare those energy costs to those of the factory canned goods? You compare the food miles of produce grown elsewhere, shipped to the plant, canned, and shipped to the market you have to visit to make a purchase. If you used locally grown produce—your yard or a farm nearby—then you've already reduced the food's carbon footprint significantly. By using and reusing glass jars, you've cut down on making and disposing of metal or glass for factory packaging, and probably significantly reduced the labeling activity. The impact is

different, and for anyone interested in food security, supporting local providers, retaining an historic practice, and enjoying fresher, healthier food, canning is a highly sustainable option.

For nearly any topic, that component-by-component examination process is how you can talk about sustainability with your public. Break down an activity into its components and examine how they affect the quadruple bottom line of people, planet, profit, and program. Remember, it is not about right or wrong, but about making the best choice possible at the time. Now let's look at ways to interpret, contemporize, and demonstrate sustainability topics, practices, and programs, and that allow you to challenge, involve, and connect your visitors to the environment, sustainability, and climate change—and inspire them to action.

Interpret

Picture the Catskill Mountains, a heavily forested area west of New York State's Hudson River, about 150 miles from New York City. You have probably seen representations of this beautiful rural area in paintings by the nineteenth-century artists of the Hudson River School. Hanford Mills sits in the hamlet of East Meredith, New York, with a population of about five hundred. It's pretty rural. The site has fifteen historic buildings. For centuries, the mills processing logs into lumber and grains into animal feed were true rural service agencies. They took the resources grown on or collected from the land, processed them into a more usable and portable material for use in the community, and sold to those outside the community without access to these resources. Hanford Mills's stories—past and present—are about service. Visitors expecting a static site, a picture of a point in time, will find something much more engaging.

Until recently, "adaptation" was an interpretive theme for the site, but they have changed that to "ingenuity" to illustrate past and present uses of energy. The mill operated from the mid-1840s to the late 1960s, then became a museum. Today, the mill can demonstrate twenty traditional processes on historic equipment. Annual visitation is about 7,500 people: 20 percent in school programs, 40 percent in special event participation, and 40 percent in visitors touring the site.

"We interpret almost 125 years of operating the mill as a business," says Elizabeth Callahan, executive director of the Hannaford Mills Museum. Much of that interpretation involves discussing choices—historic and present-day. The production and processes at the mill changed over time, as did the equipment. Sometimes the change was an energy or mechanical innovation, sometimes it was a response to the economy and either new or decreased demands.

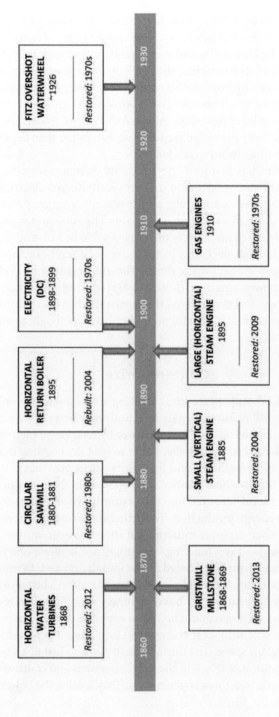

FIGURE 6.1. Timeline for power and equipment at Hanford Mills in New York State. Denise Mix.

The mill added steam power in the late nineteenth century because it was more consistent than water power, but steam power required burning coal (or scrap wood) and a crew boiler and engine tenders. As the steam power plant reached the end of its useful life, the mill's owners moved from powering many processes with hydropower—a renewable resource—to powering many functions with gas engines because gas power was not dependent on seasonal limitations and cycles of low water. After World War II, the mill focused on distribution of already processed feed and lumber, rather than depending on grinding and sawing raw materials for sale.

The museum has restored the 1926 Fitz overshot waterwheel and water turbine, the electric dynamo that provided the first electricity to the mill and surrounding community, and two steam engines powered by a re-creation of the mill's steam power plant. The interpretation focuses on "historic power resource decisions, sustainable or not, and challenges visitors to think about decisions in their lives." Different factors affected power choices and services made during the mill's century of working life: availability of power and of natural and agricultural resources, process needs, technology, and demand. As the museum reinstalls or restores each historical power source, it gave them "an opportunity to talk about power, past and present."

Contemporize

Next, the Hanford Mills Museum is creating a renewable power learning laboratory that will feature biomass heat and solar power. They are planning a switch from fuel oil as a heating source by installing a high-efficiency, low-emissions bulk feed wood pellet boiler to heat the building that houses the museum's offices, archives, and the community's post office. In an area with abundant forest, where lumber and paper mills abound, wood scraps are an excellent local resource for conversion to wood pellets for super-high-efficiency energy production. To further increase efficiency—staffing and energy—a once-separate museum gift shop has been moved into this administrative and archives building. This single-use, contemporary building is now being transformed. It needed a new foundation and, to improve the solar energy production value of the roof, it really needed a better orientation to the sun. They have turned the building ninety degrees and set it down on a new foundation with maximum Southern exposure so they can power it as efficiently as possible with solar energy. And they'll use it as an exhibit space *and* public program space. The museum also plans to install and interpret a microhydro turbine nearby—in the site's waterways—to contrast contemporary and historic water power generation. They'll call it the Power House.

CASE 5

SUSTAINABILITY
AT WYCK

Eileen Rojas, Executive Director,
Wyck Historic House, Garden, Farm,
Germantown, Pennsylvania

Trigger Story

Wyck was home to nine generations of the Wistar-Haines family, a Quaker family with a commitment to social justice and environmental responsibility. In the mid-2000s, our board of directors recognized that the future of historic house museums was uncertain. In 2006, we completed a strategic planning process that launched a reinvention of our site and our organization, establishing a vision for Wyck that is in keeping with the legacy of the Wistar-Haines family members who lived there and their passion for education, horticulture, and social and environmental responsibility.

Wyck sits on a 2.5-acre site that consists of the house, outbuildings, original family furnishings and personal papers, an 1820s rose garden, and a vegetable and herb garden that is a rare survival in our urban neighborhood. With a new strategic vision, we leveraged our unique historic landscape and established the Home Farm, interpreting our agricultural history by actually farming on the same soil that has been cultivated for centuries at Wyck. The Home Farm holds a large vegetable garden consisting of numerous heirloom variety vegetables, an herb garden, strawberry and raspberry beds, fruit trees, an asparagus bed, a cutting garden, and a large, historic grape arbor. Additionally, we have a small flock of laying hens and numerous bee hives onsite. The Home Farm is cultivated using traditional farming techniques, and no chemicals or gas-powered machinery are used.

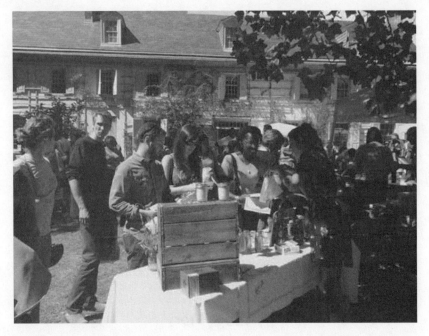

PHOTO 6.1. Philadelphia Honey Fest at Wyck learn about beekeeping, honey extraction, mead-making, and bee- and other honey-related topics.
Courtesy Wyck Historic House, Garden, and Farm.

Activity Story

We developed programs using the Home Farm to meet the needs of our immediate community, which suffers from alarmingly high rates of poverty, food insecurity, and health problems. Our farmers market and outdoor education program address these concerns and provide educational opportunities for underserved schoolchildren in Germantown needing a safe place to experience and learn from nature, and critical access for neighborhood residents to nutritious, affordable, local produce.

We sell the produce, eggs, and honey from Wyck's Home Farm at an onsite weekly farmers market held in partnership with the Food Trust, which operates twenty-five farmers markets throughout Philadelphia. Wyck's market is the longest-running market in our area. It takes place along Germantown Avenue (the main commercial corridor through Germantown) and runs from early June to mid-November. Usually picked within hours of being offered for sale, our very high-quality produce is sold at below market prices to our customers, and we accept the federally funded Farmers Market Nutrition Program vouchers and Supplemental Nutrition

Assistance Program benefits, the successor to food stamps. These ensure that all of our neighbors in our socioeconomically diverse area can access this fresh, local produce.

Very few farmers markets take place at the growing site, and of these even fewer are located in an entirely urban neighborhood. Visitors to Wyck's farmers market are always encouraged to visit the gardens and grounds at Wyck to see where and how their food was grown. Our farmer is always on hand to answer questions about growing and cooking the produce she has for sale each week. The market serves approximately 2,400 people, many of them repeat visitors. Almost 50 percent of shoppers walk to the market and in general, their produce consumption (based on market sales) increases and becomes more diverse each year. Wyck's farmers market has become a mainstay of the community and an important way of making Wyck more accessible for, and therefore relevant to, our neighbors.

After adopting our 2006 strategic plan, Wyck's youth education program developed a new emphasis on outdoor education, with our landscape serving as a living classroom. Our education program provides outdoor experiential education for schoolchildren, ranging from preschoolers to high schoolers. The goals for the program are to nourish an appreciation for natural systems and our role as humans within them.

Wyck provides a natural forum for interdisciplinary connections. Students practice math skills by measuring plant growth, strengthen language arts skills by following clues to locate objects in the garden, and discover history through the use of traditional garden techniques, such as the Native American Three Sisters planting. In the outdoor classroom, students are able to help direct learning, increasing their engagement in lessons. By learning through discovery and observation, students develop skills in classifying, experimenting, and critical thinking. Wyck's lessons are aligned with teachers' thematic units and Pennsylvania Academic Standards to ensure that concepts students learn at Wyck are easily carried throughout their classroom learning and their sense of excitement about the natural world is sustained. On the Home Farm, students understand the impact the local environment, resources, and weather have on the success of the farm. We specifically reach out to Germantown children who are able to walk over for lessons. Learning locally increases student pride in their school and shapes the way they view their community.

Spinoff

With the success of the farmers market and outdoor education program, we realized there was more we could do for adults and families. We expanded program activity related to the farm and the rose garden. We

held workshops on topics related to urban agriculture and homesteading, such as permaculture, edible landscaping, composting, food canning, and beekeeping. With an update to our strategic plan in 2010, we streamlined these into a new format to engage the public with our site in a more holistic way through our Behind the Fence Festivals intended to engage our diverse audiences with not only our site, but with each other.

We launched a two-year pilot series of these community festivals geared toward themes that connected Wyck's history with contemporary trends. Generally, the themes included natural history, collecting/heirlooms, food, honey, and bees as part of the Philadelphia Honey Festival. Each of these allowed us to weave modern-day ideas connected to sustainable living with our site and history. Festivals include interpretive activities such as demonstrations, special tours or exhibits, talks, and tastings, combined with casual, social components such as live music and food. The festivals have been a huge success, almost doubling in visitation in the second year.

We have also emphasized sustainable practices through programs highlighting our garden of old roses, including an annual symposium. The Fifth Old Rose Symposium addressed the concept of sustainability specifically and how it applies to both public and private gardens.

One funder, the 1772 Foundation, saw the potential of our work, particularly in agriculture, to serve as a model for historic sites and encouraged us to host an educational program specifically for our colleagues. In 2011, we held an agricultural symposium for about thirty representatives from historic sites around the Eastern seaboard who wanted to explore the possibility of using some part of their sites for agriculture. Several attendees have since implemented these changes, causing an unforeseen ripple effect from our work.

Summary Story

Emphasizing our sustainable legacy and being ahead of trends helped Wyck triple its audiences in the last four years. It has also opened us up to new funding opportunities that would not have been available for the traditional activities of a historic site.

Our organizational philosophy has become clearer, as we have committed to be as green as possible within our means in terms of our operations. Office and cleaning supplies reflect our commitment to sustainability, as does our use of rain barrels, employing traditional and organic gardening techniques, and supporting local businesses when possible. We buy local when we can and partner with local businesses, artists, and other vendors at our Behind the Fence Festivals and farmers market. This helps build an

overall sense of community with our programs as well as showcases local businesses and organizations for our diverse audiences.

In 2012, we received exciting national recognition for our work. The Institute of Museum and Library Services awarded us a $148,643 two-year Museums for America grant for engaging our community. This grant supports the growth required to implement our strategic plan, expanding program staff positions to accommodate more time for program planning, promotion, and implementation. We feel that the less traditional aspects of our work, namely our Home Farm–related programs and our commitment to social and environmental stewardship, distinguished our application from the rest of the field. Reviewer comments validated our work:

- Keeping the site's historic Home Farm in production, and then selling the produce through a farmers market, which therefore gives an urban neighborhood access to fresh produce, is brilliant.
- I found this proposal extremely compelling and is a real departure from the way in which large numbers of small history organizations tend to focus their activities.
- The proposal is choosing a novel approach to bring history to diverse and underserved communities. Wyck is capitalizing on its strengths in the area of agricultural/horticultural history by making itself acceptable and welcoming to these targeted audiences by creating a sanctuary for an inner-city community and by instilling an appreciation for nature and the protection of the environment. It also is addressing a nation-wide concern re: the need for better nutrition and for access to low-cost health foods.
- This proposal is highly aligned with the strategic goals of the institution and with the Engaging Communities Category of [Museums for America]. The project presents a thoughtful and inspired approach and model for an historic site in meeting contemporary community needs.

Future

Wyck's commitment to sustainability is fully ingrained in how we operate and how we are perceived by the neighborhood and surrounding area. We intend to continue our work to offer programs that encourage healthy, sustainable living and to lead by example with our operations. Our next challenge is to incorporate the concept into more of our interpretive materials, highlighting that while this commitment stems from modern-day concerns, it is also the legacy of the family who lived at Wyck. Our sustainability efforts will always be a work in progress, dictated to a certain degree by our

human and financial resources. But we are encouraged by the progress we have made thus far and the opportunities that have presented themselves as a result of implementing this vision. Our commitment to sustainability has opened many doors and accelerated our organizational reinvention, focusing early on how to make Wyck relevant to our twenty-first-century audiences, which now includes much more of our immediate neighborhood. We still see much more potential in this area and look forward to realizing it. At Wyck, we are not simply preserving our historic site and collections, but we are actively using them to build a healthier, more vibrant community, with sustainability as a core value. Our programs and events bring together people of different backgrounds and perspectives to share information with each other, connect with an ongoing history, and enjoy nature right in the heart of Germantown.

When Danielle Henrici began her job as director of education at the Farmers' Museum in Cooperstown, New York, in early 2014, she recognized that New York's rural farming heritage was the interpretive driver, but she wondered what it means "to understand peoples' relationship to agriculture and connect them in ways that define its value in their lives." Museum President Paul D'Ambrosio and Board President Jane Clark were thinking along similar lines. Together, they are strengthening and sharing more broadly the message that farming is not history; farming defines this region of New York State, and is an economic driver and a lifeway there presently. So how can the Farmers' Museum use its talents and resources to celebrate and support agriculture? Its 120 acres began as a working farm in 1790s and has continued without a break. The museum has co-sponsored the local Cooperative Extension's 4-H junior livestock show since 1947. It is the second-largest youth competition in New York State.[4] The museum's collection of tools and other artifacts related to farm life and farming communities have a strong emphasis on the nineteenth century, and the museum actively documents twentieth- and twenty-first-century farming.

When Henrici wanted to extend and expand the agricultural exhibits and programs at the farm as a resource for local farmers, she approached State University of New York Cobleskill for a partnership developing exhibits on agriculture. State University of New York Cobleskill's School of Agriculture and Natural Resources counts as its "laboratories" a working farm, greenhouses, fish hatchery, a two-hundred-cow dairy, and an agricultural

engineering technology facility. Modern talent, technology, and science help train young farmers and food production technicians.[5] The result is *Seasons of Change: Heritage and Innovation in Agriculture*, a two-year partnership creating six seasonal exhibits.

Seasons of Change is a student/staff-designed six-part exhibit for 2015 and 2016, reflecting "distinct agricultural production seasons and the stunning progress in technologies/processes important to season-specific activities." Each installation will have a seasonal focus, compare-and-contrast exhibits on early and modern agricultural techniques, video interpretation of modern in-the-field activities, examples and samples of great varieties of cultivated foods and agricultural resources, and how-to activities. Each year there will be an April to May exhibit called "Primavera! From Winter Scene to Splashes of Green," which will focus on spring planting and early growth. The June to July exhibit, called "Let it Grow!," will focus on the in-field work of agriculture and aquaculture. The August to October exhibit will be called "Time to Reap!"

The existing Featured Farm Friday program that Henrici debuted in July 2014 dovetails nicely with the exhibit plan. During the growing seasons, the farm hosts weekly events for area producers to showcase their animals, produce, and practices—it's essentially a mini-farmers market with educational and interactive components. Visitors can participate as part of admission. It is too soon to determine if the program affects attendance significantly, but the Farmers' Museum is receiving positive feedback from museum guests and participating farmers.

In the fall of 2014, the museum will host a conference called "A Celebration of Our Agricultural Community" and explore the importance of agriculture in our communities and our economy, while also providing new and experienced farmers with the tools and connections to be successful. The conference purpose "is to inform and inspire farmers as well as the public, unifying and driving the agricultural economy in Central New York." The night before the conference, the museum will screen the film *The Great American Wheat Harvest*.

It is not just a conference, though; it's a new way of working with the community. The Farmers' Museum describes its approach in the conference promotional materials:

> The Farmers' Museum recognizes the importance of contemporary farming and is committed to providing resources and networking opportunities for regional farmers to connect with information, potential partners and prospective customers. In so doing, we expect to update our image and encourage our guests to view us as a part of

the fabric of farming both yesterday and today. The conference will highlight heritage-based as well as biotech farming and ways in which traditional techniques can and should inform modern ones.

At the same time, this conference will empower the public to become educated and engaged consumers as we explore current trends, providing opportunities for people to learn more and get involved. It is in fostering a deeper appreciation for and understanding of the various processes involved in farming, as well as the issues farmers face today, that we support and stimulate the exciting agricultural evolution that is so vital to the health and well-being of our citizens, our animals and our land. We start local to go global, becoming an active part of the agricultural movement that will shape the [twenty-first] century.[6]

Now *that* is how to contemporize history and engage with your community around sustainability.

Adding a new layer of programming and interpretation, such as this, may require new levels of effort for your organization. One open air history site began building its new interpretative emphasis with the help of a summer intern dedicated to sustainable agriculture. The goal was to develop potential programs on sustainable agriculture, but the focus was flexible: options ranged from heritage breeds and heirloom fruit and vegetables, to a Farm-to-School program or farmers market. That flexibility illustrates both the newness of the programming and wide-open opportunity. The approach also demonstrates a willingness to build on the students' interests and expertise. If you are looking for green talent, there may be more sustainability knowledge in your interns or youngest staff than in those who have been around a long time, but it is important that everyone begin to acquire the knowledge, just as they would for any new interpretive work. It's not an add-on; it's good work.

Challenge

Andrea Jones is the director of programs and visitor engagement at Accokeek Foundation in Accokeek, Maryland, about halfway down the western shore of Maryland, up against the Chesapeake Bay. Hers is a new position, one designed to help unite the site and coordinate interpretation. The property includes the Ecosystem Farm and the Colonial Farm, and has a land conservation mission plus a heritage breed program.

What has been known as the Museum Garden has a new life this year as a study in cultural influences on gardening: Native American, African,

and European descent. The contrasts of a People of the Potomac garden versus the straight-line, heavily ornamental English version, and the African garden with its raised bed and compost-ready design help visitors recognize the variety of cultural values demonstrated by how humans cultivate plants, and it is a great beginning point for discussing the evolution of agriculture over centuries and still today.[7] Jones points out how the Native American garden appears overgrown and disorderly, and the African garden has crops that seem to persist despite less than perfect conditions, while the European one "clearly dominates nature!" "Value systems are very powerful." She marvels at how the system from Europe focused on growing cash crops to send to England rather than developing a subsistence farmer. That emphasis meant that the goals were more about upward mobility than subsistence. Many diverted energies into working for cash returns that brought them a mirror, window glass, or a finer house that demonstrated their wealth to others involved in the cash economy. Upward mobility—more, better, faster—challenges sustainability today and is a symptom of that upward mobility drive Americans have that is "part of the problem," she says. "History can show us how strains of value systems have stayed with us and how they have continued to propel problems."

An excellent blogpost by Anjela Barnes, marketing director, reviews sustainability on the Colonial Farm. She compares modern industrial farming to historic techniques. She illustrates how historic approaches made choices about land use based on ensuring the continuing ability to farm the land successfully given the limitations of nonmechanized, single person cultivation of colonial acreage. Frontier, or near-frontier, farmers used crop rotation, hill planting, and crop selection to focus on food production most efficient for their conditions. That was a more sustainable approach for the long term.[8] Farming designed to support a cash crop—historically or today—emphasizes monocultures and current returns over soil management for long-term sustainable site production.

Enhancing environmental sustainability and unifying the interpretation at the site are not Jones's only challenges. She feels keenly the field-wide, national worry about too many historic sites being a threat to coexistence. "There are too many of the same thing," she says, and that at Accokeek it is time "to use a different lens." So she is piloting a new interpretive program that turns its back on the "point-and-tell tour" and instead engages students in an adventure.[9] There's no loss in the history story, she says, but a shift in content *and* method. Jones's work as an educator, both in the classroom and in museums, has focused on making history relevant and personal. Using techniques such as role-playing, simulation, and theater, and to use historical events, from the Freedom Rides to the Trail of Tears, to help

learners in a quest to answer the essential question: Who Am I? "After all," she says, "much of learning is like building a patchwork quilt of experiences that shapes how we live and the choices we make." This new effort to teach visitors about environmental sustainability through a past-to-present lens seems to her to be a natural extension of her work. "People make choices every day about whether to buy organic vegetables or how to commute to work. And there is no cut-and-dried "right" answer. So it's easy to make history extremely relevant because it can be used to inform these daily choices. When a visitor learns that people used to go to bed at sunset, it can lead them to consider the value of electricity. Is three extra hours of awake time worth the coal extraction and burning as a result? That's where Eco-Explorers: Colonial Time Warp comes in."

This new school program for grades second through fifth challenges students to reexamine historical and present-day choices. Jones explains that although modern inventions may harm the environment more, looking at historic lifestyles helps illustrate how *little* our values have actually changed. This program challenges visitors to consider: Who am I? Do I have the same values that Americans had two hundred years ago as they worked long hard days just to obtain material goods and a higher status in their community? What environmental cost does a "better life" have? Do I care?[10]

Demonstrate

We know from our training in museum education that to be effective we must first meet the learner at his or her stage of understanding, then progress from there. This approach reduces the chance of disengagement through confusion or overload. We also know that many learners do not prefer books, lectures, or even guided tours; many prefer active learning that requires them to physically participate, to contribute to a discussion or exploration, or to learn in a nontraditional setting. Sustainability topics are ideal for this.

The increasing involvement of the public in growing and preparing local, healthier food for themselves is a healthy change. The obvious options are a produce canning workshop or an heirloom vegetable garden tour and tasting. The visitor will look at local, sustainable farmers and community-supported agriculture programs in a new way because of a chance to tour the fields or help for a morning. Would they have that same connection if they had heard about this in a lecture?

You might have something more physical to offer such as learning to spin on one of the many extra spinning wheels you have (that you have

Description of Accokeek Foundation's School Program Launched in the Fall of 2014

Andrea Jones describes how the school program works:

Normally, children at our site would learn about the laborious life of middle-class tobacco farmers—what they ate, what conveniences they lacked, how much time they spent in the fields. Teachers and students marvel at how much better our lives are today. The Eco-Explorers tour takes a different approach and asks the question: If we gave colonial farmers modern conveniences to improve their lives, would it be worth the toll on the environment? To extend that question, what conveniences in our lives today are worth the environmental cost? Students still learn about the colonial lifestyle, but they learn about it in a more relevant context.

In one portion of the program, the students come across an actor who plays "Mrs. Bolton" in the tobacco barn. She has discovered modern-day pesticide and is hopeful and excited that this invention will save her labor, increase her social standing in the community, and allow her to make a better profit to take care of her family's needs. After all, her son Ben was sick last year and they had no money for a doctor, since the lousy flea beetle ate half of their tobacco crop. The students on tour, having been briefed about the ill effects of synthetic pesticide on the ecosystem, often try to talk Mrs. Bolton out of using the new discovery, despite its apparent ability to help the family. But sometimes students think the environmental costs are worth the benefit. In this way, we are encouraging them to make informed decisions, but the decisions are still theirs. It's part of prepping them for life in the twenty-first century, as we all struggle with how green we want to be. Is it worth it to ride a bike to work, knowing you'll be sweaty when you get there? This tour will hopefully help students to learn how to navigate those everyday decisions with more knowledge and awareness.

We sometimes get questions about whether our tour is actually teaching history. I think people are skeptical because history is the setting or the backdrop in the story. It's similar to any work of historical fiction for kids, like the wildly popular *Magic Tree House* series, where characters are involved in an adventure within the context of history. Students learn about history through the story, but not because facts are dictated to them. In this case, the mission of our characters is to use time travel to save the Earth. It's exciting and students have a goal—a reason to learn about colonial times.

ere is the program description provided to teachers:

> A perfect way to integrate history and environmental sci-
> ence, *Eco-Explorers: Colonial Time Warp* is not a tour; it's an
> adventure!
>
> As members of a specially appointed Eco-Explorer
> team, students are engaged in a very important mission to
> save the Earth and change the course of history! A problem
> arises in real time when the Eco-Explorer team learns that
> a group of well-meaning time travelers has recently trans-
> ported back to the year 1770 to give one family several mod-
> ern objects that will make their lives easier. But, if left on the
> farm, some of these objects could set in motion a chain of
> events that destroys the environment for future generations.
> It's up to the Eco-Explorer team to zoom back to 1770 to
> recover these items and replace them with colonial items
> that serve the same function. Along the way, they will care-
> fully weigh the positive and negative effects of the modern
> conveniences to decide whether to confiscate the objects.
> To make matters more complicated, the Eco-Explorers run
> into real-life characters who will challenge decisions that the
> students make and humanize the impact of these decisions.
> In the process, they learn valuable lessons about the pace
> and practices of everyday life in a very different era.
>
> The essential question explored in this program is one
> that we all ask ourselves every day, but which has no easy
> answer: *Which modern inventions are worth the environmen-
> tal impact that they have?*
>
> By the end of this program, students come to learn that
> they may not have the technology to travel back in time, but
> by making eco-friendly decisions, they *do* have the power to
> change the future.

transferred to your education collection). Or maybe it is something more
active such as helping to replant a prairie, or learning to drive a horse-
powered plow in the farm field. Colonial Williamsburg lets visitors step
barefooted into the clay pit to mix materials for bricks. What about the
wattle-and-daub Cherokee homes? Can a guest help you as you repair the
exhibit annually? Your description of how these buildings helped families
keep comfortable, efficiently, in winter and summer, will last longer when

they think of their role in helping keep them up. The opportunities are endless, but they require thought and a change to our hands-off history approach.

Gwendolyn Miner has an awesome job: supervisor of domestic arts at the Farmers' Museum, Cooperstown, New York. Name any modern home-steading trend, and she and her team are probably proficient in the 1840s version. The working nineteenth-century Lippitt Farmstead is busy with dinnertime farmhouse cooking and domestic activities, and the poultry house, pigpen, turkey house, and a hop house are nearby. The gardens produce hops, vegetables, and herbs. The farm is home to Narragansett turkeys, Cayuga ducks, Dominque chickens, and Milking Shorthorn cattle—all heritage breeds. Twelve months of the year, it produces for the historic food-ways program—all with a pre-1840s focus. They grow, harvest, store, and cook. Miner has a wealth of knowledge on historic practices, foodways, and agriculture and industry in the area, and how that all translates to modern-day agriculture and domestic arts. Any visitor can catch the bug for do-it-yourself practices and leave with a few tips on how to start. The gift shop stocks an impressive selection of the most useful books on hop-growing, home vegetable gardening and canning, beekeeping, and all sorts of domestic crafts.

But even with such talent and knowledge, there are some limitations to what can be accomplished. The Lippitt Farmstead's staff practice some seed saving, and they're well versed in the area's history of seed saving by farmers and businesses in the area. The Farmstead's practice is small scale for good reason. She explains how saving the larger seeds is easiest because those varieties are much less likely to cross-pollinate. To truly protect seeds sources for purity requires larger, more separate fields providing nearly iso-lated conditions for particular plants such as beets and carrots. The larger seeds, such as squashes, tomato, and beans, are also much easier to handle. This lends itself to an important, long-term partnership with the Pathfinder School, a nearby program for youth ages five to twenty-one with devel-opmental disabilities. As part of the prevocational program, the students package seeds that will be used on the farm and sold in the gift shop. The process provides a good, dependable product and saves museum staff hun-dreds of hours annually, and the students practice the executive functioning and practical skills of selecting, matching, sorting, counting, and packag-ing seeds. It also helps support heirloom seed work, something each of us should consider supporting where appropriate. And as a bonus, the Fore-sight Research Report "Environment and Resource Sustainability in Muse-ums" published by the California Association of Museums forecasts that by the year 2030, global warming could have reduced native plant availability

to the point where museums and gardens with seed banks will be selling their seed products to earn significant incomes. What do you think about that?

As vegetable gardeners inquire about the potential for seed saving, craft beer enthusiasts are also curious. At Lippitt Farm, this is an opportunity to talk about how to raise and dry hops, and ferment and mix the liquid into table beer as local farmers of the period would have. At one time, hop growing was a lucrative business in upstate New York, and local farmers progressed to growing it as a cash crop in the nineteenth century. Today, at Strawbery Banke in New Hampshire, the heirloom hop crop and beer making is a small program but a useful community connection. John Forti, previously the horticulturist there, says that the "mid-sized, small-scale and micro-breweries" are experimenting with different hops without required large quantities for production. Strawbery Banke Museum's more than one-hundred-year-old vines growing on its Aldrich Museum arbor have been used for green-hop beers (those brewed within an hour of harvest) with Portsmouth Brewery. The museum has also successfully dried and freeze-dried hops for use in beers with other breweries.[11]

Hop producing and processing, though, is not quite the grain-to-beer process today's home brew kits suggest; nevertheless, it is an engaging topic for visitor conversations. Beer making is a difficult project involving the same degree of skills, time, and attention that many less-common arts require (milling corn and making cloth, for example). Museum beer production as a business is complex, so examine your options carefully and speak with growers and brewers before you begin your new program. You could consider growing hops as a crop or letting a brewer use your land for cultivating. The surge in craft brewing is supporting rising prices for hops—again.[12]

Miner, at the Farmers' Museum, is being modest when she says they do a "decent job of land-to-product" with wool, making good use of what they collect. It is more than at most sites, and perhaps not as much as they would like. Some is hand processed at the Lippitt Farmstead, some is collected and custom processed in a mill, and some is processed onsite. What they produce is woven or knitted for use in the museum setting or sold in the shop. She says the museum makes a conscious economical decision based on the number of sheep that can be kept on the land. She says they send one hundred pounds of fleece every two or three years to be processed and returned as yarn. She saves one or two fleeces to hand process. All the yarn is used for knitting or for weaving cloth. Flax is "tricky to grow," she says, it requires more acreage for sufficient production, must be harvested by hand, and has a complex process of soaking followed by separating and breaking

before it's time to spin, weave, and use the product. "There's a reason why people stopped doing some things," she says. When hops could be sold for industry to brew, and the farmer could earn cash instead, hops were grown for trade, not home use. When mills were readily available for spinning wool and weaving cloth, it made more sense in effort and cost to choose manufactured material than to grow, process, and weave it all on the farm. In the 1820s and 1830s, when growing flax for seed became more viable as a linseed oil source, or for seed sales to Ireland, home linen making faded.

No wonder these skills are not common anymore—beer making, seed saving, milling, and making linen or wool cloth all became easier, more efficient, and more affordable in a larger-scale, mechanized industry. This can be an important discussion with visitors about "the old ways" and whether, or why, they were or were not more environmentally sustainable. It is an excellent way to discuss the coming of the Industrial Revolution and the changes in family life and work, in cultivation and production, consumption and spending and earning—and in changing the climate.

Involve

The John Hair Cultural Center at the United Keetoowah Band Tribal Center in Oklahoma is planning a heritage garden for demonstration purposes and student volunteering. Many band members have grandparents and great-grandparents practicing some of the historic foodways—making kunachi from hickory nuts and rice, or hominy (from field corn), and popcorn—but few have an opportunity to see and practice it on their own. These are great opportunities to involve learners of all ages through the heritage garden, and its snack-making and meal-making activities during the season. The obvious planting choices, and good ones for young growers, are heritage tomatoes, beans, peppers, pumpkins, squash, potatoes, and corn. The garden activities may even attract more attention to the museum since it will be visible to all who come to the Tribal Center for services and work, which is next door.

The Cultural Center's foodways program can also lead to gathering trips to the woods and prairie, whether on their own allotments or tribal property, or alongside the road. Keetoowah elders can teach younger generations to recognize appropriate foods such as hickory nuts and mushrooms. With the help of tradition keepers, the center can expand gathering activities to include natural materials for basket making, for stick making (for stickball games), and for dying raw materials for textile making. When the nearby elder housing complex is complete, it is possible the heritage garden and a new community garden area can be combined. This will provide

intergenerational opportunities for teaching and learning, create a connection to heritage plants and foods, and support healthy activities and healthy eating.

At Living History Farms near Des Moines, Iowa, the programs tackle where food comes from very seriously.[13] The museum's purpose is increasing public awareness of the significance of agriculture in the development of America. It uses scientific and technological changes that have occurred in agriculture and interpret how those changes affect Midwestern rural life experiences. "One of the ways farming and agriculture greatly impacts everyday life of Americans is through the food that we eat."[14] There has been a dramatic transformation of some sectors of the public from anonymous grocery shoppers to farm foodies, or at least farmers market foodies. This comes from concern over genetically modified food and food safety scares and concerns. It has been encouraged through media exposure of factory farming and animal processing practices, and the writings of authors interested in smaller-scale, locally focused, organically grown food.

Living History Farms began a program in 2009 that educates seventh graders about their food instead of distancing them from it by contrasting old and new: the program was chicken dissection. Since food preparation, particularly meat preparation, has long been removed from family activities, how a chicken gets to your table is no longer a familiar topic. By branding the program in language aligning it with longstanding curricular activities, the interpretive staff got themselves in the door with teachers. They tied the science of physiological systems (muscular, skeletal, digestive, neurological, etc.) to the historic processing aspects. Interpreters discuss science and food while using a nineteenth-century approach to scalding, plucking, and, this is important, cutting up the chicken and identifying the sections students are most likely to find on their plates at their own meals. "This part of the program drives home the interpretive themes. It is the reason why Living History Farms interpreters interest the kids in dissection: It might encourage them to learn more about their food. By taking food back to the source, the interpreters provoke thought about the modern availability of food compared to farms in 1900, about the different sides of agricultural debates today, and about the environmental sustainability of current food systems." Give those educators a gold star!

Food is big. The discussion is too. Bumper stickers abound: "Who's *Your* Farmer?," "No Farms, No Food" (and now "Yes Farms, Yes Food"), "My Other Ride Is a Tractor," "How Far Does Your Food Travel? Support Your Local Farmer," "Know Your Farmer, Know Your Food," "Eat Well, Eat Local," and "Boycott Factory Farming." Museums and sites with an agricultural message have an obvious engagement opportunity. At Accokeek

Foundation, the Robert Ware Straus Ecosystem Farm was established in 1991 to teach sustainable agriculture and living. It is a solar-operated, certified organic farm with workshops, volunteer-to-learn opportunities, and a farm market. The monthly Modern Homesteading Workshop Series, offered for free, includes a skills workshop plus a tour of the farm for related demonstrations—extending the growing season, seed saving, organic planting, putting up foods, fermenting and home brewing, etc., and wraps up with an end-of-season celebration in December that reinforces the community and communal value of local food. Beyond offering one's own community-supported agriculture program or hosting a farmers market, farms can teach skills and awareness for where food comes from, how it is grown and processed, what goes into it and what doesn't, and how those choices affect the quality of the food, the lives of the people involved in growing it, and the lives of the people in surrounding growing areas. It is a complex topic, and it is politically charged. It is powerful, and as an engagement opportunity, it can be as moving as you wish it to be.

Connect

Environmental sustainability is about not harming the planet and possibly helping it. People most often think of recycling and saving energy and water when they hear the term. Recycling has grown in popularity as an antipollution campaign originally, and now a resource- and land-management situation. As we become more sophisticated in recognizing our direct impact on the land, air, and water, we've also discovered signs of previously invisible changes. These changes occur at more of a distance—out in the ocean, up in the atmosphere, and gradually, with few of us noticing or knowing where to look. These changes have finally become so large and so complex that we've noticed them, but we can't quite understand them fully yet. And reversing them is even more complex. So we're pretty nervous about them, and about *talking* about them. Well, there is enough data now—anecdotal and empirical—to demonstrate that the climate is changed, so let's get moving.[15]

Still, history organizations appear to be very reluctant to discuss a changed climate. Some science museums take it on, but few history museums or historic sites. Many are reluctant to step into what may become a politicized discussion; others feel they do not have the climate and physics knowledge to explain what is involved in a changing climate. Many avoid appearing to state an opinion and choose only to provide data so visitors can draw conclusions. Possibly, museum professionals tell themselves that climate is a topic for scientists and science museums, and that recycled materials are for community art programs. And/

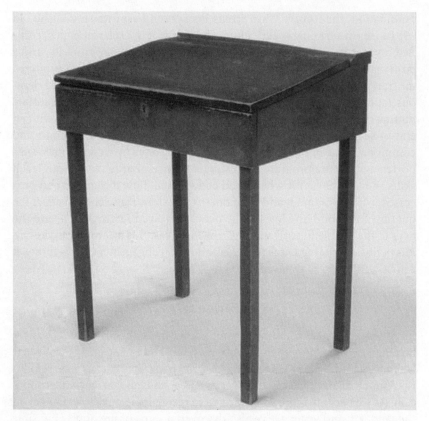

PHOTO 6.2. Henry David Thoreau's Desk, about 1838. Painted pine, iron. Gift of Cummings E. Davis, 1886.
Courtesy of Concord Museum, photograph by David Bohl.

or perhaps they think that history buffs don't visit for a depressing lecture on present-day climate, but instead for immersion in archives and objects, papers, books, and peoples' stories. Well, history museums and historic sites are well placed to tell stories about weather and about climate, and they can do it using photographs, archives, objects, oral histories, and journals, for a start.

But first it is important that we all recognize that weather is not climate; the variability in local or regional weather by day, season, or even a year or two is in no way similar to the phenomenon of climate on a global scale. Any confusion of weather and climate really is about geologic time and scale. Changes to climate take place over decades and centuries, and are amplified by ecosystem feedback loops. That's what we're tracking when we

measure temperature and greenhouse gases across decades and centuries. Given the long arc of climate, isn't historical perspective an important characteristic of communicating climate change? Of course it is. So, again, why is there is so little discussion of climate change in exhibits in history museums or historic sites? Welcome to *Early Spring: Henry Thoreau and Climate Change*, a jewel of an exhibit at Massachusetts's Concord Museum in 2013 and now online.[16] It all started with a journal. Thoreau's. 1837 to 1846. And it was a perfect bridge from past to present, between history and science, and a connection to anyone with a backyard, front path, or nearby park.

> Moist banks covered with the nearly grown but green partridge berries now. Prenanthes almost. Tobacco pipe how long? Coral root well out.
>
> —Henry David Thoreau, Journal, July 29, 1853

Data mining journals and day books are a staple of good history work. It's also expected and therefore perhaps not so particularly remarkable. Why is this exhibit different? Two reasons: the celebrity of the author (and icon status of Thoreau's journal), and the comparative observation taking place, right now, through Boston University in the exact spot where Thoreau made his observations. Science and history—the two critical components to understanding a changing climate.

Walden Pond and the Concord area of Eastern Massachusetts are pilgrimage destinations for Thoreauvians. The Concord Museum has long been home to the most physically and intellectually accessible collection of Thoreau artifacts and history. The Thoreau Gallery is a permanent space housing important collections. It showcases Thoreau's writing desk, some of his survey equipment, and items related to his life in Concord with his family and his experience living at Walden Pond just two or so miles out of the town center. In 2013, the museum created an exhibit for its major temporary exhibit gallery, afterward repurposing components to overlay interpretation in other areas of the museum, including the permanent Thoreau Gallery. Now the museum has extended the work to a longer-lived, globally accessible online format.[17]

The temporary exhibit was curated by David F. Wood of the museum with ecologist and guest scholar Dr. Richard Primack of Boston University; Caroline Polgar served as a scientist in residence. Using the immensely powerful icon of observer and writer Henry David Thoreau, the exhibit demonstrates the value of comparing historical to present-day bloom dates of hundreds of plants species, plus other local climate phenomena, for visualizing changes in climate in a Massachusetts "backyard."

Many of us have noticed that trees or flowers in our own yards or communities bloom at different times each year, or that different vegetables are happier in our gardens this year than in years past, but how does this personal experience connect to a global phenomenon of climate change, especially one that seems like it happens in other countries or other altitudes and latitudes? And, how does a museum or historic site share that with the public? Here's an introductory text from *Early Spring* as a great example:

> After years of hearing about climate change affecting distant alpine wildflowers and polar bears, Dr. Richard Primack of Boston University decided to search for evidence of climate change closer to home. When alerted to the fact that Thoreau had kept detailed records of natural phenomena in Concord, especially flowering times, Dr. Primack and his students set out to continue Thoreau's work and discover how a warming climate had changed the time of seasonal life cycle events of Concord's woods.
>
> By comparing their own observations of natural events to those of Thoreau and other Concord naturalists, the Primack Lab scientists have been able to measure how seasonal events like flowering and leafing times, migratory bird arrival, and butterfly emergence are advancing with warming temperatures and changing over time. There is overwhelming evidence that as the climate warms, spring is coming earlier to Concord. Concord has emerged as a living laboratory for climate change research and is regularly featured in newspapers, magazines, websites, and textbooks as one of the clearest examples in the world of the ecological effects of climate change—all building on the legacy of Thoreau.

The exhibit moves from the convergence of data from two different centuries, to case examples in Concord, to what-can-you-do messages for the visitor. Visitors could see expected collections artifacts such as Thoreau's journal and writing desk (together again for the first time in over a century), herbarium specimens of his own making, and his spyglass for bird watching, among others, but also photographs and stories about other professional and amateur naturalists from Thoreau's time to today. When did/does the ice leave Walden Pond in the spring? When do the red maples turn color? When do which migratory birds arrive? When is the first snow fall? The timing of Lady Slipper blooms? These phenomena can be compared while telling the history of Thoreau, Concord, and Walden, while connecting it all with present day experiences, even on the visitor's path to the museum's entrance.

Thoreau kept records about the ice on Walden Pond, noting "ice out" from 1846 to 1860: then the average date was April 1st. From 1950 to 2009 that average was March 17th, or two weeks earlier.[18] The "Ice In" label text describes temperature and snow cover changes in the area and explains how snow is an insulator for the soil, and that without it frost penetrates more deeply. Scientists are studying what ecological changes that may bring, suspecting it affects small insects and smaller shallower plant roots. On a more personal note for some visitors, these changes affect today's opportunities for recreational activities. The exhibit displayed Thoreau's snow shoes alongside historic images of Concordians enjoying the winter landscape. Thoreau reported skating along the Concord River on January 14, 1855, to visit a friend. A photograph of the same space on January 14, 2013, shows the Concord River free of ice.[19]

The exhibit's photographs of present-day birdwatchers in the field, and the species they find in the area, made the birding notes from distant history feel more personal for the visitor. Visitors might have recognized themselves or their own experiences as they read about four similarly minded, twentieth- and twenty-first-century Concordians who contributed to the environmental record-keeping tradition and also found themselves contributors to the exhibit. There is a long line of professional and amateur historians, photographers, ornithologists, ecologists, and botanists in Concord's history, and the visitors were invited to be a part of that special group, citizen scientists, really.

When this particularly popular exhibit closed, and during the second year of the grant from the Institute of Museum and Library Services, the museum staff thoughtfully, and sustainably, repurposed portions to the permanent Thoreau gallery and added exhibit components in adjacent areas to extend the learning. The grant allowed the museum to build on its relationship with the Concord-Carlisle High School, working with two teams of students in a semester-long internship on projects inspired by *Early Spring*. In fall 2013, students developed activities for a new "Be Thoreau" family corner in the permanent gallery, taking inspiration from Thoreau's writing, nature observations, and time at Walden Pond to develop fun and engaging activities for family visitors: leaf rubbing, drawing, and a Lego game, guided by directed questions developed by the students, and posted on a magnetic board by visitors, to help families connect with Thoreau's life, work, and philosophy. The activities have been very popular with families; museum staff have noted anecdotally that visiting families spend significantly more time in the museum's permanent gallery than was typical.

This exhibit ran five months in 2013 attracting 18,243 visitors, students, and tour groups. This audience differed significantly from the museum's

usual history-focused visitors. How did the museum fund the new program and partnerships? In the way any efficient institution does: saving money where possible, involving supporters and donors to provide funding and promotion, and piggy-backing nearly all activities and ideas on others so as to increase impact for each segment of their efforts. Most importantly, in 2012 the Institute of Museum and Library Services supported the main exhibit, programming, and online components with a two-year, $140,979 grant. Executive Director Margaret Burke said that Institute of Museum and Library Services staff had been very encouraging about the plan to blend the science and humanities. When announcing the grant, she said, "The Concord Museum is pleased and proud to receive this highly competitive federal grant in recognition of the national importance of our Thoreau collection. The funding of *Early Spring* will allow us to significantly broaden the collection's visibility and use by citizen scientists interested in the natural environment and scientific inquiry."

The local garden club supported a phenology garden onsite. No, not phrenology, that would be the nineteenth-century practice of mapping the skull and associating personality and behavior characteristics based on the features of the cranium. Phenology, the word without the "r," is the observation of annual and seasonal cycles, such as the bloom times, flight times, etc., of interest to Thoreau and Primack, as indicators of climate. The museum's front-door garden contains plant species most frequently monitored by phenologists. The goal was to encourage people to explore the Concord environment. Now any visitor participating in an activity with the garden is an instant phenologist and well on his or her way to participating in citizen science if they so choose.

The museum also offered three online resources through its website and on iPads in the exhibition to encourage visitors to explore further and spend more time in the gallery.

> **Go Botany:** The museum teamed up with the New England Wild Flower Society to create a customized version of the Go Botany online tool (http://concord.newenglandwild.org/) to list plants found in Concord, so visitors could observe the same species that Thoreau studied. Go Botany helps users observe plants closely, collect samples, take photos, answer questions, narrow down to the correct identification, and join an online community of plant enthusiasts.

> **Project BudBurst:** *Early Spring* provided links to Project BudBurst (http://www.budburst.org/), an online tool designed to engage the

public in collecting important ecological data such as when plants leaf, flower, and fruit in a consistent manner. The Concord Museum encourages visitors to participate in Project Budburst[20] to record bloom times for plants in their yards and contributing data to the main database. They become citizen scientists. Hopefully, a subgroup is developing: those citizens contributing to collective sustainability changes are practicing citizen sustainability. Scientists can then use the data to learn more about the responsiveness of individual plant species to changes in climate locally, regionally, and nationally.

Thoreau Trail: To create a framework to link the Thoreau-related sites throughout Concord, museum staff produced a mobile phone application, Concord's Thoreau Trail, which provides visitors with historical and tourist information, maps, audio clips, and ways to practice citizen science while out in the natural world. Because this app could be manipulated in ways the printed brochure and webpage could not, and while on the move, it offered a new level of museum interaction for visitors, and even after they left the museum. A total of 1,176 people accessed the Thoreau Trail phone application while at the museum. Another 131 people, including 55 out-of-town visitors, accessed it from websites including the Concord Museum's website, Google, and Facebook. The museum continues to offer a print version of the Thoreau Trail, now in its fourth reprinting.[21]

Two of these, the Thoreau Trail and Project Budburst, continue to be available to visitors even since the exhibit closed:

The process of developing this exhibit—collaborations, historic content, and visitor engagement—was familiar territory for the museum. The synergy of historical and scientific methods, with a shared landscape as the laboratory, and in service of a very interested public, meant that this exhibit reached a special level of success for all involved, and will continue to encourage such good work. Curator David F. Wood writes:

> The underlying principle of the *Early Spring* exhibition—in Thoreau's terms, that properly speaking there is no history but natural history, and in E. O. Wilson's terms, consilience—is now given regular consideration in exhibition planning and in programming. Because of the work of Richard Primack and his students, Concord remains a living laboratory for the study of phenology and climate change, and the Concord Museum will continue to share in the results of their studies.[22]

Action

Citizen Science mobilizes the public as a volunteer workforce for collecting field data to augment databases for species-specific projects or for monitoring environmental conditions or phenomena. So, for example, home owners collecting water samples off their docks in stream or river locations would be citizen scientists supporting water quality research. The Project Budburst participants are citizen scientists. ClimateCentral.org posted a call in August 2014 for everyone to take "drought selfies" to help climate scientists because crowd-sourcing images of drought provides data very different from the analytical measures the scientists already collect such as rainfall, soil moisture, and temperature.[23] "To classify a drought is one thing; to really understand how people experience it is another," says one scientist, Brian Kohn. Not only is this a great climate assessment resource, it becomes a great historical image database. The photos are marked for location, date, and photographer, so already they are partially organized. Just think what museums and sites could do with that information and how they could help collect and curate it to help the long-term climate discussion.

That isn't just science; it's sustainability work—citizen sustainability. And it's being practiced in all sorts of ways. If your site has an heirloom breeds program and launched an associated 4-H group as an outreach program, your institution is fostering citizen sustainability. This is an invaluable opportunity for your site to educate visitors, strengthen bonds with the public, and demonstrate quantifiable impact outside your property.[24] If you encourage seed saving for protecting heirloom plants and sharing nonchemically raised plants, you're encouraging citizen sustainability. If you participate in the Christmas Day bird count or you distribute saplings for visitors to grow heirloom apple trees, you're encouraging citizen sustainability. All these activities ask individuals to act, to participate in some collective aspect of supporting the planet where it's needed. Each aspect has the historic base that supports our missions. History organizations are an incredible force for mobilizing the public to improve sustainability habits and to encourage others—friends, neighbors, and leaders—to do the same. Don't skimp on making your difference.

Notes

1. Colonial Williamsburg uses the phrase "That the Future may learn from the past." Many institutions use similar approaches. Accessed September 28, 2014, http://historymatters.gmu.edu/d/7052/.

2. John Forti, email communication with author, April 21, 2014.

3. Michael C. Henry (principal engineer-architect, Watson & Henry Associates) in interview with the author, July 11, 2014.

4. The Farmers' Museum, "67th Annual Junior Livestock Show," accessed July 28, 2014, http://www.farmersmuseum.org/jls.

5. SUNY Cobleskill, "Academics," accessed August 22, 2014, http://www.cobleskill.edu/academics/.

6. Conference flyer provided by Danielle Henrici, September 12, 2014.

7. Anjela Barnes, "What's Growing On: Matt's Garden," Accokeek Foundation (blog), February 13, 2014, accessed July 27, 2014, http://accokeekfoundation.org/whats-growing-on-matts-garden/.

8. Anjela Barnes, "Sense and Sustainability: Colonial Maryland Planters and the Land," Accokeek Foundation (blog), March 13, 2014, accessed July 27, 2014. http://accokeekfoundation.org/sense-and-sustainability-colonial-maryland-planters-and-the-land/.

9. Andrea Jones in conversation with the author, June 20, 2014, and supporting article Andrea K. Jones, "Towards the Experience History Museum: All Hands on Deck," *History News* 69, no. 2 (2014): 18–22. http://resource.aaslh.org/view/towards-the-experience-history-museum-all-hands-on-deck/.

10. Andrea Jones, email conversation with the author, August 2014.

11. John Forti, email conversation with the author, August 13, 2014.

12. Sanne Kure-Jensen in beer-making workshop at Northeast Organic Farmer's Association Conference, August 9, 2014.

13. Erin Siebers, Janet Clair Dennis, Dan Jones, and Jackie Sciezinski, "Interpreting Farm Life in Iowa," *ALFHAM Bulletin* 42, no. 4 (2013): 25–28.

14. Siebers et al., p. 24.

15. See Spencer R. Weart, *The Discovery of Global Warming* (Cambridge, MA: Harvard University Press, 2013).

16. Except where noted, material related to *Early Spring: Henry David Thoreau and Climate Change* was collected through author interviews with museum staff on February 20 and March 7, 2014.

17. See Concord Museum's *Early Spring: Henry Thoreau and Climate Change* at www.concordmuseum.org/early-spring-exhibition.php.

18. "Ice Out" label text, *Early Spring: Henry David Thoreau and Climate Change*, Concord Museum, April 12–September 15, 2013, Concord, Massachusetts.

19. Ibid., "Ice In" label text.

20. Carol Haines, email exchange with the author, July 11, 2014. The printed copy of the trail can be accessed at http://www.concordmuseum.org/assets/Thoreau%20Trail%20print.pdf.

21. The description of these three components is substantially taken from an email message provided by Carol Haines, August 2014.

22. Concord Museum report to the Institute of Museum and Library Services, 2014.

23. Brian Kahn, "Crowdsourced Photos Provide Drought Snapshots," *Climate Central*, August 27, 2014, accessed August 31, 2014, http://www.climatecentral.org/news/crowdsourced-photos-drought-17945.

24. Sarah Sutton Brophy and Elizabeth Wylie, *The Green Museum: A Primer on Environmental Practice*, 2nd ed, (Lanham: AltaMira Press, 2013), 213. See also www.budburst.org.

Resources

Ashworth, Suzanne. *Seed to Seed: Seed Saving and Growing Techniques for Vegetable Gardeners*. Decorah, Iowa: Seed Savers Exchange, 2002.

Sponenberg, D. Phillip, Jeannette Beranger, and Alison Martin (The Livestock Conservancy). *An Introduction to Heritage Breeds: Saving and Raising Rare-Breed Livestock and Poultry*. North Adams, MA: Storey Publishing, 2014.

Weart, Spencer R. *The Discovery of Global Warming*. Cambridge, MA: Harvard University Press, 2013.

Wylie, Elizabeth, and Sarah S. Brophy. "The Greener Good: The Enviro-Active Museum," *Museum* (January–February 2008): 40–47.

༄ ༄

MATERIALS
What Comes, What Goes, What Gets Recovered, and What Gets Transformed

Vision

Historic sites and museums manage what they buy, use, and produce in ways that are thoughtful, and ultimately advantageous to both humans and the environment.

> In the [nineteenth century], Ralph Waldo Emerson suggested that when we bought sugar, we were prospering slave plantation owners; instead buy maple syrup which supports local farmers. A similar case can be made for purchasing sustainable products for our museums.[1]
>
> —John Forti, Director of Horticulture
> Massachusetts Horticultural Society

The earlier chapters on operations and energy described the importance of audits for determining current levels of consumption and types of institutional practices. The same applies to what you buy, reuse and repurpose, and throw away. This matters. Museums and sites have a significant impact through purchasing and waste distribution. Instead of just letting

purchases and waste "happen," take control of purchases so that you can make a bigger difference. By taking the time to inventory what you use and throw away, you can make more appropriate choices for environmental improvements. Start by auditing your purchases and auditing your waste.

If you have a computerized bookkeeping system, it can help you audit purchases through a report on the types and sources of items and materials you buy. Begin by looking at your own work purchases. Examine them by material type, such as how much office paper you use and if it contains any recycled content; by process type, such as specialty manufacturing that is environmentally damaging; and by quantity to see if there are opportunities for substitutions or consolidations to allow for bulk purchasing to save money and shipping miles. You can assess sustainability options even further by sorting them purchases by purchase location so that you can calculate distance traveled, and identify what local sources you're already using, and what materials you should try to source closer to home. Practicing on yourself will make it much easier to move to the next level: inventorying the items and materials your department. When you're done, you can tackle the next department, but this will do for starters.

Now you're ready to go deeper into what you buy and use. Choose an item for practice. Think about where a material or an item comes from, what it's made of, how it's made, how it gets to you, how you use it, how long it lasts, how you dispose of it, and what happens to it after it leaves your site. This is called the cradle-to-grave life cycle of a product. Understanding it will help you consider the actual impact of what you use to do your work. Though your review will be casual compared to the technical life-cycle assessment conducted in other fields, it will help you generally evaluate the scope of your materials use and the relative value of the environmental cost to the working-life benefit of the materials.

For example, consider the table you just ordered to replace the one in the boardroom. What is the new table made of: metal and glass, wood, or composite materials? If it's metal and glass, then it's very durable and relatively easy to recycle when you don't want it anymore. Hopefully, it was made in your region so it didn't travel far to get to you. If it is made of wood, then it's probably very durable, but is the wood harvested from a sustainably managed source or an unknown one? There should be a certification on the table or on the purchasing slip, if you still have it. Wood is considered a renewable resource, but only if the source forest is replanted after a harvest. Is the wood source considered local, within a few hundred miles, or did you choose teak which likely comes by sea from Asia, Africa, or the Caribbean? If it's sourced or manufactured locally, your purchase contributes to the local economy and avoids the greenhouse gas emissions

associated with long-distance transportation. If the table is made of composites, locally sourced or not, then it will be nearly impossible to recycle because the components can't be easily separated. Of course, if those materials are waste materials, then at least you're getting good use out of them. And are the components adhered with glue containing harmful chemicals or a formaldehyde-free formula? What about the materials? By purchasing an item made with materials sourced using environmentally friendly practices, the harvest and manufacture of your table will have a less detrimental impact on the environment.

Did the table really need to be new, or could you have let your network know you were in the market for a used one? What are you doing with the table you're replacing? Are you reusing it within the museum, offering it to another organization, or leaving it next to (or in) the Dumpster? There are so many options these days that you can actually decide the answer to each of these questions. What it requires is developing an awareness of the options, committing to exploring them and choosing thoughtfully, and then creating the time to act upon your decision. At first, it is hardest to find time to do this research, but as soon as you have a system and create a habit, it doesn't take any more time at all. The process can save money, reduce the amount of waste ending up in a landfill, and reduce materials and chemicals used in creating new objects.

Often using a different route to finding and distributing items has surprise benefits as well. Your education department may desperately need another worktable but not have the budget to buy one. Using your old table may greatly improve classroom conditions when larger school groups visit. And if it costs the institution to have garbage hauled away, finding a new use for that table onsite will save good money. And if you find a colleague organization to take it, you'll avoid hauling costs for yourself and purchasing costs for them. Before we became so aware of waste reduction, and in institutions where the departments are or were more like silos, opportunities for sourcing from and repurposing to other areas of the institution were uncommon. Thankfully that is less so now. In a small institution, it is simple to ask at the staff meeting if any department could use two chairs purchased as exhibit props, or a platform for the school program space, but in a much larger institution you may need to institute an internal version of Craigslist to find these opportunities.

Yes, it may seem complex to create new criteria for purchases, and it may not always work out, but you can easily develop the habits of inquiry that uncover and avoid the worst environmental behaviors. Soon you will have developed a good working list of items and resources that fit sustainability criteria appropriate for your location and your work. By assessing

your purchases, you can make more sustainable choices next time and begin reducing your waste before it reaches your site. Remember to choose just one or two types of materials as your first targets for greening. This will improve your chances of sustaining the process until it becomes a natural part of your work.

So, what do you frequently bring onto your site? Here's a sample list.

What Comes In

- Equipment and tools for landscapes, agriculture, and vehicle maintenance
- Equipment and tools for offices, conservation laboratories, and exhibit workshops
- Food and supplies for livestock
- Plants and materials for landscaping and agriculture
- Salt for the icy driveway and sidewalks, and fertilizers for the lawn and plantings
- Items to sell in your gift shop, and the bags, boxes, and packaging material to ship them
- Food for staff and board meetings
- Food, furniture, and decorations for special events
- Building and exhibit materials from paint and floor finishes, to new boardwalk materials and siding
- Costumes and materials for demonstrating crafts and trades
- Collections care and storage supplies and furniture
- Materials to use in educational programs and at special events
- Office supplies
- Supplies for printing informational, promotional, and special event materials
- Furniture for offices, classrooms, meeting rooms, and waiting areas
- Outdoor furniture for picnic areas and seating for crowd control and animal protection
- Consumables in the bathrooms, kitchen, and café for use and cleaning
- Garbage and recycling cans; perhaps small composters

The three operations categories that commonly have the greatest materials impact at historic sites and museums are equipment, food, and exhibits.

If you are renovating or building an addition, consider creating spaces for changing uses, and for reconfiguration, as at the new North Dakota Heritage Center. The HGA Inc. team says that

planning for the new gallery spaces on the main level of the museum follows a modular system. Each individual gallery provides its own range of flexible environmental controls, which allows curators to carefully tailor the environment within to specific exhibits. This zoned approach offers the most flexibility over time since it allows for exhibits to be reconfigured as needed. Between each modular gallery, more informal, naturally lit "Halls of History" provide opportunities for visitors to rest between visits to the enclosed galleries, helping prevent museum fatigue and encouraging patrons to linger. These resting areas also increase the flexibility of the exhibit space by providing additional interpretive opportunities outside of the traditional gallery walls.[2]

Besides actually building or renovating a structure, your museum's most material-intensive activity is likely to be exhibit construction. Therefore, the best resource you have is the ExhibitSEED website (www.exhibitseed.org), a project of the Oregon Museum of Science and Industry. At exhibitseed.org, you will find a sustainability decision-making tool, the green exhibit checklist (see next page), and a materials guide. Each is very valuable for helping shortcut the process to sustainable exhibit design. It doesn't cut corners; it helps you manage your research and planning process more efficiently so that you create an exhibit that is more environmentally sustainable. Take the time right now to explore the site.

The checklist's purpose is to "inspire exhibit teams to plan exhibit with environmental considerations in mind." Its primary audience is science exhibit developers, but the principles are adaptable to any exhibit approach. Notice that the checklist was designed for planning, not for evaluating after the fact. That is because decisions early in the development process can significantly affect the resulting waste when you uninstall the exhibit. If you plan for low volatile organic compound (VOC) paint (low amounts of VOCs that evaporate at room temperature and release chemical components), you will reduce harmful chemical emissions in your exhibit. This is better for your objects, staff, and visitors. If you plan to install new rugs in parts of the exhibit, you can plan to purchase floor coverings with either natural or 100 percent recycled content. This is an increasingly common purchasing option, so do not overlook it. And if you design the exhibit panels to be bolted or screwed together without glue, then you can easily disassemble it without damaging components, and then reuse them next time instead of adding them to the waste stream headed to the landfill. Many small museums have been reusing exhibit components out of necessity for a long time, and it's a skill to nurture. At the Abbe Museum in Bar Harbor,

Green Exhibit Checklist

The Green Exhibit Checklist (GEC) is a tool to evaluate the environmental sustainability of exhibits. The goal of the checklist is to inspire exhibit teams to reduce the environmental impacts of exhibit production.

The Green Exhibit Checklist can be a useful tool in early planning to help set project goals. Then, once the exhibit is on the floor, the checklist is used to assess the final outcome.

The GEC awards points in 5 KEY STRATEGIES:

- Reduce new material consumption
- Use local resources
- Reduce waste
- Reduce energy consumption
- Reduce products with toxic emissions

A sixth category awards points for innovation in the design and construction of the exhibit. This encourages exhibit teams to strive for new and creative solutions to reduce environmental impacts.

 Step 1 Team sets the goal for the exhibit: Platinum, Gold, Silver, or Bronze.

 Step 2 Designer and fabricator review checklist to find the best strategies for meeting the goal.

 Step 3 After production, the fabricator fills out the GEC with the relevant material information.

 Step 4 Exhibit team conducts walk-through, using the material information to award points.

We encourage teams to post their checklist results online for the benefit of the entire museum industry. For more information or to post your checklist evaluation see www.exhibitseed.org.

Exhibition Title: _____

Date: _____

Producing Facility: _____

Host Site: _____

Your Name: _____

Role/Title: _____

Ratings are awarded for the total score:

 PLATINUM (20–24 points) SILVER (11–14)

 GOLD (15–19) BRONZE (8–10)

FIGURE 7.1. The Green Exhibit Checklist was developed by the Oregon Museum of Science and Industry (OMSI). Visit www.exhibitseed.org for more information. Funding for Exhibit SEED and the Green Exhibit Checklist was provided by the National Science Foundation grant #0917595.

Courtesy of OMSI.

Reduce new material consumption.

INTENT: Reduce demand for virgin materials thereby reducing industrial practices that pollute the environment and exploit natural resources.

STRATEGIES:
• Use recycled materials (regrind HDPE, aluminum, etc.).
• Reuse building materials (from previous exhibits or deconstruction of houses, etc.).
• Use wood from responsibly managed forests.
• Use rapidly renewable materials (bamboo, wheat board, etc.).
• Construct exhibits using fewer materials.

List all materials that were recycled, reused, FSC-certified wood, or rapidly renewable:	Estimated % of total exhibit (by volume):

List any virgin materials (no recycled content, newly purchased, not renewable):	Estimated % of total exhibit (by volume):

SCORING:
☐ 4 points if **AT LEAST 90%** of the materials are recycled, reused, or renewable.
☐ 3 points for **AT LEAST 75%**
☐ 2 points for **AT LEAST 50%**
☐ 1 point for **AT LEAST 10%**
☐ 0 points if **LESS THAN 10%**

SCORE:

WAYS TO IMPROVE SCORE: _____

FIGURE 7.1. Continued.

Use regional resources.

INTENT: Reduce negative effects on environment from the transportation of goods while contributing positively to the local economy.

STRATEGIES:
- Specify local raw materials, within 500 miles (ex: lumber in Pac NW).
- Source products manufactured locally, within 500 miles.
- Hire local contractors for labor, within 250 miles (ex: local welder).
- Batch orders of goods to reduce packaging material.

List all materials that were sourced locally:	Source:	Estimated % of total exhibit (by volume):

List all materials that were not sourced locally:	Source:	Estimated % of total exhibit (by volume):

SCORING: **SCORE:**

☐ 4 points if **AT LEAST 90%** of the materials were sourced locally.

☐ 3 points for **AT LEAST 75%**

☐ 2 points for **AT LEAST 50%**

☐ 1 point for **AT LEAST 10%**

☐ 0 points if **LESS THAN 10%**

WAYS TO IMPROVE SCORE: _____

FIGURE 7.1. Continued.

Reduce waste.

INTENT: Reduce amount of waste and consider end-life of exhibit.

STRATEGIES:
• Design components to be repurposed after exhibit retires (ex: standard table top).
• Choose materials that can be recycled at end of exhibit (glass, cardboard are best).
• Choose construction methods that allow components to be taken apart (no glue).
• Eliminate need for consumables that end up in trash.
• Design for durability and low maintenance.
• Use water responsibly in exhibit.

List all materials that can be repurposed or recycled:	Reuse or recycling plan:	Estimated % of total exhibit (by volume):

List any materials that cannot be recycled or repurposed:	Destination:	Estimated % of total exhibit (by volume):

SCORING: **SCORE:**

☐ 4 points if **AT LEAST 90%** of the materials can be repurposed or recycled.

☐ 3 points for **AT LEAST 75%**

☐ 2 points for **AT LEAST 50%**

☐ 1 point for **AT LEAST 10%**

☐ 0 points if **LESS THAN 10%**

☐ -1 Deduct point for wasteful use of consumables or water.

WAYS TO IMPROVE SCORE: _____

FIGURE 7.1. Continued.

Reduce energy consumption.

INTENT: Reduce energy consumption by exhibit components.

STRATEGIES:
- Choose energy-efficient electronics and parts.
- Reduce number of energy-consuming interfaces.
- Use alternative energy sources (human-powered, solar, wind).
- Use automatic shut-off on electronic components.

List all electronic components:	Auto shut-off? Yes or No:	Energy efficient model? Yes or No:

SCORING: **SCORE:**

☐ 4 points if the exhibit is **NET-ZERO energy consumption.**

☐ 3 points if **SIGNIFICANT** energy-conserving efforts are in place.

☐ 2 points if **SOME** energy-conserving efforts are in place.

☐ 1 point if exhibit **USES** energy-efficient electronics.

☐ 0 points if **NO ATTEMPT to conserve energy.**

☐ -1 Deduct one point if more than 75% of the exhibit components are electronic.

WAYS TO IMPROVE SCORE: _____

FIGURE 7.1. Continued.

Reduce toxic emissions.

INTENT: Reduce quantity of materials that emit VOC's, either in processing or after installation, because of their threat to the environment and indoor air quality.

STRATEGIES:
- Choose zero/low VOC paints and finishes.
- Avoid PVC, styrene.
- Use soy inks on graphic panels.
- Use products that are formaldehyde-free.
- Avoid carpet with toxic materials.

List all materials, sealants, adhesives, paints, and finishes that are zero or low-VOC:	Applied to estimated % of total exhibit:

List any materials that do emit volatile organic compounds:	Applied to estimated % of total exhibit:

SCORING: **SCORE:**

- ☐ 4 points if **ALL** materials are low-VOC.
- ☐ 3 points for **AT LEAST 75%**
- ☐ 2 points for **AT LEAST 50%**
- ☐ 1 point for **AT LEAST 10%**
- ☐ 0 points if **LESS THAN 10%**

WAYS TO IMPROVE SCORE: _____

FIGURE 7.1. Continued.

Innovation.

INTENT: To encourage exhibit teams to strive for new and creative solutions.

STRATEGIES:
• Post checklist assessment on ExhibitSEED website for peer review.
• Incorporate a new design or production strategy that reduces environmental impact.
• Plan ahead for the exhibit's end-life.

SCORING: **SCORE:**

☐ 1 Bonus point for posting assessment on ExhibitSEED website:

☐ 1 Bonus point for creating big visual impact with minimal materials:

☐ 1 Bonus point for innovative end-of-life plan for once the exhibit is retired:

☐ 1 Bonus point for any new design approach or construction method that increases environmental sustainability:

WAYS TO IMPROVE SCORE:

POINTS AWARDED:

☐ Reduce new material consumption
☐ Use local resources
☐ Reduce waste
☐ Reduce energy consumption
☐ Reduce toxic emissions
☐ Innovation
☐ TOTAL points

CERTIFICATION:

● PLATINUM (20+ points)
● GOLD (15–19 points)
● SILVER (11–14 points)
● BRONZE (8–10 points)

FIGURE 7.1. Continued.

Maine, designs for each exhibit take into consideration the resources already in storage. The staff repurposes exhibit materials by saving and reusing mounting boards and temporary walls as often as possible before sending them off for recycling.[3]

Before you get rid of valuable cases, furniture, and other aspects of your exhibit architecture, consider using your community's networks—electronic or otherwise—to announce items available for repurposing. Your regional or state museum association, even the chamber of commerce, may be able to spread the word that you have items to give away. In 2013, the California Association of Museums made an Ignite! Grant award to the Hayward Area Historical Society, which had proposed "The Loop: An Exhibit Reuse Program" as "an online listing of unwanted exhibition furniture, props, graphics, educational collections, interactive elements, and crates." With regular use, area museums can "prevent materials from ending up in the landfill" and also save museums money. The grant is funding a pilot project with the hopes of making the system loop available for all California museums.[4] Working to minimize impact can make an important difference, and should be considered a priority if you change exhibits even once a year. You'd be surprised how much it adds up.

To reduce impact from equipment choices, look for the most durable equipment (so that it lasts long before replacement time and will require few repairs) and the most energy-efficient model available. It may even be able to run on clean energy options. For office, indoor equipment, and small outdoor items, this means an ENERGY STAR label is a great selection guide. For larger equipment used more commonly outdoors, such as cars, tractors, and generators, the manufacturer's information will help you compare options before making your choice. Operating equipment properly and keeping it tuned will help it run more efficiently and longer. When you're done with a piece of equipment, try first to rehome it before giving it up (if you didn't get it used already). If someone can't use the whole item, they may be shopping for parts for their current model. When all else fails, explore appropriate e-waste or metal recycling opportunities.

To reduce impact with food choices, if you haven't already given up single-use beverage containers, now is the time to commit. Then focus your efforts on:

- Increasing the percentage of local and regional foods you choose so they travel shorter distances to you while you contribute to your area's economy and build stronger provider partnerships.

- Increasing the percentage of seasonal and organic foods you choose so they require less energy and chemicals to grow and will support your community's economy.
- Reducing choices requiring the most packaging to travel to you and to store, and select food in packaging can be easily reused or at least recycled.
- Reducing the degree of processed foods you select if you can prepare food onsite. This reduces processing energy and additives, and packaging, and usually leads to fresher, healthier meals.

This degree of change requires significant rethinking of food programs, sources, and serving. Wholesale change can be very difficult, so be content with a pilot program for a line of café offerings during a single season, then expand as you learn. Or, if you offer frequent special events, you might start by making a few of the hors d'oeuvres and one of the entrée options from local, seasonal, and organic foods. Promote them as a special option and observe your guests' responses. Larger institutions with multiple eating options could start out creating one venue as the local, seasonal, and organic option. Whatever your starting point, use that first experience to support expansion to more offerings and eventually an entire event.

If your audience does not already embrace this approach to eating, you will need to provide some background through menus and table cards, and server conversations, to encourage visitors to try something new and appreciate what you are doing with your food service program. This could mean taking extra space on the invitation and the menu to explain your selections, posting menus and descriptions on your website, and being very clear with special event sponsors about what you are planning. The Henry Ford Museum and Greenfield Village in Dearborn, Michigan, offers a Local Roots Dining Evening program with special meals six or so times a year showcasing regional food products with a seasonal theme, and provides entertainment to make it a special night out.

If your organization is a site for weddings and you encourage a sustainable food approach, this is a chance to educate the families and their guests. Consider this effort an extension of your mission, not simply an income opportunity. Guests who expect summer vegetables on the menu year-round, and those who want filet mignon when there isn't a cattle ranch within two hundred miles of you, may be disappointed to find you have restrictions. If the couple to be married is involving parents in the planning, you may need to provide environmental counseling for the older generation, seriously, to limit surprises and disappointments. On the eastern shore of Maryland, patrons can drive right by a buffalo ranch on the way to a few different history

organizations, yet never have a chance to taste a buffalo steak. You can make that happen. If you provide interesting options and a strong story combining setting and sustainability, you will have a happier customer.

If your only food service is a limited counter or snack machine menu, take the time to explore alternative suppliers focusing on a more sustainable snack food audience. Sensitively packaged granola bars and fruit and nut options can replace candy bars. You can offer water bottle–filling stations instead of beverage machines that hold sweetened, plastic-packaged drinks. It is now quite easy to find simple retrofit systems for existing drinking fountains for easy water bottle filling. Any type of vending machine should have an EnergyMiser sensor attached to make it even more energy efficient. It will sense movement and turn on the lights only if visitors are nearby, but will still keep the food safely cooled. Coolers with milk and ice cream can be extremely energy efficient while still offering guests sensibly packaged and healthier milk and smoothie beverages, and other treats. If you spend some time observing visitors at these food centers, it will be easier to develop effective interpretive materials to help guests understand and appreciate these changes. The bonus is that you are likely to hear parents of small children rejoice at the healthier options for their kids.

Speaking of kids, many food choices available in vending machines and appealing to children, adults as well, are made with palm oil. This ingredient is often harvested and manufactured in unsustainable ways. Since the oil is harvested from trees, many organizations are beginning to boycott candy bars and snacks made with palm oil. There is a list, though, of the growing number of organizations, and their products, that use only responsibly harvested palm oil that does not depend upon clear-cutting Indonesian rainforests for expanding palm plantations. The list is much like the now-familiar sustainable seafood buying guide put out by the Monterey Bay Aquarium. You can find the palm oil shopping guide online.[5]

What Goes Out

Someday there will be nothing to send out from our sites but recyclables and waste destined for compost or energy generation. Zero waste operations are still a long way into the future for most of us, but if we keep practicing we can at least keep true waste much lower than the amount we reuse, repurpose, or recycle. To manage materials *leaving* your site, you begin with a waste audit. It is messier than the QuickBooks report on purchases, but well worth the adventure.

To conduct this kind of audit, you will need to capture a day of waste at a large site, or a week at a smaller site, then hold it—all the garbage, the

recyclables, the compost, and anything you're going to repurpose—and sort and measure it so that you know how much of each kind of waste you're dealing with. (To get an accurate gauge of seasons, you should repeat this every other month until you feel you can accurately predict waste amounts given visitation, special events, and seasonal changes.)

Recommended waste audit practice includes a green team of helpers, with protective or well-used clothing and rubber gloves for everyone. Having five-gallon buckets for measuring either the volume or weight of waste will help keep amounts manageable. Spread the captured garbage on plastic coverings in a place with good ventilation. Then begin sorting. Start your record-keeping with photographs, then describe and measure the waste before finally disposing of it all. If you've spent some lead time reducing materials through planning purchases a few months ago, you'll have a slightly easier time of it. Your results will tell you how much you are still recycling, throwing away, or putting into the "share" pile. You can expect to find these categories of items:

- Food waste from the staff room, the café, and special events
- Animal waste from your livestock and visitors' dogs (if you allow them)
- Office waste such as paper, report and presentation covers, ink cartridges, and used-up writing tools
- Packaging waste from food and purchased supplies for across your site. These include wrappings and packaging such as deicing materials, fertilizer, gift shop deliveries, and new business cards
- Event supplies and decorations
- Building materials from construction, additions, or rehabilitation
- Out-of-date signs and posters for visitor information
- Furniture and equipment you no longer need or that no longer works, from the intern's desk to older-style electronic devices

Ask yourself if all of the recyclables made it into the recycling containers, and into the correct ones. If they did, then your receptacle design, placement, and instructions are working well. If they did not, then there is work to be done and it's one of the first places to start making change, after you finish your audit. (We'll tackle recycling bins in the next section.) Now ask yourself, of the material spread out here on the plastic, what are the largest waste types: food, exhibit materials, event banners, paper that didn't get recycled? You may find items such as the banners that you didn't realize were being thrown away instead of returned to the printer for recycling or donated to a local artist with an Etsy site who makes them into bags to sell. You might realize you have enough food waste, by extrapolation, that it is

worth talking to a local farmer or a composting business to collect your material. Or maybe you have a spot on your property where you can compost it for your own use. Eliminating food waste is becoming a very strong theme in sustainability work. You are likely to find in the next few years that your city or state may begin regulating food waste by requiring you to compost it yourself, or through a provider, or that you share leftovers appropriately with food pantries and homeless shelters if you generate significant amounts from your café or restaurant.

When you repeat this exercise in a couple of months or during the next season, do you expect to find different types or amounts of materials in the waste stream? What matters is that you look critically at your waste stream so that you understand how to start managing it and reducing as much as possible what leaves your property for the landfill. The goal is to reduce the amount of everything leaving your site, and to recycle, compost, or rehome more of it.

Let's focus on reuse first. Space available for collections materials is probably already limited, so there is rarely also space for storing reusable materials and items even in unconditioned areas. Where you can, though, you should. The more frequently you move these items out, the less burdensome this will seem. If this approach feels overwhelming, choose two types of items to focus on for the next few months; create good systems for identifying, storing, and distributing just those two types of materials. When those systems are easy to manage, choose two more materials types to manage. It will get easier as you go.

We already talked about reusing and rehoming exhibit items; what about other supplies? Office supplies and office furniture, equipment, coffeemakers and microwaves, whiteboards and bulletin boards, monitors and keyboards, lamps and area rugs—even plants—can fall out of favor in one area but serve an important purpose in another part of the museum. If an internal LISTSERV is too complex to establish and maintain, use the bulletin board in the staff room or an email among colleagues to share information on available items. For the small things, set up a supply closet (or designate a shelf) in a central location as an institutional swap site, then label it and encourage everyone to use it.

What Gets Transformed and What Gets Recovered

Now that you've used up, repurposed, and rehomed everything you can, your job is to see how much of the remainder can be turned into something besides waste.

Waste Transformation to Energy and Nutrients

Though recycling may be the most common waste recovery process these days, transforming animal and food waste through composting has been around a lot longer. You'll remember from the Strawbery Banke case that they interpret historic composting. Modern composting is gaining favor again in the public eye as gardeners look for organic sources of fertilizer, and urban farmers do, too. Local extension services usually give away or sell discounted backyard-scale composters that may be appropriate for a spot at your historic house museum. You will want to consider the smells and potential animal activities that sometimes accompany compost, but this is nearly always more of an imagined issue than a real one as long as you keep meat products out of the composter. Compost can take care of itself, but it breaks down much, much faster if it's managed properly. There are many do-it-yourself sites online to help you build and manage a domestic-sized composting arrangement. If you have more food waste than a single small composter can handle (or a few of them), there are businesses that offer urban compost pickup. There may be an urban farmer near you who can collect and use food or animal waste. If you are a rural site, there may be a farmer nearby who will want to add your materials to his or her compost.

It's common for downed trees, and any limbs from pruning work, to be mulched and used onsite. Sometimes there are new sources of mulch. At the Pennsylvania Historical and Museum Commission, construction and rehabilitation projects routinely manage materials and debris sustainably. Now if there is a wood shingle replacement project, they bring a grinder and mulch the shingles for use onsite. This reduces Dumpster fees, landfill use, and the cost of mulch for the property.

It is increasingly common to transform plant and animal waste from its biomass form into energy. You might have plant waste from mowing the field you use as special event parking lot. Perhaps your historic house's adjacent gardens and arboretum generate such significant growth in your tropical region that trimmings are too much for onsite composting. You may already have an organization in your area that has a facility for turning waste to energy and will welcome what you have to offer. They may even come collect it. Perhaps you keep almost enough animals that the waste they generate, combined with the waste from nearby farms, can be turned into energy for you. These systems consume significant amounts of waste for fuel, and their design is very complex, so plan on quite a lengthy research process to determine if such a project is appropriate. Start by finding out what others do, and supporting them with your waste, before launching into your own system. Your state's department of energy will know who has such systems or is exploring building one. This may seem complex, but as

you work through the other, easier projects, you will find yourself ready to tackle this one. And then again, someone may approach you to participate. If you have considered the options, and know your waste stream, you will be in a strong position to partner with them and benefit both organizations.

Waste Recovery

Recycling means taking a product of an existing material and converting that material into another usable item of either the same or different purpose. (Upcycling is a term for creating a more useful item than the original, but that is not an objective definition. Downcycling means creating a lower-quality or less valuable item.) Encouraging people to recycle is a science *and* an art, so it's worth looking at critically. Take the time to do whatever you can to tweak your system to improve the rate of recycling versus wasting. It will pay dividends. Not only will more of your waste go to recycling, but your recycling vendor will be less likely to reject a load due to "contamination" with incorrect or nonrecyclables. There are some basic practices that you can count on for improving success.

Consider the user: People want to quickly and easily dispose of waste.

- By *always* placing garbage and recycling containers side by side, you will significantly increase the chances that a hurried or tired visitor will recycle and throw away garbage. But if the recycling is across the room or nowhere to be seen, recyclable items will end up in the garbage.
- If the user is confused about what goes where, they will default to the broadest category of waste: garbage. Make sure you have clear signs using words, photographs, and symbols—yes, all of these—to effectively communicate which items belong in which area. This helps children, guests speaking languages other than English, and anyone in too much of a hurry to read the list of acceptable items.
- Consider that color, shape, and lid openings matter; just using an available old garbage can or a bin that looks just like all the others will not help you change employee or visitor behaviors. Equipment matters. That means a historic-looking wooden barrel disguising the recycling bins is no longer a smart choice for your site.

Design for success: The most effective containers have predictable characteristics:

- Words, symbols, and photographs are easily visible above the container opening and on the container's body: front and sides. This helps visitors

recognize recycling stations from a distance and identify the right section for their recyclables when they're standing up close making their final decision.

- Colors indicate that different items go in different containers. It matters less what the colors are than that they are different.
- The shapes of openings suggest what recyclables or waste go into each section. Round holes usually indicate bottles and plastics, slots indicate paper, larger openings usually indicate generalized garbage. Possibly making this the smallest hole sends a better message, but it may also mean users take the easier route of larger openings and will contaminate the recyclables with garbage.
- Size suggests expectations; if you make the garbage container the largest, many visitors intuit that the most material will end up in that container. Don't encourage them to think this way. If your container sizes are similar, add an extra bank of them nearby to keep up with volume if necessary.

Recycling gets more complex behind the scenes. In addition to the container and garbage waste dealt with through receptacles, there are toxic wastes you are legally bound to recycle. This includes any light bulbs containing mercury such as the CFLs in the offices and meeting rooms, and the fluorescent tubes in other spaces. The recycling process recovers the mercury to use in other products, and to keep it out of landfills where it might leach into water sources and eventually harm aquatic life and humans.

If you make a point of keeping the packaging these fluorescents come in, you can safely rehouse them when they are used up and being stored for recycling. The tube lights can be sent back to the manufacturer with your next order. You'll need to take the CFLs to an appropriate recycling center or to the place of purchase. The same rule applies to batteries and various kinds of ewaste from monitors to cell phones. And all of us recycle ink and toner cartridges because the retail stores give rebates for returns. Make sure everyone knows what to recycle and why.

Five-gallon buckets are useful here, again. Keep the ones with lids. Label the lid and the sides with the contents, and carefully store each type of small recyclable until the bucket is full and you can take it to the recycling center. You can keep one bucket of each type in the supply closet for your house museum or for a department. If you have questions about what to recycle and how to do it, your municipality will have instructions.

Still, it is not enough to recycle just the usual items. It's time to think beyond the common recycling opportunities. They are all very important and are now easy to arrange. Eco-entrepreneurs and major manufacturers are taking on new recycling frontiers as they look for new and lucrative ways to turn waste into useful products. For some, it is a mission; for others, it helps improve their corporate sustainability standing and creates potential income streams. Where these practices suit your institution, it can boost your sustainability to participate.

Though it is a still often a do-it-yourself practice, some organizations turn used cooking oil into biodiesel for powering vehicles. In some areas, there are businesses that regularly collect used oil from around the city and convert it for resale. If you don't want to use it for your own vehicles, and have used oil to share, consider contributing yours to a local business.

What about all those nitrile gloves we all use in collections care? They now have their own recycling stream.[6] Kimberly-Clark collects cartons of gloves and transforms them into park benches and Adirondack chairs. You may not generate the forty-four thousand pairs of gloves required for a shipment, but maybe you have a hospital in your area that will take your carton as part of its shipment. Or maybe, between you and area museums, you just may be able to collect enough. One of you can act as the collection site, and the group can support the costs of shipping the full pallet to Illinois for processing. UPS will collect it. If you are planning on a zero waste future, recycling down to your gloves will matter.

Notes

1. John Forti, email with the author, April 21, 2014.

2. Contributing authors from HGA Inc. staff are Leighton Deer, Adam Luckhardt, Rebecca Celis, and Amy Bradford Whittey, September 30, 2014.

3. Cathryn J. Prince, "Abbe Museum takes 'greening' seriously," *The Christian Science Monitor*, July 16, 2014, accessed July 16, 2014, http://www.csmonitor .com/World/Making-a-difference/Change-Agent/2014/0716/Abbe-Museum -takes-greening-seriously.

4. California Association of Museums, "IGNITE! Mini-Grant Program," accessed September 15, 2014, http://www.calmuseums.org/index.cfm? fuseaction=Page.ViewPage&PageID=963.

5. Cheyenne Mountain Zoo, "Palm Oil Shopping Guide," accessed September 28, 2014, http://www.cmzoo.org/docs/palmOilShoppingGuide.pdf.

6. The author's visit to Dumbarton House for a waste audit, July 2013, led to this discovery. Collections and Facilities Manager Jerry Foust asked what could be done with all these gloves.

Resources

The Environmental Protection Agency website has important resources for legal issues
associated with waste management and tools for "conserving resources and reduc-
ing waste." The home site is http://www.epa.gov/epawaste/conserve/; the Waste-
Wise program is located online at http://www.epa.gov/epawaste/conserve/smm/
wastewise/index.htm, and registration of the online tracking tool, SMM, is avail-
able at https://connect.re-trac.com/register/epawastewise. This tool is much like
the Environmental Protection Agency's online water and energy measurement tool
Portfolio Manager.

Person-Harm, Angela, and Judie Cooper. *The Care and Keeping of Cultural Facilities:
A Best Practice Guidebook for Museum Facility Management.* Lanham, MD: Row-
man & Littlefield, 2014.

◉◉

SUSTAINABILITY POLICIES AND PLANNING

Vision

Historic sites and museums plan and operate using a long view of the planet and the conditions their collections and sites are most likely to encounter.

Often, sustainability polices and plans develop because an authority requested or encouraged the work. This might be a motivated parental or governmental body. Government agencies and their subgroups created sustainability plans in direct response to the 2009 Executive Order 13514, "Federal Leadership in Environmental, Energy, and Economic Performance." Executive Order 13514 expanded on the requirements of a previous executive order, setting a goal "to establish an integrated strategy towards sustainability in the Federal Government and to make reduction of greenhouse gas (GHG) emissions a priority for Federal agencies." These are public documents that are easily accessible, and you can use them to model your plan if the aspects of the focus can be scaled to suit your work.

Most sustainability polices and plans develop after initial work raises awareness, or when changes or opportunities expose an institution to environmental sustainability ideas: a motivated individual pursues a new opportunity or a personal priority in environmental sustainability, or staff must adapt when a familiar resource is no longer available because it has been

ruled environmentally inappropriate, such as incandescent light bulbs. Then an early success breeds next steps and soon the institution recognizes the need to organize and prioritize green work to become more effective. Positive experiences often lead to planning for more good results.

Andrea Jones at Accokeek Foundation feels that "sustainability is really personal" and that "people need to believe in it to practice it well." "Education is key" in bringing people around. They must come to their own understanding of their part in a larger system. If they choose to recognize this, the shift to sustainability can begin, she says. "An organization has its limits, too. It must decide, as if it is a person, what sustainability means to it, and what the limits are. It is being conscious of this decision that has begun at Accokeek." Environmental sustainability is now part of the mission and vision: The Accokeek Foundation's mission is to cultivate passion for the natural and cultural heritage of Piscataway Park and commitment to stewardship and sustainability. The vision statement says: People connected to the land and engaged in creating a sustainable world.

At the Pennsylvania Historical and Museum Commission, by necessity the agency operates under the governor's mandate for sustainability from 2007, but sustainability work really began in the 1990s and has since spread widely. The trigger event was a suggestion by the electric company serving a site in Erie, Pennsylvania. The utility suggested a geothermal design solution for a visitor center project and offered incentives to help with funding. Chief of architecture and preservation, Larry Loveland says, "It got us interested, and then we used geothermal on the next visitor center project and in other new construction." The Pennsylvania Historical and Museum Commission started using geothermal and sustainability practices for all projects. "As we got into [sustainability work] we thought 'we can do this, and let's also add this.'" Sustainability experiences tend to do this; they create an interest and excitement in developing creative and helpful solutions for doing our work better.

This is how Margaret Burke, executive director at the Concord Museum, describes how the experience of developing and implementing the exhibit *Early Spring* created change at her institution:

> By melding history and science in a sustainable framework, the *Early Spring: Henry Thoreau and Climate Change* exhibition . . . attracted new audiences [and] brought ongoing and increased attention . . . by both a general and scholarly audience. Most importantly, the exhibition process informed the Concord Museum's thinking about its future and the way it presents its temporary exhibitions and permanent galleries. In fall of 2013, the museum launched an ambitious

Campus Master Planning process with a goal of strengthening the museum's educational impact. The engaging, interactive nine-month planning process that fully involved museum stake-holders—boards, members, staff, community representatives, and others—has enabled the museum to develop new interpretive strategies and activities and to assess space needs for collections, programs, and operations.[1]

Liz Callahan, executive director at Hanford Mills Museum, says, "It's baby steps, but little steps do make a difference." As she and her board looked back on the last few years and prepared a new strategic plan, they recognized that in the last cycle the mission had been changed to include the word *sustainability*—focused on the environment but also directly benefiting the institution. Now they are considering another language change that signals a clearer description of current success and future goals: *entrepreneurship* may give way to *ingenuity*. Ingenuity suits the site's history, its current work interpreting renewable energy in so many ways, and how it looks at managing itself and its site for a future fully engaged with the public over the last decade "as the discussion of power past and present became more important in the real world." That means the decision processes needed to adapt. Most of the museum's buildings are not heated but now, for those that are, as a system comes to the end of its useful life, it's evaluated for a more efficient, more sustainable replacement. The staff and board consider options based on financial return on investment but always with an eye for increasing energy efficiency and reducing the museum's carbon footprint. They researched geothermal heat pumps to gauge appropriateness for the site, but their region isn't as well suited to it as other areas are. The regional alternative—using wood, a local waste product to heat—became a preferable option. This steady, step-by-step decision progress strengthened the institution, gave it a chance to assess "what have we got? How can we connect it to the world?" She can attest that the staff and board are all committed personally to change, which has led to creative and thoughtful change, always true to the site, historically accurate, and balanced, Callahan says.

Are you wondering how they knew what to do next? How were these stories translated into actual plans? Were there action steps and goals? No site does this work the same way, and there is no exact format to be copied for your site. You can create a standalone sustainability plan if you like, one that creates priorities for each area of operations, aligns annual goals and action steps and measurements to those priorities, and then prepares a budget to support those goals. Ideally, though, because sustainable choices should not be add-ons, you should blend that list with the core institutional

Accokeek Foundation at Piscataway Park
STRATEGIC PLAN - May 2014

Our Mission

The Accokeek Foundation cultivates passion for the natural and cultural heritage of Piscataway Park and commitment to stewardship and sustainability.

Our Vision

People connected to the land and engaged in creating a sustainable world.

GUIDING PRINCIPLES

What we do:
1. We inspire people to care about the environment by connecting people to this landscape.
2. We explore historical and cultural connections to today's trends in agriculture and conservation.
3. We engage communities in shaping a more sustainable food system.
4. We prepare people to make earth-friendly choices in their daily lives.
5. We contribute to the evolving scholarship on stewardship and sustainability.

How we do it:
1. We create meaningful experiences that engage visitors' minds as well as their hearts.
2. We ask important questions about the past, present and future of sustainability.
3. We experiment with and demonstrate best practices to advance our mission.
4. We align the allocation of our resources with our interpretive messages and mission.
5. We approach partners, funders, and other stakeholders in a spirit of collaboration to advance our mission.

Who we do it for:
1. We aim to reach audiences that are representative of the community, with a focus on traditionally underserved populations.
2. We seek to engage young, service-minded audiences.

Our Organizational Culture:
1. We create an open and positive organizational culture that inspires staff members to become invested in the Foundation's future.
2. We foster an environment in which learning – about the past and about best practices for a more sustainable future – is highly prized.
3. We approach serious content in a serious manner, but we embrace novelty and convey a sense of fun.
4. We encourage thoughtful dialogue on important topics, always honoring differences in perspective.

FIGURE 8.1. Accokeek's Plan/Statement.

PRIORITIES 2014-2016

Priority 1
Unify all programs (history and culture, conservation, agriculture) under the interpretive message of sustainability.
1. Clarify interpretive goals internally and externally.
2. Align the allocation of resources with interpretive messages and mission.
3. Integrate program planning with marketing planning.
4. Clarify brand identity and align market perception with mission and goals.

Priority 2
Create transformative learning experiences that engage visitors and encourage critical thinking.
1. Create programs that connect to visitors' emotions and are thought-provoking, participatory, and inclusive of different perspectives.
2. Increase opportunities for engagement with the concept and practice of sustainability through time.
3. Expand the reach of the Accokeek Foundation to include new and more diverse audiences.
4. Transform visitors into engaged members and donors.

Priority 3
Expand and diversify funding sources to lessen dependence on the federal appropriation and become more financially sustainable.
1. Create a long-term comprehensive plan for financial growth.
2. Develop financial accountability measures to ensure maximum impact and profitability.

Priority 4
Build a strong team and a strong network of stakeholders.
1. Redefine and strengthen a mutually beneficial partnership with the National Park Service to support mission and goals.
2. Align the skills and experience of board and staff with organizational priorities.
3. Increase site-wide staff collaboration and knowledge sharing.
4. Seek input from stakeholders to guide decision making on relevant projects.
5. Lead regional efforts that align with the Foundation's mission.

FIGURE 8.1. Continued.

plan you already use on a regular basis. The sustainability work should be fully integrated with all your priorities.

The plan's design should suit your institution's culture and priorities, and help you do the work to fulfill those priorities. Use your experience as a professional—as a curator, the chief financial officer, the education director, the executive director, or the historic interpreter—to manage your professional practice on behalf of your institution. Your training and experience will help you know which options are the most important and appropriate to your organization. If you are new to sustainability work, be careful to choose a limited number of early priorities. This will help you learn and plan in phases so you can develop the sustainability expertise you need for more complex projects. Set goals, pilot all activities, record your findings, adjust the goals, launch the full activity when ready, and do it all over again in a new area. Remember, no one goes all green at once.

Institutional planning works best when it aligns the profession's planning standards with the character and culture of the organization responsible for implementing the plan. Institutional priorities and maturity will influence the format and complexity of your plan. If you are part of a larger organization, such as a state agency or a national system that has its own sustainability plan, yours will reflect the format and goals of the larger organization. This is the case for individual parks within the National Park Service, for example. If you are a smaller, standalone organization, you will have much more control over plan design. Either way, your plan will grow out of your institutional mission and depend upon available levels of institutional knowledge and the capabilities of your organization.

If you are ready to begin developing a plan from scratch, though, here are some components to use as examples for discussion with your planning team:

1) A sustainability statement, your vision of sustainability for your organization, such as:

Through its programs and actions the Pittsford Historic Society is recognized as a resource and a significant contributor to the community's work of enhancing its environmental sustainability.

2) Principles that will guide your choices as you pursue sustainability, such as:

We educate staff, volunteers, partners, and the public about our sustainable actions.

We look for partnerships that will strengthen our sustainability practices and share the benefits more broadly.

We use all available technology and knowledge to pursue thoughtful sustainability practices in line with institutional capacity.

We make choices using a quadruple bottom line approach to benefit people, the planet, profit, and our program. This includes balancing preservation principles and environmental sustainability in support of our mission.

3) Priorities as guideposts for selecting which activity to follow, such as:

Priority #1: Significantly reduce fossil fuel consumption.

Priority #2: Work toward becoming a zero waste organization.

Priority #3: Contribute more significantly to protection of heritage breeds and heirloom plants recognized for their suitability to and historic roles in our region.

4) Strategies and activities, such as:

Strategy #1: Audit all energy used in heating, cooling, and transportation onsite and plan to reduce consumption and for alternative fuel use.

Activity: Prioritize systems changes using audit information, beginning with all appropriate projects with a payback period of three years or fewer.

Activity: Install a solar charging station; all future vehicles will use solar electric energy.

Strategy #2: Review all materials choices and measure all waste produced to prioritize changes in purchasing, use, reuse, and disposal, leading to a zero waste future.

Activity: Conduct materials and waste audits.

Activity: Set specific priorities and goals based on audits.

Strategy #3: Review current knowledge of heritage breeds and heirloom plants most appropriate for this region.

Activity: Align those breeds and varieties most in need of support with the capabilities of our site before choosing appropriately moderate expansion of current programs.

5) Goals and measurements to demonstrate degree and rate of success, such as

Goal #1A: Reduce systems energy consumption by 25 percent from 2012 baseline by December 31, 2020.

Goal #1B: Convert 100 percent of onsite, mechanically powered transportation to solar power electric energy through a mix of solar-powered golf carts and solar-charged vehicles by December 31, 2015.

Goal #2: Complete materials and waste audits by December 31, 2015. Implement initial work to address goals in three waste areas by June 20, 2016.

Goal #3: Complete review of and make selections for at least three animal breeds and twenty plant varieties by December 31, 2015. Complete site preparations by June 30, 2016.

Cuyahoga Valley National Park's plan, with goals and strategies, is an excellent example and includes details of specific actions such as native plant cultivation and zero waste activities.[2] As part of the National Park Service and under the mandate of Executive Order 34105, this plan emphasizes GHG emissions. Your plan may include a broader scope of actions addressing other aspects of environmental sustainability work such as improving water quality or encouraging sustainable choices among visitors. Here is a summary:

Cuyahoga Valley National Park has identified the following goals to reduce its GHG emissions produced by park operations as follows:

- Energy use consumption emissions to 30 percent below 2008 levels by 2020.
- Waste emissions to 50 percent below 2008 levels by 2020.
- Transportation emission to 20 percent below 2008 levels by 2020.
- Cumulatively, this will result in a GHG reduction of 30 percent below 2008 levels by 2020 in GHG emissions for the park.

To meet these goals, the park will implement strategies proposed in this plan that relate to the park's current and future emission inventories. Specifically, the plan recommends three strategies:

Strategy 1: Identify and implement mitigation actions that the park can take to reduce GHG emissions resulting from activities within and by the park.

Strategy 2: Increase climate change education and outreach efforts.

Strategy 3: Carbon storage through reforestation efforts.

Strategy 4: Actions to anticipate and adapt to a changing climate.

As part of this, the park will continue to monitor progress with respect to reducing emissions and identify areas for improvement.

A strong plan, most likely the private version, includes costs and sources of funds, and a schedule for reviewing costs, activities, and success. As with any plan, it is important to conduct regular reviews so that you can update the plan to account for work completed and course corrections you have found necessary. The good news is that monitoring results and updating the plan makes it very easy to promote your good work in your annual report or in a sustainability page on your website.

Connecticut Landmarks' mission is "to inspire interest and encourage learning about the American past by preserving selected historic properties, collections and stories and presenting programs that meaningfully engage the public and our communities."[3] The organization has twelve properties, plus its collections, covering four centuries of history. In 2005, when Sheryl Hack began as executive director of Connecticut Landmarks, at what was then the Connecticut Antiquarian Society, the organization had plans to build a new visitor center. Adaptive reuse, or renovation, of the two historic barns already on the property hadn't been considered. For Hack, this was counterintuitive: her approach was to think about constructing a new building only "when we've fully utilized the existing space within our historical properties. Adaptive reuse of our historic assets must come first," she says.

Hack began trying to find the language to define and communicate sustainability practices to the public and to the board, staff, and stakeholders within her preservation organization. She brought in consultants to assess energy efficiencies in the buildings and operations, and developed a green vision statement to guide decision-making and be shared in all staff training. Its tenets are "part of who Connecticut Landmarks is," Hack says. The importance and opportunities of green practices had not "always been self-evident to others," but this is "now how we operate." She says her board welcomed the new path because it made sense, and because they were excited about the concept and excited about doing something that clearly embodied the organization's new tagline: "History Moving Forward." Hack leads with the view that environmental sustainability "is a perspective you bring to bear on all the decisions you are making." Since sustainable practices are

now the organization's natural approach, business as usual, there is no separate list of green goals, or even a separate sustainability plan added to the strategic plan; sustainability is integrated in all planning. That is where all our sites and history museums should be headed.

Notes

1. Margaret Burke (executive director, The Concord Museum), email to the author, July 24, 2014.

2. U.S. National Park Service, "Cuyahoga Valley National Park Climate Action Plan," *Climate Friendly Parks program*, accessed September 15, 2014, http://www .nps.gov/cuva/parkmgmt/loader.cfm?csModule=security/getfile&pageid=430544.

3. Connecticut Landmarks, accessed July 25, 2014, www.ctlandmarks.org.

CREATING OUR FUTURE

Vision

Historic sites and museums actively assess future scenarios and prepare for those most likely to affect their sites and collections either positively or negatively. They actively create a shared future for their communities that provides for comfort, safety, health, and cultural vibrancy in that future.

Hanford Mills Museum's Executive Director Liz Callahan believes that "exploring and advancing sustainability is a fascinating and worthwhile process for where we are headed, and for future generations."[1] There is no question: to keep our institutions safe and solvent, as well as culturally relevant, preparing for future sustainability issues is critical. Yet as we talk with visitors, chase down the loose cow, or dash off to a chamber of commerce meeting, it is nearly impossible to think deeply about the future. We have better luck considering future trends or drawing connections between our organizations and the events of the outside world when we are outside our daily work environments. You may be out of that environment right now as you read this. So give yourself credit for taking the time to think into the future and to identify what you can do today to make your job easier in the future. You are investing in your institution's long-term health, and that is an important indicator of leadership. The field, and your institution, needs it, so don't skimp! Here is a preview of what

you and your institution are going to have to manage in the not-so-distant future, and they all connect to environmental sustainability:

- What you interpret disappears or changes dramatically
- Legislated green building goals
- Water shortages
- Anticipating climate disruption and more weather events
- The Internet of Things
- Changes in transportation
- Environmental literacy education
- Positioning for green financial support
- Pressure to make payments in lieu of taxes (PILOT) fees

Most of us do not know enough about anticipating these changes to do it effectively. So talk to those who do: the American Alliance of Museums' Center for the Future of Museums provides annual reports that address much of what is covered here, the California Association of Museums has a trained forecasting committee, and experts in topical areas can give you solid advice. Meet with area emergency services providers to find out what they wish you were doing. Talk to the building code enforcers and see what they anticipate. Interview educators and staff at community agencies to identify their collaborative needs and interests. This is management by walking around in your community—the local one and the professional one. We know it has dividends; we're looking for the environmentally sustainable ones.

What You Interpret Disappears or Changes Dramatically

Glaciers in Colorado are disappearing. So are the Chesapeake Bay islands along the eastern shore of Maryland. Folsom Lake in California, and Lake Mead in Nevada and Utah are seriously diminished due to drought in California—and the long-ago flooded towns, farms, and homesteads are reappearing![2] When your natural and cultural resources disappear or are substantially altered, will you be ready to mitigate the change or interpret the situation?

Lake Mead, the reservoir behind the Hoover Dam, was built to manage floods and to provide irrigation and power. Today, the original "intake straws" for delivering water to the valley and communities below put in at 1,050 and 1,000 feet of water depth are about to be dry. Estimates indicate the lake level will have dropped below that first intake level by 2015, so

they are building a new one at eight hundred feet.[3] That means that 250 feet multiplied by 247 square miles of water surface have gone missing. Beyond the water shortage issues, this means long-ago flooded communities are reappearing. The *Wall Street Journal* reported that "In Utah, the decline of Lake Powell on the Colorado River to less than half its capacity in the past decade has uncovered artifacts including Native American ruins known as Fort Moki by [nineteenth] century pioneers. It has also restored some natural features, such as a towering waterfall called Cathedral in the Desert that had been buried when the federal government dammed the river to create the giant reservoir in the 1960s." The National Park Service has to deploy staff to protect "new" sites and visitors—and it now has new interpretive opportunities to manage.[4]

And sea level rise is affecting, and will affect, countless coastal archaeological sites and historic landscapes and buildings. Julia Clark, director of collections and interpretation at the Abbe Museum in Bar Harbor, Maine, says that "In recent years, the museum's annual archaeological field school program has focused research on coastal sites in the Wabanaki homeland that are threatened by rising sea levels and increasingly intense storms. The hope is to gather archaeological information from these sites before they are washed away, preserving at least a small sample of this critical source for understanding and interpreting Wabanaki history."[5] When Hurricane Sandy hit New York City in October of 2012, at high tide, the storm surge was 9.2 feet. When it hit Boston, it was low tide and the surge was only 4.6 feet. If the storm had hit Boston five and a half hours later, at high tide, 6 percent of Boston would have been underwater. If storm conditions collided to add just another 2.5 feet, 30 percent of Boston would have been flooded.[6] Just as in New York, think of the historic sites and the infrastructure that was threatened. Are you ready?

Legislated Green Building Codes

You can prepare by planning to manage all your water onsite, cutting your waste significantly, using energy efficiency guidelines for repairs and rehabilitation, and by generally assuming that any current discussion of new practices will be legislated within the next ten years. Get ready now so that the changeover isn't so costly later on.

For water issues, expect to keep more and more of your water onsite, and to treat it at least to a minimal degree. And prepare to be limited in how much waste can leave your site. Remember when we used to think that it was difficult to comply with parking requirements by providing enough spaces onsite? Working with regulations will never be that simple again.

Expect energy efficiency reports to be public on all buildings over a certain square footage—and probably posted on your building, too.

Municipalities, states, and the federal government are going to choose standards, or certification systems, for legislating building performance. This means Leadership in Energy and Environmental Design (LEED), Green Globes, Living Buildings, and others might not be an option, or might be preferred. What we don't know is which standards and to what degree. Working now to understand them, and to define which ones will be adopted, will help prepare us all for compliance. At the 2013 American Alliance of Museums' Annual Meeting, the Professional Interest Committee on Environmental Sustainability hosted a summit on environmental sustainability. The goal was to begin a discussion within the profession to review existing standards programs to help the field determine which ones, or portions of ones, make the most sense for our organizations, and to consider whether we need a system of our own. If we create or acknowledge standards as a field, we are more likely to be able to direct which ones are applied to us.[7]

Dan Snydacker, who managed the geothermal process at Newport Historical Society, acknowledges that there are vocal detractors for LEED and its requirements, but says "LEED is the best initiative we've got right now; let's work with it to help bring about these changes [where we think the program doesn't work]." Managing this will be even more of a nightmare if it's extended even to domestic-sized structures, so it probably will not reach to that level, but larger purpose-built museum structures and visitor centers may have to comply.

Working toward zero emission and zero net energy is becoming more common. Pennsylvania's governor announced an energy independence strategy with a goal of zero emissions. The Pennsylvania Historical and Museum Commission had been working along sustainability lines since before 1998, so this mandate did not add unexpected challenges. Zero emission means energy use without any greenhouse gas production from its generation or use. Zero net energy means a site does not use more energy than it produces in a year, even though at times it might over- or underproduce for its needs. Both goals will take years to accomplish, but it is reasonable to expect that each of us will be required to begin and continue to regularly document significant progress toward these goals within the next decade.

What about limits on waste? In early 2014, Massachusetts Governor Deval Patrick announced what he calls a "commercial food waste disposal ban." Organizations generating a ton or more per week of food waste will be required to donate or repurpose usable food and send the remainder

to appropriate energy-generating or composting facilities. This will reduce the waste stream headed to the state's landfills and will potentially increase clean energy generation. It will also focus institutional energy on how to provide food for retail or for institutional services in ways that limit waste, and to create systems to distribute usable food to institutions and individuals in need. The goals are marvelous and the mandate will accelerate the work to achieve them. If this happens in your state, will your café or your special events program be prepared?

Dark skies regulations will expand. Light pollution is all the illumination escaping from unshielded outdoor fixtures and building windows. It is enough to keep us from seeing the stars at night if we are in a populated area. Migrating birds and other wandering creatures find the light at least distracting and sometimes fatal. Many new outdoor fixtures will be manufactured to eliminate light escaping beyond the horizontal, but soon you may be expected to retrofit any nonconforming lights. If you have a light to replace, or if you are adding outdoor fixtures, make them dark sky friendly now instead of later. And if you use your interior lights at night, prepare to install light management systems that automatically extinguish lights or to develop protocols instructing staff to turn off lights by certain times.

Water Shortages

The Museum Futures Community of the California Association of Museums published a Foresight Research Report "Environment and Resource Sustainability in Museums." In the list of trends and projections for facilities. it states "The current drought in California will cause a severe water crisis in the state. Some climatologists are predicting a possible 'megadrought.' Are museums equipped to handle a water crisis?" No, we are not. Do you know how much water you use and for what reasons? Do you know what aspects of your work require potable water and not greywater or rainwater? The Western states have water conservation in their DNA, and others of us are familiar with summertime conservation requirements for outdoor watering, but are we ready to respond to potable water use guidelines and water rationing? The first step toward managing such a future is metering your water. If you are a small site, a single meter may do the trick, but larger sites will benefit from metering high-use buildings or individual water processes such as for heating, ventilation, and air-conditioning systems; irrigation; and animal support. This will be a wasted effort if you don't actually review those readings and use them for decision-making. If you know how much water you use for irrigation, and your site is subject to water limits, you will know exactly how much rainwater or greywater you need to capture

PHOTO 9.1. At Temple Workman Homestead, La Casa Nueva's main hall gives visitors a taste of the rich decorative arts that are found throughout the house.
Courtesy Homestead Museum.

to continue fulfilling your irrigation needs while reserving your quota of potable water for higher-use needs. If the difference between need and limit is small, you may be able to strategically water during cooler times of day to conserve and may not need the extra tanks at all. With metering data, you'll be able to plan better. For sites with landscapes, that's critical.

The Workman and Temple Homestead in the city of Industry, California, has an interpretive conundrum: in 1900, the landscape at the Homestead would have had no lawn, but in 1920, near the end of the interpretive time period, it would have. Maintaining such a lawn in these more environmentally conscious times makes little sense; doing so during a drought makes even less sense, but it's historically appropriate. Virginia House in Richmond, owned by the Virginia Historical Society has a similar siuation. It has historic plantings with water-hungry elephant ear plants. They're not native and they require a lot of water, yet they are part of the historic plantings. The solution is to cut back on the number of elephant ear plants in the area so that water demand is manageable and the appearance is adhered to,

though the density is less. For now it is an effective compromise. But all sites are going to have to make choices about the appropriate amount of water they provide for their landscapes.

Next-Level Disaster Preparedness: Anticipate Climate Disruption and Climate Events

While Southern California is experiencing a long-term drought, in some areas residents also must deal with sporadic periods of heavy rain. In 2013, at the Workman and Temple Family Homestead, there was mold in one of the homes for the first time ever. They'd had so much rain that it was creating new conditions that hadn't needed to be addressed before. Instead of a steady dryness, now there are longer periods of drought, yet also rain events at unexpected times. They have discontinued their Christmas festival because it was rained out too many years. They changed the date of the spring festival as well, because too often it was too warm for a successful event. Weather, including extreme heat and rain, has interfered now with special events enough that they're rethinking outdoor programs because they can't rely on ideal conditions as before.

We can expect to experience climate events and climate change effects with increased scale and frequency. So which ones are you most likely to experience? The answers are pretty regional: increased or decreased amounts of rain or snow, increased frequency and impact of storm events, or range and duration of unfamiliar temperatures, for example. How about storms? In many states, museums and sites have to build tornado shelters by code. Many more of us may very soon need to create shelter-in-place options in our buildings. Do you have a shelter to offer? A place to build one?

In response, your power needs may change (requiring more or less cooling, heating, and dehumidification) or you may need to plan for a more local power source so you can reduce your exposure to damage-related outages and can expect faster repair response. Perhaps you should begin looking for your own backup or continuous energy sources (energy independence). Those of us adjacent to water probably have flood plans in place, but remember that flood zones and flooding incidents are spreading, and we who are unused to unwanted water may need to reexamine preparedness. More urban sites should look at flood attachments for doors and be universally proactive about basement storage area changes, flood damage prevention, and flood damage responses. Make it a point to consider your response ability not just for your own needs, but also to support others in the community who may be affected even when you are not. Is there a way to be an evacuation site for other museums, archives, or public records? Do

you have spaces that can be temporary shelters for humans or animals? Do you have equipment others can borrow if they need to respond to fire or flood when you are safe? If you put this thinking into your planning, and share it with others doing theirs, response time and effectiveness will be better in times of stress.

The Internet of Things

The "Internet of Things" and the development of location- and context-aware technologies is pointing the way to a new order of complex interactions that will erase the gap between networked digital devices and the physical world of objects and human beings. . . . The network is brought to life by gadgets such as sensors and transmitters that connect these "things" to the Internet or local networks, enabling them to exchange information and trigger actions.

—American Alliance of Museums *TrendsWatch 2013*

We already see this in smart buildings and smart meters where they provide near real-time feedback on energy and water consumption, and building conditions. If your museum has energy and water meters that digitally connect with your building management software, you are already participating. In the future, you may be able to receive accounts payable alerts for carbon production warnings or waste budget excess notices. *TrendsWatch 2013* explains that your garbage will know when you've thrown out a cereal box and tell you to order more,[8] but you can also expect that the garbage container will soon tell you that you should have put that box in the recycling container instead! And when the recycling and garbage containers measure use, you can stop Dumpster diving to assess your waste numbers each month.

If your heating, ventilation, and air-conditioning system calls your curator when the conditions exceed tolerances, you're already participating in the Internet of Things. Don't worry if you aren't yet. Some of us will lead the way and work the technology until the bugs are gone and the options are affordable and highly dependable. Still, you must prepare your institution to anticipate ways that objects, systems, and devices will communicate with machines held by staff to support energy efficiency, and resource and time management, and by visitors to report energy, water consumption, as well as purchases, learning time, and onsite movements. This will open up new ways to identify visitor learning, and comfort service needs and interests, that you will use as much for environmental sustainability as for visitor service.

Changes in Transportation

Trends toward increased use of public transportation, urban living without owning personal vehicles, and an emphasis on bikeable destinations will create visitation challenges for rural sites. If the trend to city living continues and North Americans head into cities to a greater degree than the 82 percent already there,[9] and more of those city dwellers give up on cars, this is great news for urban historic sites and history museums, but the farm-life museums, plantations, or fishing village destinations must prepare. How are we going to get the people to them? Where there isn't public transportation, you may have to work collaboratively to provide convenient and appropriate options, whether it's a trolley system on special days and weekends, or a shared-car promotion with discount tickets on every rental. You will need to think outside the expectations of a car per visiting family. The field has experienced such a contraction before when the money for school bus transportation dried up and we saw a cut in group visits. We responded by funding bus trips, taking the programs to the schools, or creating distance learning options. Continuing to provide long distance education and learning to use technology to provide more participatory learning options will only increase in importance and in public currency. But in-person teaching isn't going to disappear, so plan to add an energy-efficient, alternative fuel vehicle to your fleet so your car-free employee has a vehicle to get him- or herself out to the schools.

Even urban sites struggle with access to public transportation. It has taken more than a decade of hard cooperative work, but there is a new intermodal transport station opening up in Dearborn, Michigan. The location makes it a door to the Henry Ford's campus that allows access to the museum, Greenfield Village, and the Benson Ford Research Center.[10] It connects to twenty-five miles of bike and walking trails, commuter rail, and eventual high-speed rail.[11] The museum has the marvelous challenge of managing a probable increase in visitors, but since parking lots already frequently reach to capacity, this new access is a welcome opportunity. Now even staff can take direct, convenient public transportation to work. The museum provided some land for the station and for access, and in return has a space inside the building to permanently display a locomotive and other exhibit components. That's a smart partnership for everyone.

Environmental Literacy Education

This could become an income stream. Plan now to become a green partner with public schools, community service groups, and higher and professional education providers. They will find they have to respond to new mandates

or program opportunities and will need help with capacity and content. As other states follow Maryland's example of adding environmental education to learning standards (mandated, funded, or neither) and environmental literacy becomes a valued attribute, historic sites and history museums can capitalize on the great spaces and experiences they can offer. So ally yourself with the green movements in public schools where you can provide experiential education and professional development, with community agencies where you can provide facilities and expertise, and with continuing and higher education programs to provide content and instructors or instructional sites and thesis projects. Agencies building environmental literacy will need you for content and delivery.

Your staff talents and institutional resources can support continuing and higher education organizations using digital badges for distance learning and skills-defined credentials. Offer to provide or support digital badges as the location for the tactical, tactile skill-building work. The movement to create master naturalists[12]—recognize the name format from master gardeners?—is well established but not particularly well known as a partner for many museums and sites. The goal is to train the volunteers as stewards of the natural environment and deploy them to teach those skills to others. Can your site host a training program? Can you adapt this and develop a volunteer-led program that mentors sustainable practices on- and offsite, transferring between history and today and the future? A student who learns how to can foods and dry herbs will have those skills for a lifetime; another who helps replant an historic hedgerow learns about the history of your site and the ecology of sustainable planting. Our sites often have green space that community agencies lack and more natural science expertise than their staff. The community agencies have the volunteer learners and the supervisory staff we look for. That synergy creates the strength that is the hallmark of successful programs.

Public schools may find themselves subject to environmental literacy standards, whether or not they have the funding and knowledge to comply, we can help. Maryland was the first state to set such a standard.[13] Commonwealth of Maryland (COMAR) Regulation 13A.03.02 reads

> Beginning with students entering high school in 2011-2012, all students must complete a locally designed high school program of environmental literacy as set forth in COMAR 13A.04.17 that is approved by the State Superintendent of Schools. ... The purpose of Maryland's Environmental Education program is to enable students to make decisions and take actions that create and maintain an optimal relationship

between themselves and the environment, and to preserve and protect the unique natural resources of Maryland, particularly those of the Chesapeake Bay and its watershed.

You need not be a science museum to help students understand the historic relationship between people and the land they live in.

Positioning for Green Financial Support

Build, or continue to build, your political alliances to take advantage of rapidly changing public funding for green initiatives. The money available for energy efficiency or water purity initiatives changes with each administration—state or national. If you have an interest in making changes in these areas, you should have your projects ready to go when the money becomes available. By staying in touch with the legislators and the service industries interested in these topics, you may hear of change early and be able to get in first. This is undependable money, but it can be significant. If you have a sizable project, this money is worth pursuing.

Individual giving to sustainability projects is not yet significant, but it may become a powerful resource nevertheless. In a report on giving by the richest donor for 2013, the *Chronicle of Philanthropy* noted that "Causes for children and youths, the environment, religion, and public broadcasting took in the fewest gifts and the least money from the biggest donors."[14] Medical centers, research, and arts organizations fared better. "'Pursuing policy changes' is a trend among philanthropists who 'want to have the most bang for their buck,'" says one foundation president, including environmental policy and regulations. Watch where the major funders put their policy efforts and you'll have some indication of future funding.

A *TrendsWatch 2013* article on giving explains that

> The preferences of Millennial and female donors are part of a larger trend towards "strategic" or "outcome-oriented" philanthropy, sustained by a cultural climate of accountability, testing, metrics and return on investment (ROI). Unlike giving based on trust in a charity's mission or good intentions, strategic philanthropists set defined goals and expect their grantees to pursue evidence-based strategies for achieving those objectives. And the donor (whether foundation or deep-pocketed individual) often plays an active role in monitoring progress toward outcomes, assessing success and evaluating whether changes in approach are needed.[15]

Sustainability work, with its opportunities for measurement and proof of return on investment, is well suited for attracting the outcome-based donors of the future: metering can measure energy production or savings, and water savings; waste hauling records can demonstrate reductions in waste sent offsite; and purchasing reports can identify the growing percentage of environmentally preferred purchases over time. So start a habit among staff right now for measuring green impact so that you have a history of data to share, not a hastily prepared report in time for the annual appeal. A smart green funder wants to know exactly *how* green you are; you'd better be prepared to show them.

Payments in Lieu of Taxes Fees

This is *not* about spending money. As financially stressed municipalities turn to Payments in Lieu of Taxes (PILOTs) to build revenue, history museums and historic sites should prepare responses before they are needed. The idea is that institutions such as museums and sites use, but do not pay for, public services such as emergency and safety services, road construction and maintenance, and other infrastructure costs traditionally supported by tax payments by individuals and for-profit organizations. Some municipalities are asking for financial help through PILOT fees instead of tax payments. If you receive such a request, whether you support your municipality financially in this way is your institution's decision. If you do not wish to, environmentally sustainable practices may give you a line of explanation or, if need be, defense. If you have reduced your consumption of municipal water and cut back on the greywater and blackwater you send away from your site through city sewers, you have already limited your consumption of public services and therefore your impact on the infrastructure required to deliver those services. If you have reduced the amount of material you send to the municipal landfill, whether it is collected by a public or private service, you have reduced your impact on municipal services. If you have cut back on energy consumption and your town owns its own utility, you have helped the town reduce its capital requirements for energy production. And if you encourage the use of public transportation, carpooling, and walking and cycling to work, then you have reduced your impact on the traffic infrastructure your municipality maintains.

These are all examples of how you have saved money for the municipality. Now, if you have carefully documented your reduced impact, then you can make your case for how your changes have offset any amount demanded for a PILOT payment. Can you do that now? Can you plan to do that next year? Liz Callahan, executive director of Hanford Mills, says,

"Institutions should act responsibly in their communities, and environmental sustainability is an example of that." Yes, it is. As community members, sites and museums are responsible for reducing their costs to the environment and their community, and that they should "get credit for those savings in lieu of Payments in Lieu of Taxes!"[16]

Notes

1. Liz Callahan in interview with the author, July 10, 2014.

2. Jim Carlton, "Drought Provides Window to Old West," *The Wall Street Journal*, January 26, 2014, accessed January 26, 2014, http://online.wsj.com/news/articles/SB10001424052702304419104579322631095468744.

3. U.S. National Park Service, "Lowering Lake Levels—Lake Mead National Recreation Area," accessed September 4, 2014, http://www.nps.gov/lake/naturescience/lowering-lake-levels.htm.

4. Jim Carlton, "Drought Provides Window to Old West," *The Wall Street Journal*, January 26, 2014, accessed January 26, 2014, http://online.wsj.com/news/articles/SB10001424052702304419104579322631095468744.

5. Email with the author, September 25, 2014.

6. Ellen Douglas, Paul Kirshlen, Vivien Li, Chris Watson, and Julie Wormser, "Preparing for the Rising Tide," The Boston Harbor Association, February 2012, accessed September 26,2014, http://www.tbha.org/sites/tbha.org/files/documents/preparing_for_the_rising_tide_final.pdf.

7. Adrienne McGraw, "Museums, Environmental Sustainability and Our Future," American Alliance of Museums, January 2014, accessed September 28, 2014, http://www.aam-us.org/docs/default-source/professional-networks/picgreenwhitepaperfinal.pdf?sfvrsn=4.

8. Elizabeth E. Merritt and Philip M. Katz, "When Stuff Talks Back: The Rise of Networked Objects and Attentive Spaces," in *Trends Watch 2013: Back to the Future*, 24–25, Center for the Future of Museums, American Alliance of Museums, 2013, accessed August 7, 2013, http://aam-us.org/docs/center-for-the-future-of-museums/trendswatch2013.pdf.

9. Elizabeth E. Merritt and Philip M. Katz, "The Urban Renaissance: What Does It Mean for Museums?" in *Trends Watch 2013: Back to the Future*, 36, Center for the Future of Museums, American Alliance of Museums, 2013, accessed August 7, 2013, http://aam-us.org/docs/center-for-the-future-of-museums/trendswatch2013.pdf.

10. City of Dearborn, Michigan, "Intermodal Passenger Rail Photo Gallery," accessed September 12, 2014, http://www.cityofdearborn.org/city-departments/economic-and-community-development/trainstation/2-uncategorised/745-intermodal-passenger-rail-photo-gallery.

11. "Construction Begins on Dearborn's Intermodal Passenger Rail Station," City of Dearborn, Michigan, press release, April 10, 2012, http://www

.cityofdearborn.org/city-departments/economic-and-community-development/
trainstation/2-uncategorised/746-intermodal-rail-station-press-release.

12. Carole Sevilla Brown, "Master Naturalist Programs by State," EcosystemGardening.com, accessed September 1, 2014, http://www.ecosystemgardening.com/
master-naturalist-programs-by-state.html.

13. Jason Koebler, "Maryland to Require Environmental Literacy for Graduation," *U.S. News & World Report*, July 18, 2011, accessed September 1, 2014, http://
www.usnews.com/education/blogs/high-school-notes/2011/07/18/maryland
-to-require-environmental-literacy-for-graduation.

14. Doug Donovan, Ben Gose, and Maria Di Mento, "Gifts Surge from Rich
U.S. Donors," *Philanthropy 50—The Chronicle of Philanthropy*, February 9,
2014, accessed September 1, 2014, http://philanthropy.com/article/Gifts-Surge
-From-Rich-U-S/144601/.

15. Elizabeth E. Merritt and Philip M. Katz, "The Changing Face of Giving: Philanthropic Trends for the Future of Museums," in *TrendsWatch 2013: Back to the
Future*, 8–12, Center for the Future of Museums, American Alliance of Museums,
2013, accessed August 6, 2013, http://aam-us.org/docs/center-for-the-future-of
-museums/trendswatch2013.pdf.

16. Sarah Sutton, "The PILOTs Are Coming: Use Sustainable Practices to Pay
Your Payments in Lieu of Taxes," *Sustainable Museums* (blog), May 6, 2010, http://
sustainablemuseums.blogspot.com/2010/05/pilots-are-coming-use-sustainable
.html.

Resources

Barthel-Bouchier, Diane. *Cultural Heritage and the Challenge of Sustainability*. Walnut
Creek, CA: Left Coast Press, 2013.

Conn, Megan, Leslie Matamoros, Steve Windhager, and Lisa Eriksen. *Foresight Research
Report: Environment and Resource Sustainability in Museums*. California Association of Museums, 2013. http://www.calmuseums.org/_data/n_0001/resources/live/
Baseline_EnvironmentSustainability_14.02.10.pdf.

Douglas, Ellen, Paul Kirshlen, Vivien Li, Chris Watson, and Julie Wormser. "Preparing
for the Rising Tide." The Boston Harbor Association. February 2012. http://www
.tbha.org/sites/tbha.org/files/documents/preparing_for_the_rising_tide_final.pdf.

Maryland State Department of Education. "Maryland Environmental Literacy Standards." http://www.msde.maryland.gov/NR/rdonlyres/EC79EC27-40BF-4017
-894B-63A12A89A3D1/31625/MD_ELIT_STANDARDS.pdf.

Merritt, Elizabeth E., and Philip M. Katz. "TrendsWatch 2013: Back to the Future." The
American Alliance of Museums. http://aam-us.org/docs/center-for-the-future-of
-museums/trendswatch2013.pdf.

CONCLUSION

"Sustainable Stewardship":
What Business-as-Usual Should Look Like

R ichard Moe was president of the National Trust for Historic Preservation in 2007 when he gave a speech accepting the Vincent Scully Prize recognizing "exemplary practice, scholarship, or criticism in architecture, historic preservation, and urban design." In the award ceremony's lecture at the National Building Museum, Moe talked about how

> Montgomery Meigs' Pension Building outlived its original function decades ago. Incredibly, there was talk of demolishing it for a while—but wiser heads prevailed, and the building was given new uses. Today, having reached the ripe of age of 120, this architectural and engineering marvel is still here for all of us to enjoy, learn from, and be inspired by. The story of the National Building Museum encapsulates what historic preservation is all about: When you strip away the rhetoric, preservation is simply having the good sense to hold on to things that are well designed, that link us with our past in a meaningful way, and that have plenty of good use in them. . . . The key phrase is sustainable stewardship.[1]

Moe was making a case for preserving buildings instead of demolishing them in favor of building new ones using new technologies. Sustainable stewardship applies to all aspects of changing behavior to reduce impact, and to museum work. Let's hold on to what works, and learn from practices

developed when energy use was a *decision*, not a habit, and when we understood more about what materials and processes were part of everything we did or used.

In the Introduction, I explained that I suspected, while you read this book, you would provide a constant refrain to my verses of "how do I pay for this?" If my answer didn't take then, perhaps it can now. Sustainable operations and principles are fast becoming the new standard. When you adopt a new standard, you pay the cost of change the way you pay for any other professional practice at your institution: you move from looking at the change as an add-on or a trend that requires new funding sources, to seeing it as simply what you do. Green *is* a cost of doing business—all business. Sometimes it puts you ahead; sometimes it costs a little more. More sites discover this every day. The Pennsylvania Historical and Museum Commission's Chief of the Division of Architecture and Preservation Barry Loveland writes that

> Every day, more products, new equipment, and groundbreaking ideas surface that are energy efficient, use recycled materials, rely on less natural resources, and are more affordable. ... Integrating sustainable design practices not only fits well with the agency's mission of preserving the historic sites and museums that tell the stories of Pennsylvania history, but the greening of the [Pennsylvania Historical and Museum Commission] also makes good economic sense.[2]

When you and those around you are able to recognize and internalize this, the rate of change in your institution will escalate exponentially. Through self-study, training programs and workshops, and talking with your colleagues, you can develop the necessary skills in yourself and current staff to make these changes. You will likely find new hires come with interest and skills in sustainability. The positions of director of sustainability, sustainability manager or officer, sustainability intern, sustainable agriculture program manager, and sustainable farm manager will proliferate in our field until "sustainable" is understood as business as usual.

The good news is that embracing these principles and practices creates an energy loop of its own. As you build your knowledge, experience, and networks, your sustainable results will grow into a constantly recharging progress loop that will help you make more good changes. Sustainability breeds sustainability, but only if you *choose* to encourage it.

Go green and prosper!

Notes

1. Richard Moe, "Sustainable Stewardship: Historic Preservation's Essential Role in Fighting Climate Change," remarks on receiving the Vincent Scully Prize, December 13, 2007.

2. Barry A. Loveland, "Pennsylvania History Goes Green," *Pennsylvania Heritage*, Spring 2009, accessed September 15, 2014, http://www.portal.state.pa.us/portal/server.pt/community/energy__impact/4701/phmc_conservation/471379.

INDEX

199

ABOUT THE AUTHOR

Sarah Sutton is an independent consultant to museums in the United States and, increasingly, internationally. She is also a LEED-AP: an accredited professional in Leadership in Energy and Environmental Design through US Green Building council. She has a BA in American Studies from Sweet Briar College and an MA in history from the College of William & Mary, and a certificate in history administration from the William & Mary museum training program with the Colonial Williamsburg Foundation. She is a founding member and past co-chair of the American Alliance of Museums Professional Network on Environmental Sustainability: PIC Green. With Elizabeth Wylie, she cowrote *The Green Museum: A Primer on Environmental Practice* under the name Sarah S. Brophy.

She works with historic sites and museums, zoos, aquariums, gardens, and other educational and cultural organizations to find the most efficient and appropriate ways to become more environmentally sustainable in operations, building decisions, and education programs. She is as happy speaking to boards as she is dumpster-diving with a team of green colleagues. Her daily commitment is to help any and every museum find a path to a stronger mission and greater community connections through reduced impact on the environment. Her goal is to help museums contribute to restoring their portion of the environment while contributing to an informed citizenry leading change in their communities. You can reach her for consultation or connections at www.sustainablemuseums.net.

Sarah aspires to shorter showers, eating more local food, living in a net-zero-energy house, and learning how to proofread manuscripts onscreen. She keeps an organic garden, loves her clothesline (because in the winter she moves it to the basement), finished proofreading this book on a sustainably-sourced and locally-made desk, and drives a Subaru from the zero waste plant in Indiana.